Image Science

ICONOLOGY,
VISUAL CULTURE, AND
MEDIA AESTHETICS

W. J. T. Mitchell

IMAGE SCIENCE

The University of Chicago Press
Chicago and London

The University of Chicago Press, Chicago 60637
The University of Chicago Press, Ltd., London
© 2015 by The University of Chicago
All rights reserved. Published 2015.
Paperback edition 2018
Printed in the United States of America

27 26 25 24 23 22 21 20 19 18 2 3 4 5 6

ISBN-13: 978-0-226-23133-4 (cloth)
ISBN-13: 978-0-226-56584-2 (paper)
ISBN-13: 978-0-226-23150-1 (e-book)
DOI: https://doi.org/10.7208/chicago/9780226231501.001.0001

Library of Congress Cataloging-in-Publication Data

Mitchell, W. J. T. (William John Thomas), 1942–
author.
 Image science : iconology, visual culture, and
 media aesthetics / W. J. T. Mitchell.
 pages cm
 Includes index.
 ISBN 978-0-226-23133-4 (cloth : alkaline paper)
 ISBN 978-0-226-23150-1 (ebook)
 1. Image (Philosophy). 2. Pictures—
 Philosophy. 3. Visual communication—
 Philosophy. 4. Mass media—Philosophy. I. Title.
B105.I47M58 2015
701'.8—dc23 2015010449

♾ This paper meets the requirements of ANSI/NISO
Z39.48-1992 (Permanence of Paper).

For Michael Camille and the Laocoön Group

Becky Chandler
Elizabeth Helsinger
Robert Nelson
Margaret Olin
Linda Seidel
Joel Snyder
Martha Ward

CONTENTS

ILLUSTRATIONS

0.1 Edgar Rubin, "Rubin's Vase" (1921).
One vase/two faces.

PREFACE
Figures and Grounds

A distinction is drawn by arranging a boundary with separate sides so that a point
on one side cannot reach the other side without crossing the boundary.

GEORGE SPENCER-BROWN, *Laws of Form* (1969)

There is an Outside spread Without, & an Outside spread Within
Beyond the Outline of Identity both ways, which meet in One . . .

WILLIAM BLAKE, *Jerusalem* (1804)

We Germans have no lack of systematic books.

G. E. LESSING, *Laocoon: On the Limits of Poetry and Painting* (1766)

"How to begin without having begun, since one needs a distinction in
order to begin." The answer, for philosopher Niklas Luhmann, is a simple
imperative: "draw a distinction."[1] This remark might be taken as the fun-
damental mantra of modern systems theory, as important to contempo-
rary social and natural sciences as the Cartesian cogito, "I think, therefore
I am," was to early modern science. But it is also a foundational moment
for iconology, the science of images. An iconologist is bound to notice
the figurative expression hidden in the notion of *drawing* a distinction,
and then to insist on taking it literally, as a visual, graphic operation. The
philosopher or sociologist might say it means merely to *make* a distinction,
to provide a verbal definition that distinguishes one thing from another—
truth from falsehood, good from evil, clarity from obscurity, here from
there—especially when the two things might otherwise be confused:
art and life, meaning and significance, expression and imitation. In any
case, the iconologist's attention is drawn to *drawing*, to the inscription of
a boundary, the marking of a form in space, the contrast between a thing
and the environment in which it is located. In short, the delineation of
figure from ground.

Of course, drawing a distinction between figure and ground is only

1. *Art as a Social System* (Stanford, CA: Stanford University Press, 2000), 31.

the beginning. In systems theory, that distinction marks the boundary between a system and its environment or between a form and the medium in which the form appears. It inevitably draws attention to three things: (1) the boundary between an inside and an outside that constitutes a figure or form in a space; (2) the frame or support in or on which an image and its surrounding space make their appearance; (3) the outline that curves in upon itself, drawing the beholder into a vortex that reverses the locations of figure and ground. Thus, what was marked becomes unmarked, and the previously unmarked suddenly emerges as remarkable: the vase disappears to reveal two faces, or vice versa.

From the standpoint of image science, then, systems theory ceases to be abstract. It takes on a body and locates that body somewhere. It becomes visible, graphic, and even palpable. And it puts into question its own Cartesian moment of drawing because, after all, is drawing really all there is to images? What about color? Doesn't color obey a different logic, one that spills over boundaries, shades into an infinite spectrum of infinitesimal differentiations and vague indeterminacies? Is it not the ultimate ground out of which every figure must emerge? And isn't color precisely the phenomenon that defies the fundamental gesture of systems theory, insofar as every distinction that is drawn between one hue, one tonality, and another generates an intermediate possibility, a mixture of the two colors being distinguished, the gray zone of the everyday?

The following essays, written unsystematically over the last decade in response to a variety of occasions, display a certain adherence to these basic gestures and limitations of systems theory. The essays are gathered here as a diptych, part 1 focusing on figures, part 2 on grounds. The first eight essays deal with the nature of images, from the ways in which they breach the disciplinary borders of art history, to their potential as scientific objects, to their centrality in questions of language, social and emotional life, realism and truth-claims, technology and life-forms, and, finally, in the notion of world pictures, or "the world as picture," as Martin Heidegger put it.[2] The second eight essays focus on the media in which images appear, the sites and spaces where they live, and the frameworks of temporality and spectacle that frame them in a history of the present.

2. "The Age of the World Picture," in *The Question Concerning Technology*, trans. William Lovitt (New York: Harper & Row, 1977), 129: "world picture, when understood essentially, does not mean a picture of the world but the world conceived and grasped as picture."

ACKNOWLEDGMENTS

I could go on at great length acknowledging the numerous friends and colleagues who have inspired these essays. Most were written in response to a question or a challenge, and I have tried to specify all of those in the notes to each chapter. But there is also one long-overdue debt that the book as a whole tries to address, and that is to a small group of colleagues at the University of Chicago that brought art history, literature, and philosophy into dialogue almost thirty years ago. It called itself the Laocoön Group, naming itself after the late classical sculptural group, and the crucial book of G. E. Lessing that provided us with an exemplary synthesis of critical theory across the arts. Lessing's *Laocoön: On the Limits of Poetry and Painting*, a capstone of Enlightenment aesthetics, was deliberately and proudly unsystematic, much like our motley group of scholars. It is to that group that this book is dedicated, especially to its most brilliant member, the late Michael Camille. The first chapter, "Art History on the Edge," is in effect an explanation of this dedication, a naming of names, and a genealogy of image science as I have experienced and understood it.

Many individuals contributed advice, counsel, and comfort as these essays were being written (and rewritten). As always, Joel Snyder and Alan Thomas have been crucial in saving me from errors and raising the game. Lauren Berlant, Neal Curtis, Stephen Daniels, Ellen Esrock, Michael Ann Holly, Janice Misurell Mitchell, Keith Moxey, Florence Tager, and Michael Taussig provided timely interventions. Jacques Rancière agreed to engage in dialogue about image theory in a way that has been endlessly productive. Nova Smith provided crucial help with permissions. And Sally Stein was incredibly generous in allowing me to reproduce the late Allan Sekula's wonderful photograph.

I must also mention three institutions that have made it possible for me to finish this book. The first is the Getty Research Institute, headed by director Thomas Gaeghtens, which provided space, time, inspiration, and resources in the winter and late summers of 2013 and 2014. The second is the Clark Institute for Art History, where, under the benign gaze of director Michael Ann Holly, the first drafts of several of these essays were written

in 2008, and which gave me a precious asylum for writing in the spring of 2013. Lastly, the Division of Humanities at the University of Chicago, headed by Dean Martha Roth, provided reliably regular leave time and research funds that have made my life as a scholar possible.

Chapter 1, "Art History on the Edge: Iconology, Media, and Visual Culture," was written for "Discipline on the Edge: Michael Camille and the Shifting Contours of Art History, 1985–2010," a session in honor of Michael Camille at the College Art Association's 2010 meeting. Chapter 2, "Four Fundamental Concepts of Image Science," first appeared in *Visual Literacy*, ed. James Elkins (New York: Routledge, 2008), 14–30. Chapter 3, "Image Science," was written for the Thyssen Lecture at Humboldt University in Berlin, with the generous support of the Wissenschaftskolleg zu Berlin; it first appeared in *Science Images and Popular Images of the Sciences*, ed. Bernd Huppauf and Peter Weingart (New York: Routledge, 2007), 55–68. Chapter 4, "Image X Text," first appeared as the introduction to *The Future of Text and Image: Collected Essays on Literary and Visual Conjunctures*, ed. Ofra Amihay and Lauren Walsh (Cambridge: Cambridge Scholars Publishing, 2012), 1–14. Chapter 5, "Realism and the Digital Image," first appeared in *Critical Realism in Contemporary Art: Around Allan Sekula's Photography*, ed. Jan Baetens and Hilde Van Gelder, Lieven Gevaert Series, vol. 4 (Leuven: Leuven University Press, 2012), 12–27; it was translated into Italian by Federica Mazzara as "Realismo e imagine digitale," in *Cultura Visuale: Paradigmi a Confronto*, ed. Roberta Coglitore (Palermo: Duepunti Edizione, 2008), 81–99, and reprinted in *Travels in Intermedia: ReBlurring the Boundaries*, ed. Bernd Herzogenrath (Aachen: Mellen Press, 2011; Hanover, NH: Dartmouth College Press, 2012). A different version of chapter 6, "Migrating Images: Totemism, Fetishism, Idolatry," appeared in *Migrating Images*, ed. Petra Stegmann and Peter Seel (Berlin: House of World Cultures, 2004), 14–24; it is reprinted here with permission by Haus der Kulturen der Welt, Berlin. Chapter 7, "The Future of the Image: Rancière's Road Not Taken," first appeared in "The Pictorial Turn," a special issue of *Culture, Theory, and Critique*, ed. Neal Curtis (fall 2009), reprinted in book form as *The Pictorial Turn*, ed. Neal Curtis (New York: Routledge 2010), 37–48. Chapter 8, "World Pictures: Globalization and Visual Culture," first appeared in a special issue on globalization in *Neohelicon*, ed. Wang Ning (34, no. 2; December 2007); it was reprinted in *Globalization and Contemporary Art*, ed. Jonathan Harris (Malden, MA: Wiley-Blackwell, 2011), 253–64.

In part 2, chapter 9, "Media Aesthetics," first appeared as the foreword to *Thinking Media Aesthetics*, ed. Liv Hausken (New York: Peter Lang, 2013),

15–28. Chapter 10, "There Are No Visual Media," first appeared in *Journal of Visual Culture* 4, no. 2 (2005): 257–66; it was reprinted in *Media Art Histories*, ed. Oliver Grau (Cambridge, MA: MIT Press, 2007), 395–406, and in *Digital Qualitative Research Methods*, ed. Bella Dicks (New York: Sage, 2012). Chapter 11, "Back to the Drawing Board: Architecture, Sculpture, and the Digital Image," first appeared in *Architecture and the Digital Image: Proceedings of the 2007 International Bauhaus Colloquium*, ed. Jorg Gleiter (2008), 5–12. Chapter 12, "Foundational Sites and Occupied Spaces," was the keynote address for Grundungsorte, a 2012 conference convened by the Research Group on Culture, Politics, and Space at the University of Munich; it appeared in *Grundungssorte der Moderne von St. Petersburg bis Occupy Wall Street*, ed. Maha El Sissy, trans. Sascha Pohlmann (Paderborn: Wilhelm Fink, 2014), 23–38. Chapter 13, "Border Wars: Translation and Convergence in Politics and Media," was the keynote address for the International Conference of the English Language and Literature Association of Korea (ELLAK), Busan, Korea, December 2012; many thanks to the organizing genius of Youngmin Kim. Chapter 14, "Art X Environment," was written as the keynote address for the "Art + Environment" conference at the Nevada Museum of Art in 2008. Chapter 15, "The Historical Uncanny: Phantoms, Doubles, and Repetition in the War on Terror," was written for the Kunstwerke lecture series in Berlin. And chapter 16, "The Spectacle Today: A Response to Retort," first appeared in *Public Culture* 20, no. 3 (2008): 573–81 (© 2008, Duke University Press, all rights reserved; republished by permission of Duke University Press); it has since been updated to the conditions of 2013.

PART ONE *Figures*

1.1 Anonymous, Book of Hours, Rouen, France (ca. 1500–1510). Parchment (detail). MS 343, ff. 89v–90r. Photograph: Special Collections Research Center, University of Chicago Library.

1: ART HISTORY ON THE EDGE

Iconology, Media, and Visual Culture

It has been a long time since I could claim to be an outsider to art history. Despite my lack of academic credentials in this field, I have been ploughing it for so long that, as Karl Marx would have put it, my brains and muscle have long since been mixed with the soil of the visual arts, and that is where I expect to be buried.

But there was a time back in the 1980s when I was part of a generation of literary critics and philosophers who migrated into the visual arts. Scholars like Norman Bryson in England, Mieke Bal in the Netherlands, and Gottfried Boehm in Switzerland, not to mention the hordes of semioticians, structuralists, and deconstructionists, began to invade the quiet domain of the visual arts and set up camp with new methods and metalanguages. At the same time, art historians like Michael Baxandall, Svetlana Alpers, Hans Belting, and David Freedberg were expanding the boundaries of traditional art history into rhetoric, optical technologies, and vernacular or nonartistic images, and a new debate over modernism was emerging between T. J. Clark and Michael Fried.

Closer to home, in fact right at the heart of my own Department of Art History at the University of Chicago, was a remarkable scholar who epitomized these new tendencies, and who dazzled us all with his audacious efforts to revolutionize the study of medieval art, a field that many of us in literature and the visual arts had regarded for some time as hopelessly orthodox and stuffy, dominated by religious dogma and the archaic conventions of aristocratic romances. My own literary training had led me to think of medieval culture as unbearably pious and obsessed with higher, more spiritual things than we modern, secular humanists could bear to contemplate. Even the great Chaucer, with his bawdy humor and scatological realism seemed to have been made safe by a comprehensive framework of Christian allegorizing that assured us of the stable theological system underlying all the deviations. As Albert Baugh put it in his classic textbook, *A Literary History of England*:

One is constantly aware in medieval literature of the all-important place of the Church in medieval life. It is often said that men and women looked upon this life mainly as a means to the next. Certainly they lived in much more fear of Hell and its torments and were vitally concerned with the problem of salvation for their souls. Religious writings are, therefore, a large and significant part of medieval literature, not off to one side as in our day, but in the main stream. They bulk large because religion over-topped the common affairs of life as the cathedral dominated the sur-rounding country. . . . [E]ven where religion is not directly concerned, a moral purpose is frequently discernible in literature, openly avowed or tacitly implied as the justification for its existence.[1]

It may seem all too obvious in retrospect how such a situation was tailor-made for a scholar like Michael Camille who devoted himself to exploring the boundaries, margins, and outsides of this hegemonic picture of medi-eval culture. His approach to the dangerous supplements and dialectical oppositions of canonical medievalism were refreshingly contemporary, if not quite postmodern, in procedure. Camille was an obsessive student of the detail who loved to pore over the intricate and overlooked "ornamen-tal" features of medieval texts, placing the primary and dominant message in the context of the secondary elements that often complicated, parodied, and undermined the master discourse.

When Michael Camille joined the faculty of the University of Chicago in 1985, fresh from his Cambridge training with Norman Bryson, he found a group of young scholars eagerly awaiting his arrival. Medievalist Linda Seidel, Byzantinist Rob Nelson, photographer-philosopher Joel Snyder, and modern art historians Becky Chandler, Martha Ward, and Margaret Olin had already, along with literary scholars Elizabeth Helsinger and myself, formed an informal workshop known as the Laocoön Group, named not primarily for the ancient sculpture, but for G. E. Lessing's classic reflec-tion on the relations of literature and the visual arts. The Laocoön Group was dedicated to studying the intersections of the visual arts, philosophy, and literature, and its monthly meetings were enlivened by visits by the young Gayatri Spivak, who led us through Derrida's *Of Grammatology*, and Tom Crow, who denounced the group as a deviation from serious art history.[2]

I do not remember exactly when the Laocoön Group ceased to exist.

1. Baugh et al. (New York: Appleton Century Crofts, 1948),115.
2. My impression is that Tom has mellowed considerably since the 1980s.

Perhaps it was when its members began to be promoted to tenure and took over the running of Chicago's art history department in the late 1980s. I do remember that Michael Camille's arrival coincided with the publication of his wonderful first article, "Seeing and Reading: Some Visual Implications of Medieval Literacy and Illiteracy." As one can tell from the title, this article was well suited to the Laocoön Group, as was Camille's deep engagement with French theory, especially in its emphasis on nonverbal systems of meaning. Michael quickly became the heart and soul of Chicago art history. He was a fabulous teacher, an exquisite writer, and a colleague who made us all feel as if we belonged to a very special club—the "école Chicago"—that was blessed by his brilliance and enthusiasm. I know that I date my own identity as an art historian to a moment when I confessed to him my fear that *Iconology*, my 1986 foray into image theory, would never pass muster among art historians, and he expressed astonishment that I would have any such doubts.

It is difficult to separate Michael Camille's influence on my work from the whole ambience of the Laocoön Group, but it may be worthwhile to identify a few tendencies in his thought that pervaded our discussions. Of course, "word and image" was central to our discussions already, but Michael had a way of grounding this topic in the materiality of texts and graphic arts, and in the technological revolutions that change the ratios of what Foucault called the "seeable and the sayable." There was also Michael's close attentiveness to the self-reflexivity of images, the ways in which the mimetic "monkey business" of ornamental features in architecture and book design constituted a whole other level of theorizing and criticizing the dominant ideologies of artistic monuments. Perhaps most inspiring for me was a moment of convergence in our work around the problem of idolatry and iconoclasm in the visual arts. As Michael was beginning work on his first book, *The Gothic Idol* (1989), he quoted back to me a sentence from *Iconology* that he had found useful: "a book which began with the intention of producing a valid *theory* of images became a book about the *fear* of images" (3). I don't think Michael himself had any fear of images, but he loved to contemplate the exuberance of their lives, and their tendency to exceed all forms of discursive control. He gave us all permission to think poetically about our work, to cross disciplinary boundaries, and to ask forbidden questions such as (in my own case) "what do pictures want?"[3]

3. A question that haunts my book by that title, *What Do Pictures Want? On the Lives and Loves of Images* (Chicago: University of Chicago Press, 2005).

I want to turn now from these reflections on the moment of Michael Camille to the aftermath of his influence, and that of the Laocoön Group, on subsequent developments in art history, or at least of my own sense of how the field has evolved in the last twenty years. I'm especially interested in the way Michael's merry insistence on crossing the boundaries of medieval orthodoxy was also expressed as a freedom to cross the borders of traditional art history. Michael's lovely second book, *Image on the Edge* (2004), gives me the courage to try to think broadly, if somewhat autobiographically, about art history itself as a "discipline on the edge," an edgy discipline capable of veering between hostility and hospitality to border crossings from adjacent fields such as literature, cinema, and cultural studies.

My migration into art history was spurred, initially, not by any abstract or theoretical imperative, but by the practical requirements of understanding the work of William Blake, a painter, poet, and engraver whose composite art of "illuminated printing" made it necessary to think across the boundaries between word and image, literature and the visual arts. Blake's work also required, as Michael pointed out to me once, the exploration of a past-present dialectic among the highly disparate moments of medieval illumination, Enlightenment book technology, Romantic poetics, and contemporary cultural politics. It was as a later result of this forced migration from one disciplinary territory to another that I began to reflect more broadly on art history's relation to adjacent disciplines that have influenced, supplemented, and to some extent transformed its identity.

In my view, art history may be understood as the convergence of three distinct fields of study that reside upon its borders, provoking, stimulating, and sometimes threatening its identity as the "history of works of art": (1) iconology, the study of images across media, and especially of the interface between language and visual representation; (2) visual culture, the study of visual perception and representation, especially the social construction of the field of visibility and (equally important) the visual construction of the social field; and (3) media studies, specifically the emergent field known as "media aesthetics," which aims to bridge the gaps between technical, social, and artistic dispositions of media. All these fields are, in some sense, outside the boundaries of art history, constituting its horizon or frontier, while at the same time providing a necessary and sometimes dangerous supplement to its work.

Iconology opens the border to the image, the fundamental unit of affect and meaning in art history. Visual culture opens the border to the specific

sensory channel through which the "visual arts" necessarily operate. (It is, in this sense, analogous to the relation of linguistics to poetics, language to literature; Ernst Gombrich called it a "linguistics of the visual field.") And media aesthetics opens the border on the relation of the arts to mass media, avant-garde to kitsch, polite to popular arts, art to the everyday. These fields also cross-fertilize: visual culture provides one of the principal channels for the circulation of images, constituting the primary (but not exclusive) domain of their appearance and disappearance; media aesthetics provides a framework for considering the larger "ratio of the senses" (Marshall McLuhan) or what Jacques Rancière calls the "distribution of the sensible," studying the relations of the eye to the ear, the hand to the mouth, at the same time putting technical innovation and obsolescence at the center of attention.

The first of these fields, iconology, is very ancient. It goes back at least to the Renaissance and Cesare Ripa's *Iconologia*, and perhaps earlier to Philostratus's *Imagines*,[4] and now includes the full range of nonartistic images, including scientific images.[5] It is the field that interrogates the very idea of the image in philosophical discourse and traces the migration of images across the boundaries between literature, music, and the visual arts (the three great orders of *lexis*, *melos*, and *opsis* outlined in Aristotle's *Poetics*). From the standpoint of iconology, the notion of a *visual* image is not a redundancy but a tacit acknowledgment that there are verbal and acoustic images as well. Iconology is therefore as much concerned with tropes, figures, and metaphors as with visual and graphic motifs, as much with formal gestures in auditory time and sculptural-architectural space as with pictures on a wall or screen. In Erwin Panofsky's classic formulation (restricted to the visual image), iconology includes the study of iconography, the historical study of the meanings of specific images, and goes beyond it to explore the ontology of images as such, and the conditions

4. *Iconologia di Cesare Ripa Perugino* (Venice: Cristoforo Tomassini, 1645). Philostratus the Elder flourished in the third century AD; his work was continued by his grandson, Philostratus the Younger. Both produced collections of essays on paintings entitled *Imagines*. See the English translations by Arthur Fairbanks in the Loeb Classical Library (Cambridge, MA: Harvard University Press, 1931).
5. The great exemplar here is, of course, Aby Warburg. His program for a global art history implied a kind of merger with anthropology and performance studies (Warburg witnessed and photographed the coronation of Mussolini); his "Bilder-atlas" project promised both a universal iconology and something like an emergent visual cultural studies.

under which images attain historical significance.[6] In the post-Panofsky era of what I have called "critical iconology,"[7] it has taken up such matters as "metapictures" or reflexive, self-critical forms of imagery; the relations of images to language; the status of mental imagery, fantasy, and memory; the theological and political status of images in the phenomena of iconoclasm and iconophobia; and the interplay between virtual and actual, imaginary and real images captured by the English vernacular distinction between images and pictures.

Iconology has found work to do as well in the realm of the sciences, investigating the role of images in scientific research, specifically (in my own work) in the phenomenon of the "natural" image (e.g., the fossil and the type specimen) and the entire question of speciation and evolutionary morphology.[8] At the same time, the advancement of the life sciences in the last century has revolutionized the ancient conception of the image as an "imitation of life." Biotechnology has now made it possible to make a *living* image of a life-form in the process known as cloning, with profound consequences for our concepts of both images and life-forms. When these developments are coupled with the revolution in information science produced by the invention of the computer, we find ourselves entering a new era of what I have called "biocybernetic reproduction," characterized by the appearance of the "biodigital picture." This vitalistic and animistic conception of the image (whose pedigree in the work of Michael Camille would be worth exploring) has led me to speculate that the proper question to ask of pictures is not merely what they *mean* or what they *do*, but what they *want*.[9]

Visual culture, in contrast to iconology, is a fairly recent object of study, though it has a long pedigree in philosophical treatments of the spectator as the exemplary subject of epistemology, from Plato's Allegory of the Cave to Descartes's *Optics*, to the tradition that Martin Jay has termed

6. Panofsky, "Iconography and Iconology: An Introduction to the Study of Renaissance Art," in *Meaning in the Visual Arts* (New York: Anchor Doubleday, 1955), 26–54.

7. Mitchell, *Iconology: Image, Text, Ideology* (Chicago: University of Chicago Press, 1987), 1–3.

8. See, for example, Lisa Cartwright's important work on medical imaging and visual culture in *Scientific Images and Popular Images of the Sciences*, a wide-ranging collection of essays on this and related topics edited by Bernd Huppauf and Peter Weingart (New York: Routledge, 2007).

9. See *What Do Pictures Want?*, particularly chapter 15, "The Work of Art in the Age of Biocybernetic Reproduction."

"ocularcentrism."[10] As a technical matter, visual cultural studies probably emerges from innovations in optical recording technologies such as photography, television, and cinema, and from studies of culture and psychology centered on visual perception and recognition.[11] Visual anthropology and studies of material and mass culture are important inspirations for the field of visual culture, as well as a variety of artistic movements that challenge the centrality of painting and sculpture to the canon of art history. Artistic forays into popular culture, installation and environmental art, conceptual art, and new media have, in alliance with critical iconology, forced an expansion of the field of art history that both recalls and goes beyond the founding ambitions of the Warburg and Vienna schools. Art history under the pressure of visual culture now includes a wide variety of research agendas, ranging from Lacan's scopic drive to the phenomenon of racial profiling and the power of the gaze, to the dialectics of spectacle (Guy Debord) and surveillance (Michel Foucault). It aims to investigate the specificity of the optical field in relation to tactile and acoustical modalities, as well as the Foucauldian-Deleuzean strata of the "seeable and sayable." Visual culture also explores the frontiers of visuality in its relation to the so-called visual arts,[12] its imbrications with language, with the other senses, and with the limits or negations of visuality in phenomena such as blindness, invisibility, and what might be called the "overlooked" elements of everyday life. It is especially concerned with the phenomena of intersubjectivity in the scopic field, the dynamics of seeing and being seen by other people as a critical moment in the formation of the social. Inspired by such foundational texts as Jean-Paul Sartre's "The Look" and Franz Fanon's "Algeria Unveiled," visual culture helps us see how works of art may "look back" at spectators. Most fundamentally, it aspires to explain, not merely the "social construction of the visual field," but the visual construction of the social field, the way that modes of spectacle and

10. Martin Jay, *Downcast Eyes: The Denigration of Images in Twentieth Century French Thought* (Berkeley: University of California Press, 1994).

11. For a truly authoritative history of visual culture, one should immerse oneself in the writings of Nicholas Mirzoeff, particularly *An Introduction to Visual Culture*, rev. 2nd ed. (New York: Routledge, 2002), as well as the tradition inaugurated by John Berger's classic *Ways of Seeing* (London: Penguin, 1972). Margaret Dikovitskaya's collection of interviews, *Visual Culture: The Study of the Visual after the Cultural Turn* (Cambridge, MA: MIT Press, 2005), includes a much more extensive set of reflections on the field.

12. My reasons for the phrase "so-called visual arts" will be explained in chapter 10.

surveillance coupled with mass and social media constitute our brave new world of drones, NSA data mining, and hactivism.

The third field, media aesthetics, is also quite young, tracing its genealogy to the writings of Marshall McLuhan, who was the first to articulate the principles of a general field of media studies that would go beyond representation to include the entire range of technical "extensions of man."[13] For McLuhan, everything from the skin to clothing to the railroad system constituted the field of communication and expression, forming a "second nature" around individuals and societies. At its center, of course, was the modern invention of the mass media, especially the broadcast media. But McLuhan was equally concerned with what we now call "social media," such as the telegraph, telephone, postal system, and (avant la lettre) the "extension of the nervous system" known as the Internet. He was also concerned with the artistic use of both old and new media. Indeed, McLuhan reserved a special place for art as the realm of experimental play with new media inventions, the place where the effect of media on the sensorium and social formations could be explored. All the questions about medium specificity, mixed media, intermedia, and what Rosalind Krauss has called "the post-medium condition," are ranged under contemporary research in media aesthetics.

Contemporary media aesthetics seeks to revive the ambitions of McLuhan's project by thinking across the boundaries of mass and artistic media and technical, socioeconomic, political forms of mediation. In the work of theorists such as Bernard Stiegler, Niklas Luhmann, and Friedrich Kittler, it has opened up a world of total mediation in which the frontiers of thought make a dialectical turn toward the *immediate*: the phenomenology of the unmediated, the transparent, and the uncoded—a development that brings us back to the notion that the senses themselves (particularly seeing and hearing) can be understood theoretically and historically. When I teach media studies these days, I am tempted to rename it "immedia studies" or (on the model of climatology and weather forecasting) "mediarology."

These are the three fields that have grounded my own approaches to and departures from art history. I am not sure they have any systematic relationship to one another. Perhaps their relation to art history is something like the contingent relations of national borders, as if art history were something like Switzerland, a multilingual country bounded on three sides by major national entities (France, Germany, Italy), with the fourth

13. *Understanding Media: The Extensions of Man* (New York: McGraw-Hill, 1964).

border, on the east (Austria), opening out toward an orient, and an orientalist history, that disrupts any tidy, Eurocentric synthesis. But this is surely a fantasy that would only occur to an American who grew up in the wide open spaces of the Western desert, and whose approach to disciplines and field boundaries has always been summed up in the old cowboy ballad "Don't Fence Me In." I like to think it is a fantasy that might have been shared by a working class lad from Yorkshire named Michael Camille.

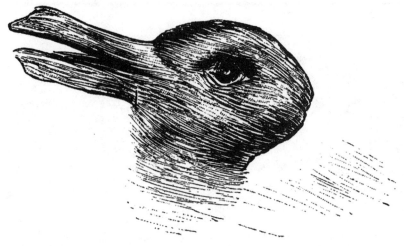

2.1 Anonymous, "The Duck-Rabbit" (1892). Detail from a page in *Fliegende Blätter*.

2: FOUR FUNDAMENTAL CONCEPTS OF IMAGE SCIENCE

When I published *Iconology* twenty years ago, I had no idea that it would be the first volume in what has turned out to be a trilogy (*Picture Theory* and *What Do Pictures Want?* in 1994 and 2005 are the sequels). In the mid-1980s, notions such as "visual culture" and "new art history" were nothing more than rumors. The concept of "word and image," much less an International Association for Word and Image Studies (IAWIS), was hardly dreamed of. And the idea of "iconology" itself seemed at that time like an obsolete subdiscipline of art history, associated at worst with a kind of tedious method of allegorizing and motif-hunting, at best with the founding fathers of the early twentieth century, Aby Warburg, Alois Riegl, and Erwin Panofsky.

Now, of course, the terrain looks quite different. There are academic departments of visual studies and visual culture, and journals devoted to these subjects. The New Art History (as inspired by semiotics, at any rate) is yesterday's news. The interdisciplinary study of verbal and visual media has become a central feature of modern humanistic study. And new forms of critical iconology, of *Bildwissenschaft* or "image science," have emerged across the fields of the humanities, social sciences, and even the natural sciences.

Iconology played some part in these developments. Exactly what its influence has been would be difficult for me to assess. All I can do at this point is to look back at the ideas that it launched in relation to their further development in my own work. In twenty years of working through problems in visual culture, visual literacy, image science, and iconology, four basic ideas have continually asserted themselves. Some of these were already latent in *Iconology* but were only named in later writings. I hope these remarks will help readers obtain an overview of the consistent themes and problems that grew out of *Iconology* and that have now become (with apologies to Jacques Lacan)[1] what I think of as "the four fundamental

1. See Lacan's *Four Fundamental Concepts of Psychoanalysis* (New York: W. W. Norton, 1981).

concepts of image science." I call them "the pictorial turn," the "image/picture distinction," the "metapicture," and the "biopicture." Here, in very schematic form, are the basic outlines of these concepts.

THE PICTORIAL TURN

This phrase (first developed in *Picture Theory*), sometimes compared with Gottfried Boehm's later notion of an "iconic turn"[2] and with the emergence of visual studies and visual culture as academic disciplines, is often misunderstood as merely a label for the rise of so-called visual media, such as television, video, and cinema. There are several problems with this formulation of the matter. First, the very notion of purely visual media is radically incoherent, and the first lesson in any critical account of visual culture should be to dispel it.[3] Media are always mixtures of sensory and semiotic elements, and all the so-called "visual media" are *mixed* or hybrid formations, combining sound and sight, text and image. Even vision itself is not purely optical, requiring for its operations a coordination of optical and tactile impressions. Second, the idea of a "turn" toward the pictorial is not confined to modernity, or to contemporary visual culture. It is a *trope* or figure of thought that reappears numerous times in the history of culture, usually at moments when some new technology of reproduction, or some set of images associated with new social, political, or aesthetic movements, has arrived on the scene. Thus, the invention of artificial perspective, the arrival of easel painting, and the invention of photography were all greeted as "pictorial turns" and were seen as either wonderful or threatening, often both at the same time. But one could also detect a version of the pictorial turn in the ancient world, when the Israelites "turn aside" from the law that Moses is bringing from Mt. Sinai and erect a golden calf as their idol. The turn to idolatry—the most anxiety-provoking version of the pictorial turn—is often grounded in the fear that masses of people are being led astray by a false image, whether it is an ideological concept or the figure

2. *The Pictorial Turn*, ed. Neal Curtis (London: Routledge, 2010), includes an exchange of letters between Boehm and myself on the relation of the "iconic" and "pictorial" turns. This collection (originally a special issue of *Culture, Theory, and Critique* 50, nos. 2–3), contains important essays by Jacques Rancière, Susan Buck-Morss, Martin Jay, Lydia Liu, Michael Taussig, Nicholas Mirzoeff, Stephen Daniels, and Marquand Smith, plus essays and images by artists Larry Abramson, Robert Morris, and Antony Gormley, and an essay on biological images by paleontologist Norman Macleod.

3. See chapter 10, "There Are No Visual Media," for this argument.

of a charismatic leader. Third, as this example suggests, pictorial turns are often linked with anxiety about the "new dominance" of the image, as a threat to everything from the word of God to verbal literacy. Pictorial turns usually invoke some version of the distinction between words and images, the word associated with law, literacy, and the rule of elites, the image with popular superstition, illiteracy, and licentiousness. The pictorial turn, then, is usually *from* words *to* images, and it is not unique to our time. This is not to say, however, that pictorial turns are all alike: each involves a specific picture that emerges in a particular historical situation.

Fourth, and finally, there is the meaning of the pictorial turn that is unique to our time and is associated with developments in disciplinary knowledge and perhaps even philosophy itself, as a successor to what Richard Rorty called "the linguistic turn." Rorty famously argued that the evolution of Western philosophy has moved from a concern with things or objects, to ideas and concepts, and finally (in the twentieth century) to language.[4] My suggestion has been that the image (not only visual images but verbal metaphors as well) has emerged as a topic of special urgency in our time, not just in politics and mass culture (where it is a familiar issue) but also in the most general reflections on human psychology and social behavior, as well as in the structure of knowledge itself.[5] The turn that Fredric Jameson describes from "philosophy" to something called "theory" in the human sciences is based, I think, not only in a recognition that philosophy is mediated by language but by the entire range of representational practices, including images. For this reason, theories of imagery and of visual culture have taken on a much more general set of problems in recent decades, moving out from the specific concerns of art history to an "expanded field" that includes psychology and neuroscience, epistemology, ethics, aesthetics, and theories of media and politics, toward what can only be described as a new "metaphysics of the image." This development, like Rorty's linguistic turn, generates a whole new reading of philosophy itself, one that could be traced to such developments as Jacques Derrida's critique of phonocentrism in favor of a *graphic* and *spatial* model of writing, or Gilles Deleuze's claim that philosophy has always been obsessed with the problem of the image, and thus has always been a

4. This is the fundamental claim of Rorty's classic text, *Philosophy and the Mirror of Nature* (Princeton, NJ: Princeton University Press, 1981).
5. On the side of metaphor, or the "verbal image," this argument has been carried out most resolutely by George Lakoff and Mark Johnson in *Metaphors We Live By* (Chicago: University of Chicago Press, 2003).

form of iconology.[6] Philosophy in the twentieth century has not just made a linguistic turn: "a picture held us captive," as Wittgenstein put it,[7] and philosophy responded with a variety of ways of breaking out: semiotics, structuralism, deconstruction, systems theory, speech act theory, ordinary language philosophy, and now image science, or critical iconology.

IMAGE/PICTURE

If the pictorial turn is a word → image relation, the image/picture relation is a turn back toward objecthood. What is the difference between a picture and an image? I like to start from the vernacular, listening to the English language, in a distinction that is untranslatable into German or French: "you can hang a picture, but you can't hang an image." The picture is a material object, a thing you can burn or break or tear. An image is what appears in a picture, and what survives its destruction—in memory, in narrative, in copies and traces in other media. The Golden Calf may be smashed and melted down, but it lives on as an image in stories and innumerable depictions. The picture, then, is the image as it appears in a material support or a specific place. This includes the mental picture, which (as Hans Belting has noted) appears in a body, in memory, or in imagination. The image never appears except in some medium or other, but it is also what transcends media, what can be transferred from one medium to another. The Golden Calf appears first as a sculpture, but it reappears as an object of description in a verbal narrative, and as an image in painting. It is what can be copied from the painting in another medium, in a photograph or a slide projection or a digital file.

The image, then, is a highly abstract and rather minimal entity that can be evoked with a single word. It is enough to name an image to bring it to mind—that is, to bring it into consciousness in a perceiving or remember-

6. See Deleuze, "The Simulacrum and Ancient Philosophy," in *The Logic of Sense*, trans. Mark Lester (New York: Columbia University Press, 1990), 260: "philosophy does not free itself from the element of representation when it embarks upon the conquest of the infinite. Its intoxication is a false appearance. It always pursues the same task, Iconology." For Deleuze, as for iconologists more generally, I would argue, this is a "reverse Platonism," which "means to make the simulacra rise and to affirm their rights among icons and copies" (262).

7. Wittgenstein, *Philosophical Investigations*, trans. G. E. M. Anscombe (New York: Macmillan, 1953), 48 (para.115): "A *picture* held us captive and we could not get outside it, for it lay in our language and language seemed to repeat it to us inexorably."

ing body. Panofsky's notion of the "motif" is relevant here,[8] as the element in a picture that elicits cognition and especially *recognition*, the awareness that "this is that," the perception of the nameable, identifiable object that appears as a virtual presence, the paradoxical "absent presence" that is fundamental to all representational entities.

One need not be a Platonist about the concept of images, postulating a transcendental realm of archetypes where forms and ideas dwell, waiting to be incarnated in the material objects and shadows of sensory perception. Aristotle provides an equally solid starting point, in which the images would be something like the classes of pictures, the generic identifiers that link a number of specific entities together by family resemblance. As Nelson Goodman would put it, there are many pictures of Winston Churchill, pictures that contain Churchill's image.[9] We could call them "Churchill pictures"—a phrase that suggests membership in a class or series, in which case we might say that images are what allow us to identify the genre of a picture, sometimes very specifically (the Churchill picture) or quite generally (the portrait). There are also caricatures, pictures of (for instance) Winston Churchill as a bulldog. In this case, two images appear simultaneously and are fused into a single figure or form, a classic instance of visual metaphor. But all depiction is grounded in metaphor, in "seeing as." To see an inkblot as a landscape is to make an equation or transfer between two visual perceptions, just as surely as the proposition that "no man is an island" implies a comparison or analogy between the human body and a geographical figure.

An image, then, may be thought of as an immaterial entity, a ghostly, phantasmatic appearance that comes to light or comes to life (which may be the same thing) in a material support. But we need not postulate any metaphysical realm of immaterial entities. The casting of a shadow is the projection of an image, as is the imprint of a leaf on a page, or the reflection of a tree in water, or the impression of a fossil in stone. The image is thus the perception of a relationship of likeness or resemblance or analogous form—what C. S. Peirce defined as the "iconic sign,"[10] a sign whose intrinsic sensuous qualities resemble those of some other object. Abstract and ornamental forms are thus a kind of "degree zero" of the image, and

8. Panofsky, "Iconology and Iconography," in *Meaning in the Visual Arts* (New York: Anchor Doubleday, 1955), 29.
9. Nelson Goodman, *Languages of Art* (Indianapolis: Hackett, 1976), 57.
10. Charles Sanders Peirce, "Logic as Semiotic: The Theory of Signs," in *Philosophical Writings of Peirce* (New York: Dover Publications, 1955), 98–119, esp. 105.

are identifiable by very schematic descriptions, such as arabesques or geometric figures.

The relation between image and picture may be illustrated by the double meaning of the word "clone," which refers both to an individual specimen of a living organism that is the duplicate of its parent or donor organism and to the entire series of specimens to which it belongs. An image of the world's most famous clone, Dolly the sheep, can be duplicated as a graphic image in photographs, each of which will be a picture. But the image that is duplicated in all these pictures and links them as a series is quite strictly analogous to the biological image that unites all the cloned ancestors and descendants of the singular specimen in a collective series that is also known as "the clone."[11] When we say that a child is the "spitting image" of its parent, or that one twin is the image of its sibling, we are employing a similar logic in recognition of the family resemblance that constitutes the image as a relation rather than an entity or substance.

METAPICTURES

Sometimes we encounter a picture in which the image of another picture appears, a "nesting" of one image inside another, as when Velázquez paints himself in the act of painting in *Las Meninas*, or Saul Steinberg draws the figure of a man drawing in *New World*. In Nicolas Poussin's *Adoration of the Golden Calf*, we see the image of a desert landscape with the Israelites dancing around the calf, the high priest Aaron gesturing toward it, and Moses coming down from Mt. Sinai, about to break the tablets of the law in anger at this lapse into idolatry. This is a metapicture, in which an image in one medium (painting) enframes an image in another (sculpture). It is also a metapicture of a "pictorial turn" from words to images, from the *written* law of the Ten Commandments (and especially the law against the making of graven images) toward the authority of an idol.[12]

Metapictures are not especially rare things. They appear whenever an image appears inside another image, whenever a picture presents a scene of depiction or the appearance of an image, as when a painting appears on a wall in a movie or a television set shows up as a prop in a television

11. For more on the figurative and literal image of contemporary cloning, see my *Cloning Terror: The War of Images, 9-11 to the Present* (Chicago: University of Chicago Press, 2011).

12. See "Metapictures," chapter 2 of *Picture Theory* (Chicago: University of Chicago Press, 1994), for the fullest development of this concept.

show. The medium itself need not be doubled (e.g., paintings that represent paintings; photographs that represent photographs): one medium may be nested inside another, as when the Golden Calf appears inside an oil painting or a shadow is cast in a drawing.

There is also a sense in which any picture may become a metapicture, whenever it is employed as a device to reflect on the nature of pictures. The simplest line drawing, when reframed as an example in a discourse on images, becomes a metapicture. The humble multistable image of the Duck-Rabbit is perhaps the most famous metapicture in modern philosophy, appearing in Wittgenstein's *Philosophical Investigations* as an exemplar of "seeing as" and the doubleness of depiction as such. Plato's Allegory of the Cave is a highly elaborated philosophical metapicture, providing a model of the nature of knowledge as a complex assemblage of shadows, artifacts, illumination, and perceiving bodies. In *Iconology*, I referred to these kinds of verbal, discursive metaphors as "hypericons," or "theoretical pictures," which often emerge in philosophical texts as illustrative analogies (e.g., the comparison of the mind to a wax tablet or a camera obscura) that give images a central role in models of the mind, perception, and memory. The "metapicture," then, might be thought of as a visually, imaginatively, or materially realized form of the hypericon.

As the Allegory of the Cave suggests, a metapicture may function as a foundational metaphor or analogy for an entire discourse. The metaphor of the "body politic," for instance, involves seeing or imaging the social collective as a single gigantic body, as in the figure on the frontispiece of Hobbes's *Leviathan*. The familiar metaphor of the "head of state" quietly extends this analogy. This metaphor then reverses itself in modern biomedical discourse, in which the body is seen, not as a machine or organism, but as a social totality or "cellular state" riddled with parasites, invaders, and alien organisms, as well as divisions of labor between executive, judicial, and deliberative functions, an immune system that defends the body against outsiders, and a nervous system that communicates among its parts or "members." Is the metaphor of the "member" a mapping of the social body onto the organic body, or vice versa? What kind of body is imaged in the figure of the corporation? These sorts of reversible and foundational metaphors are what Lakoff and Johnson call "metaphors we live by."[13] They are not merely ornaments to discourse but structuring analogies that inform entire epistemes.

13. George Lakoff and Mark Johnson, *Metaphors We Live By* (Chicago: University of Chicago Press, 2003).

BIOPICTURES

A new version of the pictorial turn has taken place in our time, exempli-
fied most vividly by the biological process of cloning, which has become a
potent metaphor as well as a biological reality with profound ethical and
political implications. Cloning is, of course, an entirely natural process
in plants and simple animals, where it designates the process of asexual
reproduction of genetically identical cells. The original meaning of "clone"
(in Greek) was a "slip or twig," and it referred to the botanical process
of grafting and transplanting. With the discovery of microorganisms and
cell reproduction, the concept of cloning moved over to the animal king-
dom as well. But in recent years, a revolution has occurred in biology with
the (partial) decoding of the human genome and the cloning of the first
mammals. The possibility of human reproductive cloning is now on the
technical horizon, and this possibility has reawakened many of the tradi-
tional taboos on image-making in its most potent and disturbing form, the
creation of artificial life. The idea of duplicating life-forms, and of creating
living organisms "in our own image," has literalized a possibility that was
foreshadowed in myth and legend, from the science fiction cyborg, to the
robot, to the Frankenstein narrative, to the *golem*, to the biblical creation
story itself, in which Adam is formed "in the image and likeness of God"
from red clay and receives the breath of life.

Of course, numerous other ideas from *Iconology* have been further elab-
orated over the twenty years since its publication. The idea of treating
"word and image" as a distinct theoretical problem that requires not only
a semiotic, formal analysis but a historical and ideological contextualiz-
ing, has been highly productive in a number of fields.[14] The whole cluster
of anxieties surrounding the image (iconophobia, iconoclasm, idolatry,
fetishism, and the prohibition on graven images in Judaism, Christian-
ity, and Islam) has become a central concern of image study in an age
characterized by a "return of religion" that was scarcely glimpsed in the
1980s.[15] And the critique of "ideology critique" itself as a "rhetoric of icon-
oclasm" has, I hope, chastened the ambitions of a demystifying criticism

14. The founding of a journal, *Word & Image*, as the house organ of the Interna-
tional Association for Word and Image Studies (IAWIS), might be taken as one
symptom. For a recent intervention, see *The Future of Text and Image*, ed. Ofra
Amihay and Lauren Walsh (Cambridge: Cambridge Scholars Publishing House,
2012).
15. See, for instance, *Idol Anxiety* ed. Josh Ellenbogen and Aaron Tugendhaft (Stan-
ford, CA: Stanford University Press, 2011).

that invariably appeals to its own ideological infallibility. I have, by contrast, wished to ally myself with the more modest aims of "secular divination"[16] and deconstruction that I associate with the example of Edward Said and Jacques Derrida, the two critical theorists who have been to me the most inspiring contemporaries in what I still think of as the Golden Age of Theory.

16. "Secular Divination: Edward Said's Humanism," in *Critical Inquiry* 31, no. 2 (Winter 2005), a special issue on Said. Reprinted in *Edward Said: Continuing the Conversation*, ed. W. J. T. Mitchell and Homi Bhabha (Chicago: University of Chicago Press, 2006), and in *Edward Said: A Legacy of Emancipation*, ed. Adel Iskandar and Hakem Rustom (Berkeley: University of California Press, 2010).

3.1 Steven Spielberg, "Digital Dinosaur" (1993). Still from *Jurassic Park*.

3: IMAGE SCIENCE

Everyone knows that science uses imagery, both verbal and visual, as an essential part of its quest for ever more accurate accounts of material reality. Models, diagrams, photographs, graphs, sketches, metaphors, analogies, and equations (the whole Peircean family of icons or symbols by resemblance) are crucial to the life of science. They introduce entire ways of seeing and reading, particularly in dazzling figures of thought such as string theory, which seeks an elegant universe, a multiverse of parallel worlds and supple spaces, folding in upon themselves into wormholes, sparticles, and gravitrons. And these images do not remain in the sphere of technical science but quickly circulate into popular culture, especially cinema and special effects video (as in the PBS series *Nova*). As an institution, science is quite gifted at presenting itself in mass media, in popular writing as well as visual media. From paleontologists' reconstructions of extinct life-forms like the dinosaur, to the model of the atom, to speculative images that circulate across the borders between science and philosophy, science and science fiction, science and poetry, and reality and mathematics, science is riddled with images that make it what it is—a multimedia, verbal-visual discourse that weaves its way between invention and discovery.

But amid the proliferation of scientific images, there is one conspicuously missing component, and that is a scientific focus on images themselves. I don't mean to suggest that scientists fail to examine images critically, trying to sort out the true from the false, the misleading or fanciful from the verifiable and accurate. I'm thinking instead of a more general problem, a science of images or *Bildwissenschaft* as such, which would treat images as *objects* of scientific investigation and not merely as useful tools in the service of scientific knowledge. So I would like to take the topic of image science and turn it "inside out," as it were, and reframe the discussion of "images of science and the scientist" within some reflections on the science of images. In particular, I would like to raise the following questions:

1. Is a "science of images" even conceivable, or are images, as social and cultural constructions, simply outside the domain of the sciences in the

usual sense of the word, so that their proper domain is that of the arts and humanities, the realm of interpretation, appreciation, and performance, rather than that of empirical investigation and abstract, rational, or even mathematical modeling? If your answer to this question is no, then you should probably stop reading, because I want to proceed on the assumption that the answer is yes, a science of images is conceivable (and, in fact, there are a number of researchers already committed to the idea, which has been around in one form or another, sometimes under the rubric of "iconology," or the theory of images, as distinct from "iconography," the lexical sorting of different kinds of images).

2. If there *is* a science of images, what kind of science would it be? Would it be an experimental science like physics or chemistry, or a historical science like paleontology and geology? What would be its relation to mathematics, and specifically to the role of geometry, diagrams, and other graphic expressions as instruments of mathematical thinking? How would a science of images align itself with divisions between the "physical" and the "biological" sciences? Would it be a theoretical, speculative science, or a practical and technical discipline, such as medical science? How would a science of images distribute itself between the "hard" and "soft" sciences?

3. If there *were* a science of images, what use would it be to the other sciences? Would it provide a method of separating true and verifiable images from false and misleading ones? Would it help to settle what Peter Galison describes as the ongoing battle between pictures and logic, images and algorithms, in scientific procedures, a battle that has its counterpart in the arts in the phenomenon Leonardo da Vinci called a *paragone*, the contest of words and images, poetry and painting?

The ever-elastic concept of science itself as a synonym for knowledge of any sort, embracing the human as well as the natural sciences, seems on the one hand to empty the idea of science of any specificity, so that a science of images could just be any knowledge of images whatsoever. On the other hand, and in quite the opposite way, we seem to be trapped at the outset by the very terms of our topic—"images of science and the scientist"—that is, by stereotypes and caricatures of white-coated technicians, gleaming research laboratories, supercomputers, supercolliders, and supergeniuses who are depicted either as madmen threatening to destroy the world or benign sages who will show us how to save it. We are also led astray by a mainly experimental-quantitative picture of science that portrays it as a rather mechanical activity of proof and demonstration, gathering of data, and establishing of certainty and positive knowledge.

As for what might be called the "unscientific" or "soft" sciences, there the name of science is generally taken to be a meaningless courtesy. Only the Germans seem comfortable with attaching "wissenschaft" to words like *Kultur* and *Bilder*. The English-speaking scientist, hardheaded and empirical, tends to contrast "real science" with the world of culture and images, or arts and letters. In the domain of images and culture, presumably, opinion and ungrounded speculation rule, empiricism is a dirty word, data are haphazardly gathered or ignored, and impressionistic, unreliable results are acceptable if they are intuitively pleasing. Our stereotype of the social scientist is thus of someone who is gathering dubious data based in subjective opinions in order to confirm what is already commonsense knowledge. Our stereotype of the political scientist is of someone who has almost nothing to do with science at all. And the economist, as everyone knows, is a practitioner of "the dismal science," filled with tedious charts and statistics that produce "predictions" that rival the readings of tea leaves and animal entrails. Our stereotype of the human scientist is of an absentminded drudge who labors endlessly in the dusty stacks of the library, only to emerge with a set of "findings" that are of interest to absolutely no one else, or with a wild theory that is attractive precisely in proportion to its implausibility and perversity. Our picture of C. P. Snow's "two cultures" of science and the humanities, in other words, seems to dictate from the outset that the study of images would belong in one domain, science in the other. Images might be instrumental to the pursuit of science, but they would be at best incidental, ornamental, or functional, not an essential part of, much less the target of, science. Their proper home would be in the domain of culture and psychology, in the realm of subjective perceptions and poetic associations.

I hope it is clear that what I have been calling "our picture" of the two-culture split is the product of a rather cynical and jaundiced eye, and is not my own view. In fact, the relation of the sciences and the arts is much more nuanced, gradated, and complex than these simple binary oppositions would suggest. Rather than settle for this impossible dilemma in which, on the one hand, any cognitive activity takes on the name of science and, on the other, a rigid stereotype of a specific form of science dominates our thinking, I want to think about the range of scientific models that might be brought to bear on the problem of images and to ask which ones seem especially promising—or unpromising. What would such a science be? How would one move from the image considered as the instrument or medium of science to the image as the object of science, something to be tested, experimented with, described, and explained, in accordance

with the most rigorous scientific methods. What would it mean to run an experiment on an image? Would it involve investigation of the material particles in an oil painting? (New York University's Institute of Fine Arts requires considerable training in chemistry if one wants training in restoration and connoisseurship). Insofar as images are material things, objects in the world, chemistry and physics have something to contribute to their understanding, but mainly at the level of forensics, the detection of forgeries, the examination of the physical body or support in or on which the image appears. The science appropriate to the study of images has to include this level, but it also has to be an optical science, one that pays attention to visual perception and imagination, to optical illusions, reflections, transparency, and translucence. The science of images, then, would have to consider not just material objects but also the spaces between objects and the light that is transmitted from one thing to another. Insofar as images appear in nonvisual media like language, a science of images would have to engage with linguistics, with psycholinguistics, and with the study of logical as well as spatial relations. Since images are generally defined as "icons," or signs by similarity, it would have to be a science of similitude, analogy, and likeness, as well as of dissimilarity, adjacency, and difference.

The science of images would also have to be a historical science, one that deals with the spatial and temporal circulation of images, their migrations from one place or epoch to another. It would have to be a science that looks at images as groupings, families, classes, linked by resemblance to other things in the world and to each other. It would have to be a science that registers the capacity of images to represent reality, but also recognizes that images can be highly misleading and deceptive, precisely because they have such a capacity to engage our trust with their seemingly immediate testimony to the visible, the palpable, the concrete world of experience. A science of images would have to address the very divided reputation of images within science, the tendency of scientists, as Galison has observed, to divide themselves into iconoclastic and iconophilic camps, with some researchers putting great stock in the usefulness of images, others regarding them as distractions that prevent the hard questions from being addressed.

Image science would have to be, and has been, a cognitive science, an empirical study of the conditions of human perception, of the centers of pattern recognition, image formation, and transformation in the brain and the mind. Given the affective potency of images in human consciousness, however, it seems clear that a cognitive science would not be enough by itself. It would have to be complemented by a psychology that reckons with

the unconscious effects of imagery, their uncanny ability to lure, seduce, and even traumatize the beholder. The science of imagery could not just be about pattern recognition. It would have to include misrecognition, fantasy, dreaming, and hallucination. It would have to be about memory images, and also about *false* memory, screen memory, and the dubious status of "recovered memory."

If science in general uses images as part of its cognitive apparatus, then it seems clear that a science of images would also have to use images to get *at* its subject, but it would then be in the curious position of doubling that subject, of working with *images of images*, or what I have called "metapictures," to capture its object. Metapictures are pictures that show us what pictures are, how they function, where they are located; they are seen most literally in the familiar sight of pictures-within-pictures, the "nesting" of one picture inside another picture. A science of images, then, could try to be rigorously iconoclastic and limit its representations of images to nonpictorial, nongraphic forms (sentences, descriptions, equations, algorithms, etc.), or it could accept the inevitability of the metapicture and grapple with the vertiginous abyss of infinite regress that it seems to open up when we use pictures to understand pictures.

My own impulse, of course, is to commit myself to exploring the abyss. And not the abyss of culture, society, or politics, where the "soft" science of images seems most at home, but that of hard sciences—mathematics, physics, and biology—places where images abound but a science of images has yet to emerge.

DIAGRAMMATOLOGY

Peter Galison's essay on the *paragone* between the iconophiles and iconoclasts of mathematics provides a metapicture of the role of images in the abstract science of numbers, functions, and logic.[1] Galison reconstructs this struggle at many levels: as a debate between an "intuitive" approach to mathematics, stimulated by visual, pictorial, and sculptural model-building, and an approach governed by logic, calculation, and demonstration. It is also a debate between analog and digital media, between "concrete" and "abstract" renderings of problems, between an "eyes open" and an "eyes shut" approach to problem-solving. As should be clear from this

1. "Images Scatter into Data, Data Gather into Images," in *Iconoclash: Beyond the Image Wars in Science, Religion, and Art*, ed. Bruno Latour and Peter Weibel (Cambridge, MA: MIT Press, 2002), 300–323.

partial inventory, there is something slippery and even incoherent about this array of oppositions. Galison notes that, despite the vehement emotions often expressed, the battle lines are never very well defined, and that figures such as Poincare and David Hilbert, who seem to occupy opposite sides, often wind up defecting to the enemy camp at critical moments. Galison concludes that there is something illusory about the whole struggle:

> At the heart of the scientific image is the search for rules: at the heart of the logical-algorithmic has been a hunt for the recognition that is the eternal promise of representation. Said another way: the impulse to draw the world in its particularity never seems to be able to shed itself of the impulse to abstract, and that search for abstraction is forever pulling back into the material-particular. (302)

The question arises, then: is the difference between images and logic an illusory frontier, a poorly analyzed distinction that, on reflection, dissolves into a general science of signs, a semiotics that would transcend all the superficial barriers between words and images, numbers and diagrams, the abstract and the concrete? Galison's own rhetoric—"the eternal promise of representation" that is "forever pulling back into the material-particular"—is equivocal, as if he were describing something between a religious-metaphysical utopia (an "eternal promise") and a physical force, a gravitational or electromagnetic field "forever pulling." His historical account of the *paragone* of image and logic in twentieth-century science, on the other hand, suggests that the invention of a new entity, the so-called digital image, has overcome the ancient division and rendered crossovers and conversions routine:

> But now, ever more intensively, the routinization of analog-to-digital and digital-to-analog conversions has made the flickering exchanges routine: image to non-image to image. No longer only set in motion at moments of crisis, we find that ordinary, every-day science propels this incessant oscillation: "Images scatter into data, data gather into images." (322)

Is the ancient quarrel, with its eternal promises and endless tug of war, about to be settled once and for all? Has the image finally been tamed by the rule of the computer, the digitization of the analog sign? Galison does not answer this question, and perhaps it has no answer, though intuitively, I think, we want to respect both the philosophical and historical impulses in his discussion. That is, there seems to be something both eternal and

historical about this problem, as if every solution simply reintroduces the problem at a new level.

This impasse is, in my view, precisely what necessitates a science of the image, rather than a merely instrumental use of images as unexamined instruments in getting at other kinds of reality. The first step in this science, however, has to be some definition of its object. What is an image that it can, as Galison argues, "scatter into data" or (conversely) appear as a "gathering" of data? I have written on this question elsewhere and simply want to rehearse my conclusions briefly here. First, I take as axiomatic the intuition of C. S. Peirce that an image is an icon, that is, a sign by resemblance. This means, of course, that the whole notion of the specifically "visual image," and the accompanying language of intuition, concreteness, perceptual immediacy, graphic arrays, and so forth, has to be put into question. One of Peirce's deepest insights, often forgotten, was that the algebraic equation is no less an icon than its diagrammatic rendering in two-dimensional space. The equals sign (=) is itself an indexical sign, like the brackets of set theory, or other relational pointers (< as "less than"; > as "greater than"; congruence, similarity, and the signs for operations such as addition, subtraction, division, etc.). At the heart of logic and mathematics, then, the iconic relations of identity and equivalence, similitude and difference, are lurking. These relations also obtain in some pictures and diagrams, as well as in language, so that we speak of "verbal icons" and mean by that expression both the names and descriptions of objects, and the figurative comparison of one object to another. Both names and metaphors are "verbal images" but in very different senses of the word "image." An image is a double sign, then, naming something we see, like a portrait or landscape or graph, and something we comprehend as a signifying relation to something beyond itself: *this* portrait represents *that* person. Our ordinary language captures this double relation when we say that a portrait "looks like" the person it represents. Looking and likening, seeing and similitude, are fused, and *con*fused, in ordinary representational images, which is why we run into difficulty when we encounter an image that doesn't look like anything, or doesn't look like what it represents. The scientific image of the atom as a kind of miniature solar system, for instance, is widely understood to be a completely false picture of the atom, *if* we take it as a picture that is supposed to "look like" actual atoms. It is rather a model that attempts to capture some features of the atom that are graspable in other, mainly quantitative terms. It is surely an image, and a visual image, but not one that looks like what it represents.

If we are going to have a science of images, then, the first step is to

release it from the tyranny of the physical eye, literally understood, and understand that images (as icons) circulate through many domains: there are mental and mathematical and verbal images, as well as pictorial and visual images.[2] The images we should be concerned with in science are not just the pictures, graphs, and physical models, but also the metaphors that provide pictures of a domain of research—the universe "as" a heat-engine or a clock or a ball of string—pictures that need not be made visible or drawn graphically. Images are not medium-specific, though they are never encountered outside of some medium or other. An image can move from one medium to another, appearing now as an equation, now as a diagram, now as a figure in a narrative, and now as a figure in a narrative painting.[3] Panofsky called the image a "motif" to emphasize its repeatability in many different pictures, but he failed to draw the obvious conclusion that resides in our ordinary language of talking about images: the image and the picture are very distinct, yet intimately linked entities. The English language (but not German) registers this distinction when we say that we can hang a picture, but it would seem odd to speak of hanging an image. The picture is the material support, the physical medium (whether stone or paint, metal or electromagnetic impulses) in which the image appears. But the "image as such," if we can speak of such a thing, is not itself a material thing, though it must always appear in or on some material support— a statue, an embodied perceiver. An image is a relationship and an appearance: it might be better, in fact, to think of images as events or happenings than as objects, in order to register their often fleeting temporality (appearing and disappearing, going in and out of focus, or, in Galison's lovely metaphor, scattering and gathering). We might then want to speak, with phenomenologists like Bachelard and Merleau-Ponty, of the "onset" of the image or, with Wittgenstein, of the "dawning of an aspect." But only an immaterial, phantasmatic conception of the image that treats its being in what Derrida described as a "hauntology" can capture its spectral nature.

THE PHYSICS OF THE IMAGE

I realize that the foregoing remarks may convict me of being an idealist or worse, and that this is an unfashionable position in a time when invoca-

2. See the first chapter of *Iconology: Image, Text, Ideology* (Chicago: University of Chicago Press, 1987), "What Is an Image?," for a discussion of the variety of things that go by the name "image."
3. See the discussion of the image/picture distinction in chapter 2 above.

tions of materiality and embodiment are de rigueur. But a monistic materialism can never grasp the specific materiality of the image. For that, we need a dialectical materialism of the sort that led Marx to solve the riddle of the commodity: "So far," Marx points out, "no chemist has ever discovered exchange-value either in a pearl or a diamond."[4] Exchange value is not a physical property of objects but a property of the circulation and exchange of objects, their alienation from use, their abstraction from their concrete, material properties. Images are another form of the exchange-value of things, operating primarily at the perceptual and cognitive level, though of course the commodification of images is a familiar enough phenomenon, and the fetishism of commodities marks precisely that moment when the spectral, phantasmatic character of images seems to settle like an aureole around the physical body of an object.[5]

But an even simpler demonstration of the peculiar physics of the image can be glimpsed if we raise the question of their destruction. Iconoclasm is the effort to destroy images, usually for political or religious reasons, though Galison's account of twentieth-century science makes it clear that there can also be professional and epistemological motives for the effort to banish images. His story, however, makes it clear that the image invariably comes back in a kind of "return of the repressed," even in the thinking of the most relentless iconophobes. This situation could have been predicted, of course, by a historical reflection on the age-old crusade to stamp out idolatry, to purge the world of graven images, and even of verbal images. This is not simply a matter of grinding or melting down a Golden Calf, scattering it on water and forcing the Israelites to drink it, as in the Exodus story. (As we know, this sort of materialist effort to destroy an image always fails: the Calf survives as a verbal image in the very narrative that tells of its destruction, and is reborn as a visual, graphic image in scores of Renaissance paintings.) So the effort to destroy images cannot rest with their mere sculptural or graphic rendering. The most persistent effort to achieve utter annihilation of images in words and even in thought is the commentaries of Maimonides's *Guide for the Perplexed*, which finds that even the language of the Bible itself is riddled with misleading metaphors and concrete words that attribute things like a body, a face, hands, feet, and spatial location to the invisible, unrepresentable deity.[6] The mandate

4. *Capital* (New York: International Publishers, 1967), 1:83.
5. For further discussion of analogy between the commodity and the image, see "The Rhetoric of Iconoclasm: Marxism, Ideology, and Fetishism," chapter 6 of *Iconology*.
6. Maimonides's anti-iconism is discussed at length in chapter 1 of *Iconology*.

of iconoclasm is, finally, not just the destruction of graven images but also the purging of words and ideas, to arrive at a purified language, and consciousness, that is capable of thinking about God without thinking about anyone or anything. This is, of course, an impossible, unattainable state, but it has the virtue of revealing just how impossible it would be to follow or enforce the second commandment, prohibiting the making of images of any kind or any thing. The destruction of images, as Michael Taussig has argued, is a sure way of guaranteeing them an even more potent presence in memory, or as reincarnated in new forms.[7]

So a fundamental law of the physics of images is: images cannot be destroyed. The picture or physical support in which they appear can be destroyed, but the image survives destruction, if only as a memory in the mind—that is, the body—of the destroyer. The question arises, then: if we are going to pursue the metaphor of a physics of the image, is it subject to a "law of conservation" similar to the one that governs matter and energy in the physical world? That is, should we say that images can neither be created nor destroyed? It is easy to see why it is so difficult to destroy images, but creation seems to be another matter. Surely new images are always being created by artists and scientists, as well as by ordinary people, from the child's first drawing to the everyday snapshot. Here I think we have reached a boundary of our understanding, but my intuition (if that will be allowed) is that images cannot be created, at least not ex nihilo. Insofar as images are always images *of* something, then what they are images of must always logically and temporally precede them. We say that a child is the image of its parent, by which we mean that there is a discernible family resemblance, even though we also know that in many respects the child looks nothing like its parent. The image, then, is not the bearer of the new, the different, in the child, but of what was already present in the parent. The rule of likeness is a conservative rule, defying innovation and insisting on the return of the similar. This is true, I suspect, even when we are attempting to create a totally new, original image, and it explains why it is so difficult, if not impossible, to imagine what it would mean to create a radically new image.

The efforts of the surrealists are especially instructive in this regard, for their wildest innovations are invariably discovered to be novel conjunctions of already existing images. One could call these "new images," but only in the sense that a sequence of words that are themselves not new can

7. *Defacement: Public Secrecy and the Labor of the Negative* (Stanford, CA: Stanford University Press, 1999).

constitute a "new sentence" in a language. Perhaps we should say, then, that new combinations of images can be created, and even new images in the sense that we speak of "coinages" in language (which are invariably old, recognizable words "morphed" into something new). If an image (or a word) were *completely* new, how would we recognize it? It is this moment of recognition that makes the image readable as such, and that provides the thread of continuity with variation, deviation, and difference that makes it possible to see images morphing (as in a Michael Jackson video) from one identity to another. This morphing would be purely abstract and nonreferential if it did not pass through moments of stillness—"freeze frames," as it were—in which the multiple identities were registered as *this* image or *that* image. And even if we imagine the morphing of an abstract image—a very concrete and technical possibility—the various stages of morphogenesis would each have a specific gestalt as *this* form or *that* form. Perhaps the only sense in which a new image could appear would be in some composite or synthetic or transitional form, as in the Galtonian photographs that blur together several portraits to produce a portrait that looks "strangely familiar" but is of no individual who ever existed.

THE BIOLOGY OF IMAGES

I warned you at the outset that the search for a science of images might lead us into an abyss of speculation, and I hope that so far you have not been disappointed. We have traced the mathematics of images as diagrammatic and logical relations, and the physics of images as immaterial, phantasmatic entities that require a physical medium to make their appearance. But what about the life sciences? Could there be a "natural history" of images built around a metapicture of images as organisms or life-forms? This question can be broached by returning to the question of the Galtonian photograph as a "new" or "created" image. The reason this Galtonian image is "strangely familiar"—both old and new—is that it broaches the question of the image as a *type*, or "typical" representation, rather than as a representation of an individual. We are familiar enough with this phenomenon in the realm of stereotypes and what might be called "reductive" or "schematic" images. The smiley face on the bumper sticker is recognizable *as a face*, but not as any particular face. In fact, when we speak of "recognizing" what an image represents, the form of re-cognition involved can be quite general and abstract: it can amount to seeing something as a face or a body without seeing it as any particular face or body, just as, in geometry, we can recognize something as a square

or circle without thinking of it as a unique, particular entity. The specific drawing or diagram may function as the *token* of a *type*, a concrete embodiment of a quite general and generic image, one that can be translated into an algebraic icon in Peirce's sense ($x = y$, in the case of the square; of the circle, $C = \pi r^2$).

But this generalizing property of images is exactly what links them to the life sciences, and particularly to the concept of the species and the specimen. One thing we could not account for in the physical model of the image was the question of morphing, transformation, and the genesis of "family resemblance" across a series of images. But the metaphor of the image as life-form brings this process into focus, at the same time that it raises a whole new set of difficulties. If images are like living things (rather than the spectral, ghostly entities we encountered in the realm of physics),[8] then surely they can be created and destroyed. But here we must remind ourselves that we are constructing a multitiered stack of analogies, in which material objects are to apparitions as pictures are to images, as specimens are to species. I have never argued that a picture or a material object cannot be created or destroyed. This painting, that statue, this manuscript with those equations and diagrams, can surely be created and destroyed. But think of what it would mean to destroy a species, rather than a specimen. Not impossible, perhaps (and quite a realistic prospect in an era that is defined by its consciousness of "endangered species" and extinctions). So the move from the physics of the image to the biology of the image does reveal a level of our science that it was not possible to address within the sphere of physical, inanimate matter. It is in the sphere of the life sciences that our science of images would confront the problem of the *reproduction* of images, their *mutations* and *evolutionary transformations*. If the image is to iconology what the species is to biology, then pictures (in an extended sense that includes sculpture and other material constructions or "situations") are the specimens in a natural history of images. This natural history is, of course, also a cultural and social and political history, but it is one that is focused on the "second nature" we have created around ourselves—the entire image-repertoire of human consciousness and civilization. We have always understood that the arts are, as Aristotle insisted, "imitations of nature," and that this means not just that they represent or resemble the natural world, but also that they themselves are a

8. The metapicture of images as "ghostly" entities, phantasmatic apparitions, of course already links it not just to the world of physical things, but also to the world of *formerly* living things, the realm of what Derrida called "hauntology."

kind of nature "in process," an expression of the species identity of human beings. Now we live at a moment of crisis when the human is regarded by some as an extinct or endangered species, when the "posthuman" looms as the horizon of speculative thought. At the same time, we are told that the ancient, indestructible domain of images has been mastered finally by the "digital," and that numbers, calculations, and mechanical operations will finally replace us in an infinite circuit of information.[9] Neither posthumanism nor the digital image seems to me especially coherent or promising as a concept, but they belong together, I think, as symptoms of a failure to think historically or philosophically but instead to take refuge in a curious kind of posthistorical presentism. And they also help us to see why the two most conspicuous and highly publicized "natural images" of our time dominate our picture of the fate of our own species. I'm thinking of the fossil and the clone, and I'll end this chapter with a brief reflection on their meaning.

FOSSIL AND CLONE

The destruction of a species is not necessarily the destruction of its image. On the contrary, extinction of a species is a precondition of its resurrection as image in the form of fossil traces. The fossil record is a material and pictorial record, a vast iconic and indexical archive of species, most of them extinct, that have inhabited this globe. And of course fossils are not the only image-traces that we have to reconstruct the evolution of life-forms. Contemporary paleontology regards birds as the descendants of dinosaurs, placing the reptilians in quite another class. In that sense, the analogy of image and species needs to be qualified, because higher level taxa such as phyla also have their clusters of attributes, their family resemblances, their Galtonian composite images. (There is also, though I don't have time or expertise to address it, the crisis within biological theories of taxonomy as such, in which the rise of cladistics has made the notion of species itself an object of controversy. How this will play out for iconologists is beyond the scope of this book.[10])

The fossil image is what survives the death of a species, just as the

9. This is the dark message of Friedrich Kittler's wonderful history of media, *Gramophone, Film, Typewriter*, trans. Geoffrey Winthrop-Young and Michael Wutz (Stanford, CA: Stanford University Press, 1999).

10. But for some opening moves, see Norman Macleod, "Images, Totems, Types, and Memes: Perspectives on an Iconological Mimetics," in *The Pictorial Turn*, ed. Neal Curtis (New York: Routledge, 2010), 88–111.

corpse is what survives the death of the individual specimen. The sciences of natural history are the species equivalent of the rituals of mummification and preservation of effigies of the dead that find their place in the ethnographic wing of the natural history museum. Both are sciences of resurrection and reanimation, an effort of life-forms, bodies (our own), to manage mortality by means of images. But that is exactly what makes them so uncannily similar to the other great breakthrough in the life sciences in our time: the DNA revolution epitomized by the clone. The clone is the obverse of the fossil in every way. It epitomizes the hope for species immortality in the promise of therapeutic cloning to "scrub" all birth defects from our DNA, to produce replaceable organs and ever-improved specimens. It also signifies the hope for the immortality of a singular, individual specimen in the utopia of reproductive cloning, where exact duplicates of parent organisms can be produced.

The fossil and the clone, then, play the role of endpoint species for both the image and the human. Both are, quite precisely, image "families" or classes: the fossil the product of a slow process of petrification, reversed by resurrection and reanimation in the paleontological imagination. (It is no accident that most paleontologists have highly developed visual acuity and that many of them are artists and image-processors.[11]) The fossil is also an allegorical image, a premonition of our own species mortality. It is thus what Walter Benjamin called a "dialectical image," capturing history at a standstill (in this case, the "deep time" of the geological record, projected backward through the entire history of life on earth and forward toward the specter of our own extinction).

The clone, by contrast, is the technical, biocybernetic chimera of our time, and is thus generally pictured as a monstrosity, an unnatural and sterile freak. It personifies and incarnates in living flesh the anxiety about images that pervades hypericonoclastic critiques such as Baudrillard's precession of simulacra: copies without an original; indistinguishable copies, the horror of repetition and indefinite sameness; the fear of the double; homophobia and heteronormativity; reproduction without difference; confusion of identity and similitude. The clone, then, is also a dialectical image. It points forward to a utopian or dystopian future in which the rule of the "spitting image," the exact simulacrum, is extended to an unprecedented degree. It points backward toward our most archaic fantasies about images: that they are imitations of life in a more than figurative sense,

11. For more on the visual arts and paleontology, see my *The Last Dinosaur Book* (Chicago: University of Chicago Press, 1998).

that some of them possess "aura" (literally, the breath of life), that they look back, have desires and agency. All the taboos about image-making are revived around the clone, and strange political alliances emerge between eco-activists, Greens, and fundamentalist Christians. Notions such as the "circulation" or "mobility" of images in an age of globalization and genetic engineering are clearly insufficient. We need to think instead of a *migration* of images, in which their movements are incessantly regulated, prohibited, or accelerated by fantasies of contamination, plague, and purification.[12] With the clone the metaphor of the life-form as image, and vice versa, seems to be literalized. Is it that the image is like a life-form, or the reverse?

The figures of the clone and the fossil merge, as it happens, in *Jurassic Park* (1993), one of the great cinematic spectacles of the early 1990s, a period that now seems like a time of innocence. For just an instant (fig. 3.1), a velociraptor is caught in the beam of a film projector that is projecting the DNA sequence that made it possible to clone a living dinosaur from its fossil traces. Let this "digital dinosaur" stand as a nexus point for these speculations on the science of images. It is, first, a science fictional image, a speculative projection of what the convergence of paleontology and genetic engineering might produce. It is also a technical, cinematic image, an early example of the revolution in digital animation that has ushered in a whole new era in the relation of animated and live-action images. Within the life sciences, this image has to be dismissed as a fantasy, a biological impossibility. But within the science of images, it is a crucial specimen, a "missing link" in the evolutionary record of these strange, phantasmatic likenesses and apparitions. In the narrative of the film, this animal is breaking into the computer control room of the park and threatening to devour the controllers. Perhaps it is an allegory for our hope that the digitizing of the image is a way of controlling the wild kingdom of images, making peace between scientific logic and fleshly, concrete pictures, annihilating the Golden Calf once and for all. Not a likely story.

12. See my essay, "Migrating Images: Totemism, Fetishism, Idolatry," in *Migrating Images*, ed. Petra Stegmann and Peter C. Seel (Berlin: House of World Cultures, 2004), 14–24.

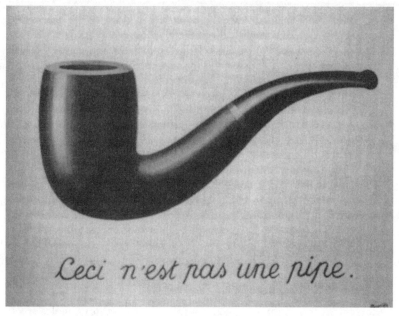

4.1 René Magritte, *This Is Not a Pipe* (1929). © 2015 C. Herscovici/Artists Rights Society, New York.

4: IMAGE X TEXT

What is the "imagetext"? We might begin not by asking what it means, but how can it be written down. In a footnote to *Picture Theory* (1994), I took a stab at a notational answer:

> I will employ the typographic convention of the slash to designate the "image/text" as a problematic gap, cleavage, or rupture in representation. The term "imagetext" designates composite, synthetic works (or concepts) that combine image and text. "Image-text," with a hyphen, designates *relations* of the visual and verbal. (89)[1]

Rupture, synthesis, relation. We are obliged to range over all three of these possibilities. On the one hand, there are what we might call "literal" manifestations of the imagetext: graphic narratives and comics, photo texts, poetic experiments with voice and picture, collage composition, and typography itself. On the other hand, there are figurative, displaced versions of the image-text: the formal divisions of narrative and description, the relations of vision and language in memory, the nesting of images (metaphors, symbols, concrete objects) inside discourse, and the obverse, the murmur of discourse and language in graphic and visual media. And then there is a third thing: the traumatic gap of the unrepresentable space between words and images, what I tried to designate with the "/" or slash.

It is that third thing that I would like to reopen. And I want to do it, again, "literally," with an exploration of a typographic sign that might synthesize the three relationships of texts and images, and suggest further possibilities as well. My chosen sign is "X," and I wish to treat it as a Joycean verbo-vocovisual pun that condenses the following meanings and inscriptions: (1) X as

1. See also, in the same book, chapter 3, "Beyond Comparison: Picture, Text, and Method," and the concluding chapter, "Some Pictures of Representation." Other key writings on the concept of the imagetext include *Iconology: Image, Text, Ideology* (Chicago: University of Chicago Press, 1987) and "Word and Image," in *Critical Terms for Art History*, ed. Robert Nelson and Richard Schiff (Chicago: University of Chicago Press, 1996).

the "unknown" or "variable" in algebra, or the "X factor" in vernacular usage; the signature of the illiterate. (2) X as the sign of multiplication, or (even more evocatively) as the "times sign"; also as a tilted or torqued modification of the simplest operation in mathematics, the "plus" sign (+). (3) X as the sign of chiasmus in rhetoric, the trope of changing places and dialectical reversal, as in "the language of images" providing "images of language"; another way to see this is to grasp the ways in which image and text alternately evoke differentials and similarities, a paradox we could inscribe by fusing the relation of image *versus* text with image *as* text, a double cross that could be notated with an invented symbol, "VS" overlapped with "AS" to produce a double X in the intersection of A and V. (4) X as an image of crossing, intersection, and encounter, like the iconic sign at a railroad crossing. (5) X as a combination of the two kinds of slashes (/ and \), suggesting opposite directionalities in the portals to the unknown, different ways into the gap or rupture between signs and senses, indicating the difference between an approach to words and images from the side of the unspeakable or the unimaginable, the invisible or the inaudible. And (6) X as the phoneme of eXcess, of the eXtra, the unpredictable surplus that will undoubtedly be generated by reopening the variety of relations subtended by this peculiar locution, the imagetext. This is the sign of everything that has been left out of my construal of the X.

Why is it possible, even necessary, to formulate such an abundance of meaning around a simple relation between two elementary, even primitive terms like "text" and "image"? One scarcely knows where to begin. A simple opening is provided by the innocent little phrase, "visual and verbal representation," that is often uttered as a kind of alternative to "word and image" or "text and image." A moment's thought reveals a strange discontinuity, a shift of levels of meaning. In order to make anything specific out of the visual-verbal, we must ask: Visual as distinct from what? Verbal as opposed to what? The obvious candidates are images or pictures as opposed to verbal signs, and visual sensations as opposed to auditory. The visual denotes a specific sensory channel; the verbal designates a specific semiotic register. The difference between the visual and verbal is actually *two* differences, one grounded in the senses (seeing versus hearing), the other in the nature of signs and meaning (words as arbitrary, conventional *symbols*, as distinct from images as representations by virtue of likeness or similitude). The phrase "visual-verbal," then, produces a productive confusion of signs and senses, ways of producing meaning and ways of inhabiting perceptual experience.

Figure 4.2 provides a picture of this confusion. The X that links and differentiates images and texts is the intersection between signs and senses, semi-

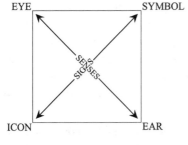

4.2 Image/text square opposition.

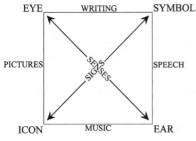

4.3 Image/text square opposition (elaborated).

otics and aesthetics. It becomes evident at a glance, then, that the apparently simple concept of the imagetext opens up a kind of fractal expansion of terms, as is captured in a more fully elaborated version of the figure (fig. 4.3).

As the sensory-semiotic dimensions of the word-image difference expand, they begin to demand some essential distinctions. When we talk about "words," for instance, are we referring to speech or writing? (Let's leave out, for the moment, gesture, which Rousseau saw as the original form of verbal expression, and which is fully elaborated today in the languages of the deaf).[2] Does the "imagetext" concept automatically rule out orality? On the side of the image, are we talking about visual images—e.g., drawings, photographs, paintings, sculpture? Or auditory images, as in poetry and music? And what happens when we include the notion of "verbal imagery" (metaphor, description, etc.), which has not yet found a place in figures 4.2 and 4.3? Is this the X factor as an excess that overflows the boundary of any conceivable graphic representation?

Any systematic analysis of the relation of images and texts, then, leads inevitably into a wider field of reflection on aesthetics, semiotics, and the whole concept of representation itself as a heterogeneous fabric of sights

2. See my "Utopian Gestures: The Poetics of Sign Language," preface to *Signing the Body Poetic: Essays on American Sign Language Literature*, ed. H. Dirksen Bauman, Jennifer L. Nelson, and Heidi M. Rose (Berkeley: University of California Press, 2006), xv–xxiii.

and sounds, spectacle and speech, pictures and inscriptions.[3] Is this not a multiply articulated fabric, in which the warp and woof are constantly shifting, not only from sensory channels (the eye and the ear) to semiotic functions (iconic likenesses and arbitrary symbols), but also to modalities of cognition (space and time) and to operational codes (the analog and the digital)? The fractal picture of the imagetext has scarcely begun with the "visual-verbal." And will we not also have to add the "thirds" that inevitably spring up between our binary oppositions, sometimes as compromise formations (could the "ana-lytical" itself be a demand for fusion or interplay between analog and digital codes?), sometimes as blank spaces in which something unpredictable and monstrous might emerge? The gap between the Lacanian registers of the Symbolic and Imaginary is the black hole of the Real, the site of trauma and the unrepresentable (but clearly *not* an unnameable place, since there it is, the name of "the Real"). Could it be the "beach" or margin between sea and land that Foucault names as the frontier between the words and images in Magritte's *Ceci n'est pas une pipe*? Is it a contested zone, as Foucault puts it, "between the figure and the text" where "a whole series of intersections—or rather attacks launched by one against the other"[4] exist. Could we then see our X as crossed lances (/ \) or "arrows shot at the enemy target, enterprises of subversion and destruction, lance blows and wounds, a battle." Leonardo da Vinci called the encounter of painting and poetry a *paragone* or contest, and Lessing described their relation as the frontier between two countries, normally friendly and peaceful, but sometimes launching invasions into their neighbors' territory.

There are, then, normal and normative relations between texts and images. One illustrates or explains or names or describes or ornaments the other. They complement and supplement one another, simultaneously completing and extending. That is why Foucault focuses on the "common frontier" between Magritte's words and images, the "calm sand of the page," on which "are established all the relations of designation, nomination, description, classification"—in short the whole order of the "seeable and sayable," the "visible and articulable," that lays down the archaeological layers of knowledge itself.[5] Word and image are woven together to

3. See "Some Pictures of Representation," the conclusion to *Picture Theory*, 417–25.

4. Michel Foucault, *This Is Not a Pipe*, trans. James Harkness (Berkeley: University of California Press, 1983), 26. Foucault also refers to the blank space between the pipe and its caption as a "crevasse—an uncertain foggy region" (28).

5. For an account of the way Foucault's playful reflections on Magritte's image-text composition serve as a basis for his whole archaeological method, see Gilles Deleuze, *Foucault* (Minneapolis: University of Minnesota Press, 1988), 80.

create a reality. The tear in that fabric is the Real. Foucault makes the space between images and texts even more radical when he denies it the status of a space at all: "It is too much to claim that there is a blank or lacuna: instead, it is an absence of space, an effacement of the 'common place' between the signs of writing and the lines of the image." X becomes, in this sense, the erasure, or "effacement," not just of something inscribed, but of the very space in which the inscription might appear, as if the X signified a pair of *slashes*, like the tearing of a page, or cuts in a canvas left by a militant iconoclast—or an artist like Lucio Fontana.

Let's say, then, that the normal relation of text and image is complementary or supplementary, and that together they make up a third thing, or open a space where that third thing appears. If we take comics as our example, the third thing that appears is just the composite art form known as comics, combining text and image in a highly specific medium. But there is also a third thing in the medium of graphic narration that is neither text nor image but which simultaneously links and separates them, namely, the *gutter*. These unobtrusive framing lines, as is well known, are neither words nor images, but indicators of relation, of temporal sequence or simultaneity, or of notional camera movements in space from panorama to close-up. Avant-garde comics, from *Smokey Stover* to Art Spiegelman to Chris Ware, have often played with the gutter, cutting across it, treating it as a window that can be opened to hang out the laundry.

So the third thing, the X between text and image, does not have to be an absence. In fact, we might argue that there is always something positive, even in the blank space of the Real, the slash of the canvas, or the nonspace beyond blankness. Something rushes in to fill the emptiness, some X to suggest the presence of an absence, the appearance of something neither text nor image. In *Iconology: Image, Text, Ideology*, I identified this third thing, as the subtitle indicated, as the ideological framework that invariably suffuses the field of image-text relationships: the difference between the "natural" and "conventional" sign; the distinction between an illiterate viewer, who can see what images represent, and a literate reader, who can see through the image to something else (typically, a text). In the polemic of Lessing's *Laocoön*, the difference between image and text is not only figured in the relation of different nations but rendered literal in his characterization of French culture as obsessed with effeminate "bright eyes" and spectacle, while German and English cultures are described as manly cultures of the word.

If we survey the history of semiotics and aesthetics, we find the positive presence of the third element everywhere. The *locus classicus* is, of course,

Aristotle's *Poetics*, which divides the "means" or "medium" of tragedy into three parts: opsis, melos, and lexis (spectacle, music, and words). Or, as Roland Barthes would have it, *Image/Music/Text*.[6] The X-factor in the image-text problematic is music, or, more generally, sound, which may be why "imagetext" has always struck me as slightly impoverished in that it confines *words* to the realm of writing and printing, and neglects the sphere of orality and speech, not to mention gesture.[7] Sometimes, this silencing of the third dimension becomes explicit, most famously in Keats's "Ode on a Grecian Urn," where the text not only conjures up the *sight* and image of its titular subject but attributes to it a silent music and speech—"a leafy tale" told "more sweetly than our rhyme," accompanied by an "unheard" music. The radio comedians Bob and Ray used to pose the riddle Why is radio superior to television? The answer: because the images we see while listening to the radio are better, more vivid, dynamic, and vital.

The triad of image/music/text must be the most durable and deeply grounded taxonomy of the arts and media that we possess, because it recurs constantly in the most disparate contexts, defining the elements of the Wagnerian *Gesamstkunstwerk*, the components of cinema, radio, and television, and even the order of technical media that constitute modernity. I am thinking here of Friedrich Kittler's masterpiece, *Gramophone, Film, Typewriter*, which is, on the one hand, an updating of the old Aristotelian categories and, on the other, a trio of inventions subject to a new technical synthesis in the master platform of the computer.[8]

Finally, we must turn to the role of the imagetext in the constitutive elements of semiotics: the fundamental theory of signs and meaning. There we encounter Saussure's famous diagram of the linguistic sign as a bifurcated oval with an image of a tree in the upper compartment and the word "arbor" in the lower (figure 4.4). It is as if Saussure were forced to admit that even words, speech, and language itself cannot be adequately represented by a purely linguistic notation.[9] The image, which stands here not just for a tree but also for the *signified* or mental image conjured by

6. *Image/Music/Text*, trans. Stephen Heath (New York: Hill & Wang, 1977).
7. A version of the Aristotelian and Barthesian triad was institutionalized some years ago in the University of Chicago's common core as a yearlong course sequence in "media aesthetics" entitled "Image/Sound/Text."
8. *Gramophone, Film, Typewriter* (Stanford, CA: Stanford University Press, 1999).
9. Since Saussure's text was a compilation of lecture notes by himself and his students, it is not possible to be certain that this diagram was actually drawn by the great linguist. Nevertheless, it has become a canonical picture of his understanding of the linguistic sign.

4.4 Ferdinand de Saussure, "Linguistic Sign," from *Cours de linguistique générale* (1916).

the verbal signifier, actually stands *above* and prior to the word in the model of language itself. Saussure is building upon a picture of language that could be traced back into the psychology of empiricism, in which mental images are the content named by words, or all the way to Plato's discussion of natural and conventional signs in the *Cratylus*. But we also have to notice that the imagetext is not all there is to the sign; there is a surplus of "third elements": the oval, presumably a graphic rendering of the wholeness and fertility of the sign-as-ovum, despite its binary structure; the arrows, which stand for the bidirectionality of meaning, a circuit of alternating current between spoken words and ideas in the mind; and (most important) the *bar* between signifier and signified, the index of the fundamental duality of language and thought.

But this mention of the index must bring to mind immediately the most comprehensive analysis of the sign to date, the semiotics of Charles Sanders Peirce, who identified three elements or sign-functions that make meaning possible. These are the elements he calls "icon/index/symbol," a triad that describes (very roughly) the distinctions between images (pictures, but also any sign by resemblance, including metaphors), indexical signs (arrows and bars, for instance, but also pronouns and other deictic words that depend upon context), and symbols (signs by "law" or convention).[10] The relation of image and symbol, we must note, is merely analogous to, and at a quite different level from, the image-text relation, because Peirce is not interested in classifying signs by their singular manifestations, such as "words and images," but by their *sign function*, which depends upon the way in which they make meaning. The category of the icon includes pictures and other visual, graphic images, but it is not exhausted by those things. Icons can appear in language as metaphor and in logic in the form of analogy. They are signs by resemblance or likeness. Similarly, indices may be exemplified by arrows and bars, but they also include elements of language, such as deictic terms (this, that, there, then) and pronouns (I, we, you). Indices are "shifters" or existential signs that

10. "Logic as Semiotic: The Theory of Signs," *Philosophical Writings of Peirce*, ed. Justus Buchler (New York: Dover Publications, 1955), 98–119.

Aristotle	*opsis*	*melos*	*lexis*
Barthes	image	music	text
Lacan	Imaginary	Real	Symbolic
Kittler	film	gramophone	typewriter
Goodman	sketch	score	script
Peirce	icon	index	symbol
Foucault	seeable	[X]	sayable
Hume	similarity	cause and effect	convention
Saussure	♣	bar	arbor

take their meaning from context. They are also signs by cause and effect (tracks in the snow indicating where someone has walked; smoke as an indicator of fire). And finally, symbols are signs that take their meaning from arbitrary conventions (we will let the word "arbor" stand for this vertical object sprouting with leaves).

From Peirce's standpoint, then, the imagetext is simply a figure for two-thirds of the semiotic field, awaiting only the recognition of its third element, the "/" as the index of a slash or relational sign in the concrete thing (a text, a work of art) that is being decoded. All these triads of aesthetics and semiotics can be seen at a glance in table 4.1, to which I want to add one final layer that will, as it were, bring us back to the surface of these reflections and the original question of how to write these things down. I'm thinking here of Nelson Goodman's theory of notation, which examines the way marks themselves can produce meaning, and which relies on categories such as "density" and "repleteness" (where every difference in a mark is potentially significant), and "differentiated" and "articulate" (where marks belong to a finite set of characters that have definite meaning, as in an alphabet, in which the letter *a* still means *a*, regardless of whether it is handwritten, typed, or printed in Gothic or Times New Roman).[11] Goodman's categories, in contrast to Peirce's, take us back to the surface of inscription. Goodman's triad—sketch, score, script—reinscribes the image/music/text triad, but this time at the level of notation.

I hope it is clear that table 4.1 does not postulate some kind of uniformity or even translatability down the columns. The rows are the strong elements, teasing out concepts of semiotics and aesthetics that happen to fall into these precise terms. The columns are merely iconic: they suggest a structural analogy between the ideas of radically different kinds of thinkers. Why, for instance, should we want to link music with the Lacanian

11. Nelson Goodman, *The Languages of Art* (Indianapolis: Hackett, 1976).

Real? Kittler provides a technical answer based in recording apparatuses and the physical structure of the ear.[12] Nevertheless, the whole point of this table is to produce a set of diagonal, X-shaped reflections, that would slash across the rigid order of the columns: the arrows in Saussure's picture of the sign are indices, for sure. But are they not also icons in that they resemble arrows, and symbols in that we have to know the convention of pointing? Point out an object to the average dog, and he will sniff your finger.

We still have not addressed the most fundamental question, which is why the image/text rupture, the image-text relation, and the imagetext synthesis should be so fundamental to aesthetics and semiotics. Why do disciplines like art history and literary criticism find themselves inexorably converging around encounters of visual and verbal media? Why does the theory of representation itself seem to converge on this primitive binary opposition? My claim is that the imagetext is the convergence point of semiotics, the theory of signs, and aesthetics, the theory of the senses. It is the place where the eye and the ear encounter the logical, analogical, and cognitive relations that give rise to meaning in the first place. David Hume understood the laws of "association of ideas" in terms of a triad very close to Peirce's analysis of the sign; similarity, cause/effect, and convention are his three laws, corresponding quite precisely to Peirce's icon, index, and symbol. The imagetext, then, is a principle of thought, feeling, and meaning as fundamental to human beings as distinctions (and the accompanying indistinctions) of gender and sexuality. William Blake glimpsed this when he asserted that the great Kantian modes of intuition, and space and time, are gendered as female and male respectively. And Lacan revised the Saussurean picture of the sign by portraying it as a pair of adjacent doors labeled "Men" and "Women," as if the gendered binary (and urinary segregation) was the foundation of semiosis itself. Of course, some will say that we have transcended all these binary oppositions in the digital age, when images have all been absorbed into the flow of information. They forget that the dense, sensuous world of the analog doesn't disappear in the field of ones and zeros: it resurfaces in the eye and ear ravished by new forms of music and spectacle, and in the hand itself, where digits are literalized in the keyboard interface and game controller. Hardly surprising, then, that the imagetext can play such a productive role, embracing poetry and photography, painting and typography, blogs and comics, and every conceivable form of new media.

12. See Kittler, *Gramophone, Film, Typewriter*, 24.

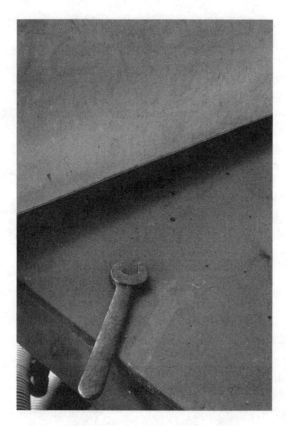

5.1 Allan Sekula, *Welder's booth in bankrupt Todd Shipyard. Two years after closing. Los Angeles harbor. San Pedro, California* (July 1991). Dye transfer print. 32⅛ × 22⅝ in. © 2015 The Estate of Alan Sekula. From the series *Fish Story, 1988–1995*. Photograph: courtesy of the Estate of Allan Sekula.

5: REALISM AND THE DIGITAL IMAGE

The currency of the great bank of nature has left the gold standard: images are no longer guaranteed as visual truth—or even as signifiers with stable meaning and value—and we endlessly print more of them.

WILLIAM J. MITCHELL, *The Reconfigured Eye*[1]

One of the most consistent commonplaces about the nature of digital photography (and digital imagery more generally) is that it has undermined the old claim of photographic images to represent the world faithfully, naturally, and accurately. Traditional chemical-based photography, we are told, had an indexical relation to the referent; it was physically compelled to form an image by the light rays emanating or reflecting from the subject. This image or likeness was thus doubly referential, a double copy in that it was both an impression or trace, on the one hand, and a copy or analogon, on the other. Both index and icon, it provided a kind of double-entry bookkeeping of the real. Like the fossil trace, the shadow, or the mirror reflection in a still lake, traditional photography was a natural sign. It carried a certificate of realism with it as part of its fundamental ontology. Of course, one could, as Mark Hansen notes, recognize that "the specter of manipulation has always haunted the photographic image," but insist that this is "the exception rather than the rule."[2] As William J. Mitchell argues, "Reworking of photographic images is technically difficult, time-consuming, and outside the mainstream of photographic practice" (7). With Photoshop, presumably, reworking or "doctoring" photographs becomes technically easy, quick, and quite ordinary.

I remember a game that my father used to play when taking family photographs. It involved lining up my sisters and me behind him on a hillside, and my mother photographing us such that we appeared to be tiny children standing on his outstretched hands. The photograph itself

1. *The Reconfigured Eye* (Cambridge, MA: MIT Press, 1992), 56.
2. *New Philosophy for New Media* (Cambridge, MA: MIT Press, 2004), 95.

was not manipulated, but the pro-filmic event was staged *for* it, in a way that took advantage of the mechanical automatism of the camera lens (its perspectival design) to produce an illusion.

When Kaiser Wilhelm came to Palestine in the first decade of the twentieth century, he met with his friend Theodore Herzl, and a photo opportunity was staged to show them together. Unfortunately, when the photographs were developed, it turned out that the two men never appeared together in a single shot. So the pictures went back to the darkroom and a famous photo of Herzl and the Kaiser together was fabricated. Was this photograph lying, given that the two men did actually meet? Was this an unusual occurrence? Was it technically difficult or time-consuming? Outside the mainstream? What would happen if a politically loaded photo fabrication like this was produced today in Photoshop? Would it be taken as authentic, or would the "specter of manipulation" automatically hover over it, by virtue of its digital character? The Herzl-Kaiser fabrication went undiscovered for many years. Would a digital trick of this sort be immediately perceptible? Or is it the imperceptibility of the "specter of manipulation" that casts doubt on *all* digital photographs. In that case, of course, we would be back to square one. If all digital photographs are equally suspect, merely by virtue of being digital, then can *none* of them be trusted—or distrusted—any more than any other digital photograph?

I use Photoshop once a year to fabricate an illusion for my family's annual Christmas card. Once I tried to shrink my wife and kids down to little Munchkins and put them on the parapet of one of my sandcastles, with me, at full size, looming above them like a Leviathan. Needless to say, this picture did not meet with the approval of the wife and kids; it exists now only in a fading print and a digital archive. Is this a rare or exceptional practice? Was it technically difficult? Outside normal professional practice? My ordinary use of Photoshop is actually just the opposite of fakery: it principally involves what is called the "optimization" of images for whatever purpose they are going to serve—crunching them down for screening or transmitting over the Internet, fattening them up in .tiff format to produce highly saturated color prints. In other words, I manipulate almost all the digital images that come into my computer, not in order to fake or fabricate anything, but to enhance their functionality in playing roles very like traditional lantern slides or photographic prints. And in fact, I am barely competent at any these practices. People often complain that my PowerPoint presentations employ low-quality, low-resolution images snatched from the Internet. And my answer is: this is a kind of realism. Why should I try to simulate the color saturation and focus of

a lantern slide, when in fact I am not showing lantern slides but digital projections at 72 dpi? If realism means anything, surely it means candor about the nature of one's images. The famous *Life* magazine photo of Lee Harvey Oswald holding the rifle that killed Kennedy is probably a fake. What difference does it make that this was a chemical-based photograph and not a digital photograph?

All of these examples are mobilized, clearly, to undercut or at least complicate the prevailing myth that digital photography has an ontology quite different from chemical-based photography, that this ontology dictates a different relation to the referent, one based in information, coding, and signage (the symbolic realm) rather than the iconic and indexical realms of older forms of photography. These examples also help us to question whether this very dubious "ontology" (which isolates the "being" of photography from the social world in which it operates, and reifies a single aspect of its technical processes),[3] has any fixed relation to issues such as authenticity and fakery, or "manipulated" and "natural" images. It seems clear that things such as the authenticity, truth value, authority, and legitimacy of photographs (as well as their aesthetic value, their sentimental character, their popularity, etc.) are quite independent of their character as "digital" or "chemical analog" productions. The notion that the digital character of an image has a *necessary* relation to the meaning of that image, its effects on the senses, its impact on the body or the mind of the spectator, is one of the great myths of our time. It is based on a fallacy of misplaced concreteness, a kind of vulgar technical determinism that thinks the ontology of a medium is adequately given by an account of its materiality and its technical-semiotic character.

I prefer Raymond Williams's account of media as "material social practices"[4] that involve skills, traditions, genres, conventions, habits, and automatisms, as well as materials and techniques. And (though this will take time to develop) I want to argue that the myth of digital photography has things exactly upside down. Instead of making photography less credible, less legitimate, digitization has produced a general "optimization" of photographic culture, one in which better and better simulations of the best effects of realism and informational richness in traditional photography have become possible for many more camera operators. My

3. As William J. Mitchell puts it in *The Reconfigured Eye* (4), "The difference is grounded in the fundamental physical characteristics that have logical and cultural consequences."

4. "From Medium to Social Practice," in *Marxism and Literature* (Oxford: Oxford University Press, 1977), 158–64.

inkjet printer can now produce 8 × 10s with glorious color, something that was a rare and exceptional experience in the old days. If we are looking for a "tendency" in the coming of digital photography, it is toward "deep copies" that contain much more information about the original than we will ever need, and "super copies" that can be improved, enhanced, and (yes) manipulated—not in order to fake anything but to produce the best-focused, most evenly lit image possible. In other words: to produce something like a professional quality photograph of the old style. We mustn't forget Marshall McLuhan's admonition that one of the first effects of a new medium is simply the simulation and replacement of an older medium. What digital photography is doing to the senses, the body, the referent, the sign, and the image, much less that ever-vanishing entity known "the Real," ought to be at least a question to be asked and answered by some empirical particulars, not a transcendental deduction from a thin description of the bare technical facts about the digitization of images.

In saying this, however, I don't mean to suggest that digitization has made no difference to photography, or to image-making and circulation more generally. It's just that this difference has to be understood as a complex shift in many layers of photographic and image culture, one that involves popular as well as professional, political, and scientific uses of automated image-production, and that is linked to modes of production more generally—that is, new ways of making a living (or not) and of reproducing life itself. My argument is against the reduction of digital photography to a bare material and technical essence, "grounding it," as William Mitchell puts it, in "fundamental physical characteristics" rather than social practices and uses. I will be using Mitchell's discussion of digital photography throughout this chapter as my principal example, simply because his book, *The Reconfigured Eye*, is so often cited as the principal authority and the "classic" statement of this argument.

The main use of digital photography has been (aside from simulating the effects of chemical-based photography for amateur users) a deepening of the referent, not its disappearance. This point is demonstrated by Mitchell's own frequent recourse to technoscientific examples, such as the "spacecraft imaging" that makes it possible to take a "perspective view" of a volcanic landscape on Venus.[5] Digital imaging in this case enhances one of the most venerable aims of "classic" or "realist" photography, namely, the revelation of realities that are inaccessible to the naked eye. Does anyone seriously argue that the digitization of X-ray images and magnetic

5. *Reconfigured Eye*, figure 2.1 (10).

resonance imaging compromises the "adherence of the referent" to these images?

Of course, the kinds of manipulation and artifice that were already possible in traditional photographic practice become even easier in the digital darkroom. Photoshop is packed with magical tools for distortion, enhancement, cutting and pasting, resizing, cropping, and optimizing. But despite the handwringing over the coming inability "to distinguish between a genuine image and one that has been manipulated,"[6] the actual professional use of digital photography in the news media has revealed remarkably few attempts to fabricate false or misleading images. The very fact that cutting and pasting is so easy has, in fact, had just the opposite effect on professional practices, and the National Press Photographers Association has gone out of its way to warn against the use of digital technology to "create lies." As for the distinction between a "genuine" and a "manipulated" image, this is a paranoiac fantasy, since every photograph that was made in the traditional way was also a product of manipulation in the sense of technical, material standards, and decisions about what to shoot, at what settings, and how to develop and print it. The concept of the "genuine" image is an ideological phantasm.

Again, none of this disputes the fact that the camera can be used to lie, or that photographs can be manipulated to deceive. It is only to insist that the invention of digital imaging does not, in itself, render this capability the key to some essentialized "ontology of the digital photograph." If ontology is the study of being, then we must not forget that the ontology of photography should focus on its being *in the world*, not in some reductive characterization of its essence.

Mitchell makes a great deal of the de-realizing image practices that were first tried out in the first Gulf War, where "laser-guided bombs had nose-cone video cameras," and "pilots and tank commanders became cyborgs inseparable from elaborate visual prostheses that enabled them to see ghostly-green, digitally enhanced images of darkened battlefields" (13). What Mitchell fails to note, however, is that these ghostly-green images permitted actual human beings to see what would have otherwise been invisible. There is a kind of paradox here in the relation of the image technology to the referent: what was dark is illuminated, what could not be seen becomes available to sight. The "de-realization" is only with reference to something like natural human night vision, which would have seen nothing. So is this a loss of reality, or a gain? My sense is that it is both,

6. Mitchell is quoting a *New York Times* photography critic (*Reconfigured Eye*, 17).

and any attempt to confine ourselves to one side of the equation will miss the point of this kind of image technology as a worldly practice.

In that same Gulf War, Mitchell complains that

> there was no Matthew Brady to show us the bodies on the ground, no Robert Capa to confront us with the human reality of a bullet through the head. Instead, the folks back home were fed carefully selected, electronically captured, sometimes digitally processed images of distant and impersonal destruction. Slaughter became a video game: death imitated art. (13)

Of course, at the level of fact, this statement is remarkably selective. There *were* real-time images of Iraqi bodies beamed by satellite from Baghdad after a US "smart bomb" destroyed what turned out to be a civilian structure.[7] There *were* photographs (probably not digital) made of the trail of destruction left by the retreating Iraqi army, massacred in a "turkey shoot" by American bombs and rockets (though their circulation, along with images of US servicemen's coffins, was suppressed). If there was no Robert Capa, there was Peter Arnett on hand to verify the authenticity of the images of dead Iraqi civilians. And one wonders what Mitchell would make of the role of digital photography and video in the US invasion and occupation of Iraq *after* 9-11.[8] The famous Abu Ghraib photographs were all digital. One of the most notorious of them (the stack of naked Iraqi men) was used as a screen-saver image on a computer at Abu Ghraib prison. The digitization of the photos had, so far as I can tell, absolutely no effect on their reception as authentic, realistic depictions of what was going on inside that prison, revealing as well the peculiar attitudes of sadistic enjoyment that characterized the American presence in front of—as well as

7. See my discussion of media practices during the first Gulf War in "From CNN to *JFK*," chapter 13 of *Picture Theory* (1994).

8. It is worth noting that the presence of digital photography has had a major impact on the circulation of realistic images of the war in Iraq. No longer the exclusive purview of professional journalists, photo- and text-blogs from Iraqi civilians and American soldiers are flooding the Internet. And the US military mission made it clear that notions of journalistic professional neutrality would not be honored in this war. The mandatory "embedding" of journalists with military units and the confinement of journalists to military-controlled compounds was only the first stage in the attempt at total media control. Direct violence and incarceration are also favored tactics: sixty-seven journalists were killed in the US war in Iraq, in contrast to the sixty-three killed in ten years of reporting in Vietnam (Salon.com, August 30, 2005).

behind—the camera. Like the American lynching photographs of the early twentieth century, these images were revelations of a structural, social, and political reality that would have remained, but for their existence, at the level of rumor and verbal report.[9] Of course, these images *could* have been manipulated and fabricated to convey false information. And many of them were quite visibly manipulated to erase the faces of the Iraqi victims. An entire Internet industry of fake, staged Abu Ghraib photographs sprang up in the wake of the authentic images. But these images were faked in the pro-filmic scenario, not in the digital processing of them. Their inauthenticity had exactly nothing to do with their status as digital images.

My point, however, is not that digitization is irrelevant, but that its relevance needs to be specified. In the case of the Abu Ghraib photos, the main relevance of digitization is not "adherence to the referent" (which is almost always, in any case, established by documentation and testimonial credentials outside the image itself) but *circulation and dissemination*. If the Abu Ghraib photos had been chemical-based, it would have been very difficult for them to circulate in the way they did. They could not have been copied so readily or transmitted worldwide by e-mail, or posted on websites (not unless they had been scanned and digitized, that is). If Abu Ghraib did not have its heroic star photojournalists to provide a human perspective, it provided something perhaps even more striking and disturbing: a revelation of the inner workings of American military prisons in the gulag outside the law that the Bush administration created as an instrument of its "war on terror," as well as an insight into a different use of photography as an instrument of torture. Above all, the Abu Ghraib photos demonstrated a new role for photography's "being in the world" made possible by digitization. They showed the way in which the rapid, virulent circulation of digitized images gives them a kind of uncontrollable vitality, an ability to migrate across borders, to escape containment and quarantine, to "break out" of whatever boundaries have been established for their control. At a time when actual human bodies are more and more fenced in by actual and virtual borders, fences, checkpoints, and security walls, when those same bodies are subjected to increasingly intensive and intrusive surveillance, the digital image can sometimes operate as a kind of "wild gas" that escapes these restrictions.

It is not so much "adherence to the referent" that is endangered by digital imaging, then, as adherence to a "controlling intention" in the

9. See my discussion of the Abu Ghraib images in *Cloning Terror: The War of Images, 9-11 to the Present* (Chicago: University of Chicago Press, 2011).

production of photographs. Certainly, the intention of the Abu Ghraib photographers was *not* exactly "realized" by their digital circulation. Their intentions (which remain obscure) were more along the lines of creating trophies of sadistic domination in a context where the American inability to contain the Iraqi insurgency was already becoming evident, and to humiliate the subjects of the photographs, perhaps even providing a basis for blackmail to coerce Iraqis to work against the insurgency for US intelligence. (See Seymour Hersh's speculations on this point.[10]) Both of these intentions were frustrated or turned against the producers of the photographs. Their "trophies" became exhibit A in the indictment of the "few bad apples" who were punished for the "abuses."And far from helping to obtain information about the Iraqi insurgency, the photographs fueled resistance and served as instruments of recruitment for the insurgency, and for worldwide terrorist networks.

What can we say, then, about the actual—as opposed to the mythical—meaning of the technical revolution in digital imaging? Are all the intelligent commentators simply mistaken in their portrayals of chemical photograph as inherently realistic and the digital image as inherently open to manipulation and deceit, de-realization, disembodiment, and dehumanization? I think that it is more complicated than a simple mistake, and that these sorts of mythic narratives of loss of authenticity and human meaning need to be stirred into whatever mixture of elements comprises the ontology of photographic images, their "being in the world" of politics, technoscience, and everyday life. The very fact that these stories are somehow compelling, that they become classic or commonplace, is a part (but not the whole) of the ontology of the image.

I want to conclude this chapter by widening the horizon of inquiry beyond photographic images to two more general domains: (1) the level of the "codes" that underlay claims about referentiality and significance in images, especially the opposition between the digital and the analog image, and (2) the analogy between images and life-forms that is drastically enhanced by the quantitative increase in production, reproduction, and circulation of images in the digital world.

William Mitchell's distinction between digital and analog codes is a convenient place to start:

The basic technical distinction between analog (continuous) and digital (discrete) representation is crucial here. Rolling down a ramp is continu-

10. See Hersh, "Torture at Abu Ghraib," *New Yorker* (May 10, 2004).

ous motion, but walking down stairs is a sequence of discrete steps—so you can count the number of steps, but not the number of levels on the ramp. A clock with a spring mechanism that smoothly rotates the hands provides an analog representation of the passage of time, but an electronic watch that displays a succession of numerals provides a digital representation. (4)

While this illustration might seem compelling at first, it quickly deconstructs itself. Rolling down a ramp may be continuous motion, but one can in fact count the number of rolls. Or one can walk down the ramp and count the number of steps one takes. As for walking down stairs: yes, one can count the stairs, but one may *experience* that descent (as my lively nieces and nephews routinely demonstrate) as a kind of flight or free fall. There is a real difference, then, between digital and analog representation, but it is a highly labile and flexible difference, a dialectical relationship, not a rigid binary opposition. It is not, most importantly, an ontological difference, but a difference in representation and perception. The same thing can be scanned, mapped, depicted, described, assessed—in a word, represented—in a digital or analog format. The stairs can be given analog representation; the ramp can be digitized.

The two forms of representation are mutually definitive and complementary. The idea of isolating one of them as somehow self-sufficient is a myth (which is why the very idea of "digital culture" strikes me as such a slovenly and misleading shorthand, even while I recognize the inevitability of its deployment). The analog only has the meaning it does in contrast to some specifiable notion of the digital, and vice versa. And the mutual, reversible translation between the two formats is essential to their practical uses. Digital sound recording, for instance, does not produce a digital output. The analog signal returns the moment the recording is played on speakers driven by an amplifier. Chemical-based newspaper photographs throughout the twentieth century were mechanically digitized to facilitate printing long before the invention of computers. Examine any older newspaper photo with a magnifiying glass and you will find that it is composed, then as now, of a grid of Ben-Day dots, pixels before the pixel. It is the human eye that "resolves" the digitized grid into an analog representation. If digitization is (as Mitchell suggests) a matter of "discrete steps," then everything from mosaic tile to pointillist painting is already digitized. Chemical-based photography itself had to contend with a digital level known as "grain." Anyone who has seen Antonioni's classic film *Blow-Up* (1966) is aware that, at high levels of magnification and en-

largement, chemical-based photographic prints dissolve into an abstract mélange of black-and-white specks.

A better guide to the relation of digital and analog is provided by Nelson Goodman, who insists that we specify the kinds of digits and marks being differentiated, and the codes that govern their combination.[11] The digital/analog relation varies, for instance, depending on what sorts of digits or "discrete elements" are being employed. Letters of the Latin alphabet and Greek numerals are already digital in the sense of being "discrete." Black-and-white tiles assembled to produce a geometric figure that seems alternately to recede and advance are digital elements that are received as analog in perception. A geometric curve that descends the y-axis and extends infinitely along the x-axis is an analog depiction that can be expressed digitally in the expression $y = 1/x$. Sometimes a system of representation can be a compromise between a precise digital quantification and a rather vague, qualitative assessment. Are shoe sizes specified by numerals—8, 9, 10—a "digital" representation, in contrast to T-shirt sizes specified by words: small, medium, large? Digitization need not, in other words, involve binary number systems (1 and 0). It need not even involve numbers but can occur whenever a limited number of unambiguous characters (e.g., red, yellow, green) are deployed to signal unambiguous meanings (stop, caution, go).

The dialectical character of the digital/analog difference is rendered vividly in Chuck Close's paintings, which simulate the look of the digital grid or screen of depiction, but then treat the individual "pixels" or discrete units as objects of individual painterly operations, as if each were a miniature abstract painting. Or, if a more widely known example is desired, consider two scenes from that universal cultural referent, *The Matrix* (1999).[12] In one scene, a character named, appropriately, "Cipher" is watching a computer screen that is awash with a stream of alphanumeric characters. When asked what he's looking at, he says it is the Miss Universe contest, that he is so familiar with the code that it has become transparent to him. He sees right through the numbers and letters to the analog images they represent (just as we "see through" the Ben-Day dots in newspaper photos to the analog images they transmit). The other scene is the moment of revelation of the "digital reality" that underlies the analog "surface" or "illusion" constructed for human beings by the Matrix. When Neo has his moment of revelation, he suddenly sees the deadly agents of the Matrix as what they "really are"—streams of alphanumeric characters

11. Goodman, *The Languages of Art* (Indianapolis: Hackett, 1976).
12. *The Matrix*, dir. Andy and Lana Wachowski (1999).

in a virtual space. But at the very moment of this revelation, we see that the ghost of the analog is returning: the shapes of the agents' bodies are clearly outlined amid the flow of numbers and letters that lie "behind" their corporeal illusion. When sophisticated commentators tell you (as they routinely do) that the "analog" era is behind us, that digitization has destroyed photography, that digital video has destroyed film, and that the image itself has been eliminated by digitization, ask them what they make of this scene. If the Desert of the Real is, in fact, just numbers, then we can take some comfort in the fact that Plato already made this point over two thousand years ago, and he still thought the only moral to be drawn from it was that we had to go on living in this world of shadows, illusions, and images—in short, in the world of the analog.[13]

But still, the mythmakers are not completely mistaken about the digital image. Digitization makes an enormous difference to the role of images in culture, politics, and everyday life, but those differences cannot simply be "read off" their material or technical features. One would expect, for instance, that since digital images can be duplicated with a simple set of keystrokes, the world would be flooded with more copies of these pictures than ever. But my own experience is just the reverse. Digital images (private, amateur pictures, that is) tend to languish unseen on the hard drives of computers or the memories of smartphones, in much the same way that 35-millimeter slides used to remain hidden away in storage boxes or carousels. Printing a digital photograph requires a new set of habits. Should one drop off the memory card at the drugstore the way one did with a film canister? Or should one first optimize and edit the image files in Photoshop, then copy them to a CD-ROM, and then take them to the drugstore? Should one buy a photo printer and print them at home (a process that looks simple until you try formatting the images for smaller sizes like 4 by 6 inches)? Or should one send them to an online service and wait for the prints to arrive in the mail?

The problem here is not that it is difficult to produce a set of prints in the traditional way, but that there are too many ways to do it. The simplest one, dropping off the memory card (or sending the photos to an online service), is complicated by the fact that one knows it would not be difficult to make the prints just a little better by taking time to optimize the images.

13. I recommend here Brian Massumi's superb essay, "On the Superiority of the Analog," in *Parables of the Virtual* (Durham, NC: Duke University Press, 2002), 133–43. See also my discussion of Plato's Allegory of the Cave in *Iconology: Image, Text, Ideology* (Chicago: University of Chicago Press, 1987), 93.

But who has time for that, or even to think about choices like these? My answer, which I suspect is typical, is to defer these decisions for another time, leaving the family photos safely (one hopes) in the digital archives.

Digital photographs have a different life-cycle from chemical-based photographs. They do not necessarily circulate in printed form but remain in a mainly subterranean realm, unseen and mostly forgotten but (thanks to a variety of search mechanisms) available for retrieval much more quickly than printed photos or transparencies. Although it is tempting to call this a "dematerialization" of the image, since it exists only as a data file on a disk somewhere, the fact is that this is also a material existence; the data occupies a real place, and it is subject to material decay just as surely as traditional photographs. William Mitchell claims that a traditional photograph "is fossilized light," and if this metaphor makes sense, then digital photographs are simply the instruments of a more far-reaching paleontology of the image.

Another implication of the fossil metaphor is that images are like dead, dormant, or even extinct life-forms that can be brought back to life by being brought back *into* the light—printed, projected, or screened. And this, I think, is one of the key frameworks for thinking about the larger cultural context of the digital image. These images have achieved technical perfection in the same period that an entirely different class of images has been subjected to an analogous process. I'm thinking here of the reproduction of organisms, biological life-forms, by the process of cloning. Clones are a living, organic version of the digital image, involving a similar relation between an underlying genetic code and a visible, bodily, analog manifestation. And much of the anxiety about digital imaging echoes common phobias about cloning: both processes are accused of replacing a "natural" process with one involving artificial manipulation; both are accused of producing endless copies that threaten the identity of the individual specimen. As Mitchell puts it, "A digital image that is a thousand generations away from the original is indistinguishable in quality from any one of its progenitors" (6).[14] The metaphor of "generations" and "progen-

14. See Lev Manovich's discussion of "Lossy compression" in *The Language of New Media* (Cambridge, MA: MIT Press, 2002) for a technical puncturing of this myth of the perfect copy. A similar problem occurs with the notion of a clone as a perfect copy. Actually, a clone is less similar to its donor or parent than an identical twin because it has generally been gestated in a different womb and matures in a completely different environment, at least one generation after its ancestor. Neither clones nor (printed) digital photographs can be identical twins in this very fundamental sense.

itors" makes clear the biological figure of the perfect, artificial double or twin, in contrast to traditional copying processes that always involve loss of detail variations and natural decay. There is a kind of horrific immortality to the digital image, whether photographic or organismic. And this may explain why the descriptions of digital photographs so often resort to biological metaphors, as if we were beset by a "plague" of images, self-generating, virulent entities that threaten not just traditional photography but also traditional forms of life itself.

One of the most fundamental consequences of the more virulent and volatile "life" produced by the digitization of images is an erosion of the boundaries between the private and public, amateur and professional circulation of photographs.[15] The digital image is not merely a matter of taking a picture with a digital camera and storing it on a disk or printing it out. It is also a matter of circulating it on the Internet via e-mail and other social media. Family albums are now easily transformed into public exhibitions, and even secret photographs (again, Abu Ghraib is the conspicuous example) can circulate globally once they break out of their quarantine.

What does all this say, finally, about the problem of realism in photography or in images more generally? It all depends, obviously, on what you think counts as realism in representation. I think it means that we must untether the problem of realism from the ontology of the medium. Despite Susan Sontag's passionate arguments, there is nothing automatic about realism in photography, nothing encoded in the ontology of the photograph that makes it "adhere to the referent."[16] And realism can mean, in any event, many other things besides adherence to the referent. For one thing, the referent of a photograph has to be stipulated. Is a photograph of my Aunt Mary referring to her? Or to her dress? Her expression on this particular day, and the meaning of an occasion? Is it realistic if she put on her Sunday best to be photographed, so that this image shows her in a way that is somewhat exceptional? And would discussions of the value or quality of this picture be likely to focus on the question of its realism at all? Or would they focus on whether she looked pretty in this picture, looked her best, and what a special day this was? My sense is that in ordinary family photographs, realism is very low on the totem pole of evaluative criteria.

Realism is not "built into" the ontology of any medium as such. Cin-

15. I am grateful to Alan Thomas for pointing this out.
16. In fact, Sontag's *On Photography* (New York: Farrar, Straus & Giroux, 1972) makes an even stronger case for *surrealism* as the net effect of photography in its capacity to alienate the spectator.

ematic realism reveals this perhaps most vividly, since it is a very special project within a medium that, if it has a built-in tendency, would tend toward fantasy and spectacle, not the faithful portrayal of ordinary life. Most people take photographs in order to idealize and commemorate, not to realistically portray something. As for what realism "really is," this is a subject that would take up a lot more space than the confines of this chapter. One can make a photograph that "adheres to the referent" in a quite literal way, by producing a direct transfer contact print. But this guarantees nothing about its realism. Socialist realism, as we know, was anything but. It was a contrived process of ideological idealization of a projected, hoped-for reality, but, as Georg Lukács pointed out, it was not the same thing as what he called "critical realism," a project of objective, historically informed representation built upon an independent point of view "outside" of socialism, a view that necessarily identifies the critical realist as someone who occupies a middle, perhaps even bourgeois, class position.[17] Literary realism, as Northrop Frye pointed out long ago in a similar vein, involves the representation of ordinary people in a "middling" situation, between the Aristotelian categories of "high" subject matter (tragedy and romance) and "low" (comic characters and incidents).[18] "Social realism" of the sort practiced by Allan Sekula tends to fuse Lukács's "critical realism" with an emphasis on the conditions of labor and an interest in exposing to photographic view a world that is overlooked or generally hidden away from public view—all this, however, in tension with his photographs' artistic status, their character as highly crafted and often beautiful objects.

As an example, consider Sekula's photograph (figure 5.1) of a displaced wrench, from his photo essay *Fish Story*.[19] The photograph exemplifies social realism in that it does not stand alone but is part of a whole world that is documented in loving detail, both in other photographs and the accompanying text. It satisfies Frye's notion of low mimetic realism in its emphasis on the world of masculine labor. It is "critical realism" in Lukács's sense in that it is the sort of image that would only occur to an outsider to the world Sekula is documenting. It is safe to say that no sailor aboard a container vessel would be likely to regard this as a picture worth taking. It would be "overlooked" and invisible, not only to the outside

17. *Realism in Our Time* (New York: Harper and Row, 1964).
18. *Anatomy of Criticism* (Princeton, NJ: Princeton University Press, 1957).
19. *Fish Story*, Exhibition Rotterdam (1995), Witte de With Center for Contemporary Art (Düsseldorf: Richter, 1995).

world, but to insiders as well. But in addition to all of this, it is an extraordi-
narily beautiful and haunting image, one that I have never forgotten since
the first time I picked up *Fish Story*. Why? First, it satisfies many of the
aesthetic criteria of abstract formalism, with its simple, bold, geometric
composition and its defiance of perspectival depth in favor of a flatness to
the picture plane that would please a Clement Greenberg. This flatness is
coupled with a high-resolution and high-color saturation, attention to the
materiality of rusting metal, and the sheer beauty of those materials when
they are isolated as a graphic specimen in a high-gloss representation (if
photography has an automatism, it is as much a tendency to aestheticize
and beautify as to adhere to a referent).[20] And finally, what is the "referent"
of this photograph? Is it the wrench? Or the ghostly trace of its displace-
ment that appears just to the right of it? Whatever else this picture refers
to, it clearly refers to the very issue we have been pondering, namely, the
adherence of an image to its referent. The ghostly trace of the displaced
wrench is a kind natural contact print traced in the medium of rusting
metal, very like those solar prints I used to make of leaves on paper in sci-
ence class in elementary school. One would like to know whether the artist
displaced the wrench himself or simply found it this way. Neither answer
would lower my high estimation of the picture, though my assumption
has been that Sekula would, as a matter of a certain realist principle, prob-
ably not have moved the wrench.[21] Either way, the photograph satisfies
another condition of modernist aesthetics, and that is the revelation of
self-consciousness and self-reference in the work of art. It would make
little difference to this meaning of the image if it turned out that it was
made with a digital camera or were projected as a digital slide.

And then, finally, there is scientific realism, which carefully defines
its notion of truth, correspondence, adequation, and information, and
which (given its quantitative basis) is deeply in love with the precision
of digital imaging. Scientific realism, however, is generally at odds with
commonsense realism, which tends to content itself with the realm of an-
alog information, with dense, qualitative impressions filled with random,

20. This is one of the central claims of Susan Sontag's classic book, *On Photog-
raphy* (1972).
21. During the discussion at the University of Leuven conference in September
2005 on "Critical Realism" and the photography of Allan Sekula, it became clear
that he had in fact moved the wrench, not to mention bringing in artificial light
to enhance the photograph's color saturation.

unsystematized detail.[22] Scientific realism, in fact, usually begins by taking issue with common sense, and showing us something that we couldn't see with the naked eye. That is why, obviously, photography (both chemical and digital) plays both sides of the fence with regard to the debate between science and common sense, verifiable truths, testable hypotheses, and the idealizations of desire. And that is why I come to rest, finally, with philosophical realism (as distinct from nominalism), the view that abstract, ideational entities are "real entities" in the real world—more real, in fact, than our confused repertoire of sense impressions and opinions. Truth, Justice, Being, and "the Real" itself (along with geometric concepts, such as the circle, the square, and the triangle) are, for the philosophical realist, the foundations of the real world. But the realism that would get *at* them is not uniquely tethered to any particular medium or its putative "ontology." They are themselves the foundations of ontology, and the media—verbal or visual, material or immaterial—are simply poor instruments for representing them. That is why realism is a project for photography, and for images more generally, not something that belongs to them by nature.

22. This is the form of literary realism that Roland Barthes termed "the reality effect." See *The Rustle of Language*, trans. Richard Howard (Oxford: Blackwell, 1986), 141–48.

6: MIGRATING IMAGES

Totemism, Fetishism, Idolatry

The migration of images is not just a metaphor but also what I call a *metapicture*. That is, it provides a picture of the way images move, circulate, thrive, appear, and disappear. It is a figure that we should examine carefully and, if not flog the metaphor to death, at least make it cry out and explain itself.

What would it mean to talk about images as migrants, as immigrants, as emigrants, or as travelers who arrive and depart, who circulate, pass through, and thus appear and disappear?[1] Or (from their own point of view) who endure the passages and vicissitudes of displacement, constantly seeing the world as a place of estrangement and dislocation? Images regarded as having a native, original, or aboriginal location, or as being foreign and exotic, coming from elsewhere and arriving either bidden or unbidden. Images as the welcomed *Gastarbeiter* on the one hand, or the illegal alien, the unwanted immigrant, on the other. If images are like migrants, do we ask them as they fill out their entry card to check off a box that tells us where they come from and how to classify them? Is the metadata that accompanies the digital image like an identity card, specifying time, place, and location of "birth," production, or first appearance in the world? Could this sort of data be amplified to include the group (genre, referential content) they belong to, the family they come from, their proper or tribal names? Are there racial categories of images, that is, Arab images, African images, Indian and Aboriginal images, white and black images?

It is important at the outset that we differentiate quite firmly between the neutral notion of images *in circulation*, moving freely, circulating basically without consequences, and the concept of *migrating images*, which suggests something much more fraught with contradiction, difficulty, friction, and opposition. The great ethnomusicologist Ry Cooder makes this distinction clear in his rendering of "Migration Blues," a ballad that was written during the Dust Bowl in the 1930s:

1. See Hito Steyerl, "In Defense of the Poor Image," *e-flux* 10 (November 2009) (http://www.e-flux.com/journal/in-defense-of-the-poor-image/).

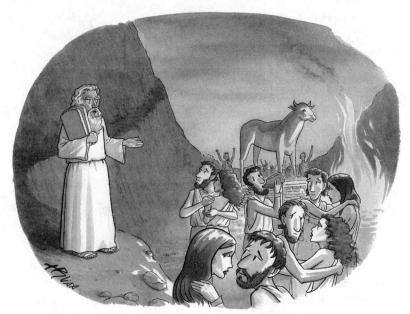

"Well, actually, they are written in stone."

6.1 Harry Bliss, "Well, actually, they are written in stone" (1999). Moses gives the Ten Commandments to the Israelites. *New Yorker* Collection/The Cartoon Bank. © Condé Nast.

> How can you keep on movin'
> unless you migrate too
> They tell you to keep on movin'
> but migrate you must not do
> the only reason for movin' and the reason why I roam
> is to move to a new location and find myself a home.

"Migration Blues" is sung by a migrant who has been told (as they routinely were) to "keep on movin'": don't stop; don't rest here; you don't belong here. The inevitable, logical question then arises: how can you keep on movin' unless you migrate too?

To what extent, then, are images like migrants: homeless, stateless, displaced persons, exiles, or hopeful aspirants to "a new location" where they might find a home? We live in a world in which a growing population is *sans papiers*, without passports, without states, dislocated. Are images like that? Ackbar Abbas has noted how contemporary cinematic images exhibit

not just the effects of hybridity or merging, an easy, frictionless picture of image circulation, but also traces of dislocation—of their origin, of hope for a new destination or home, of the contradiction between those places.[2]

Two contradictory metapictures of images emerge, then, when we consider them as moving, circulating, or migrating entities. The first is of free, unimpeded circulation, a picture that seems especially compelling in the age of virtual and digitized images, moving from one side of the globe to the other in the nearly instantaneous temporality of cyberspace. The other is of images always necessarily arriving and appearing *somewhere*, in some support or material apparatus—a computer screen, a printout, an embodied memory. The distinction between images and pictures (see chapter 2, "Four Fundamental Concepts of Image Science") is grounded in the difference between a disembodied, phantasmatic idea of images as immaterial apparitions, and the inevitable arrival and appearance of an image in a concrete, physical picture, no matter how fleeting. Pictures are the homes where images take up residence, the bodies in which their spirits are incarnated. This is why the language of metempsychosis, of the "transmigration of souls," is so easily adaptable to iconology and art history, where motifs and icons travel across the boundaries between epochs and media. Perhaps this is why museums sometimes seem like displaced-persons camps for images that came from somewhere else, refugees from religion and ritual, castaways from politics and performance. The *salon des refuses* in nineteenth-century Paris became the asylum for art works that could find no home in the Academy, and in the process created a new home for the avant-garde, migrating into new, previously uncharted territories.

All images, then, whether still or moving, are in motion. The only questions are, How fast? How far? From where to where? Still images are best seen as examples of extreme slow motion, so slow in fact that their movements cannot be seen directly but must be inferred from an art historical or iconological reconstruction of their temporal dimensions, or (in certain contemporary art works) prolonged, patient acts of attention. One thinks here of Bill Viola's extreme slow-motion video portraits that seem at a glance to be seventeenth-century oil paintings, or Douglas Gordon's *24 Hour Psycho* (1993), which stretches out the Hitchcock thriller into languorous images in which nothing seems to be happening, or eighteenth-century

2. Abbas, "Building on Disappearance: Hong Kong Architecture and the City," *Public Culture* 6 (1994): 441–59, at 453.

history paintings in which the "pregnant moment" has been displayed to arrest the beholder in front of a passing, ephemeral scene of decision.

Underlying this metapicture of images as migrants is, of course, a more general picture that I tried to capture in my book *What Do Pictures Want?* and that is the notion of images as living organisms driven by desire, appetite, need, demand, and lack. This is a metapicture that goes beyond the personifying metaphor of the image as *person* to the image as *organism.* When we talk of migratory entities, the concept is clearly not restricted to human beings but includes animals, plants, and even microorganisms, such as bacteria and viruses. Nothing is more routine than the notion of quarantining life-forms as well as persons, and it is an annual ritual of the World Health Organization to announce the arrival of unwanted immigrants (Ebola from Africa, SARS and influenza from Asia, etc.).

How seriously are we to take the notion that images are like persons or that they are more generally like living things, organisms that move, circulate, proliferate, reproduce, settle, then move on? What are the limits of the metaphor of a "life of images" and how does it bear on the other crucial question of the "knowledge of images"? It is important, I think, to say two things about the notion of a life of images, the idea that images are something like life-forms. The first is just a matter of my own personal testimony, which is that I don't believe images are alive. As a devout secular materialist, I understand that images are inanimate objects. I'm not an animist, and I do not believe in idols and fetishes—at least I am not aware of harboring such beliefs. The second is that I think it is impossible for us to talk about images for very long without falling into a vitalist metapicture, which involves attributing life to them in notions of autonomy, and in images of migration, circulation, and reproduction. The life of images seems to be an *incorrigible metaphor*, a metaphor that we can't avoid, no matter how firmly we disavow any *literal* application of it.

This leads me, then, to ask what sort of knowledge we *can* have about an entity about which we have these contradictory impulses. When our tendency to fall into the figure of the living image intersects with the epistemological issue, the question of "the knowledge of images," a curious ambiguity arises. We find ourselves not simply asking the question "what do *we* know of images?" but also "what do *images* know?" Are images not just objects of *our* knowledge, but also repositories of *their own*?[3] Is this

3. Jacques Rancière's notion of the "pensive image" would be relevant for consideration here. See his chapter by this title in *The Emancipated Spectator* (New York: Verso, 2014).

what we are looking for when we are interrogating a photograph or a work of art, hoping that it will teach us something, reveal or betray something? Is it what we feel when an image seems to demand something from us, to challenge us with something that exceeds its nameable content? Could it be that we are condemned to a "partial knowledge" of images, in the sense both of what we can know and of what knowledge they carry?

There is no way of knowing at the outset what the limits of this metaphor are, what its "proper" meaning is, what belongs to it as its home territory. In this respect, the metapicture of the living image is itself the quintessential migratory creature in its refusal of borders. We might like to keep it in its proper location—in the realm of primitive superstition, childhood, paranoid delusion—but it is not so easily contained. So we have no choice but to face the question head-on, without prejudging its limits, and to see where it takes us. We need to trace its movements, most especially where those movements are obstructed, and consider the notion of the image as something whose circulation is blocked, that must be kept out, that involves border guards that regulate the circulation of the dangerous or alien image. And perhaps even more fundamental than the idea that images are "out there" trying to gain illegal entry is the notion of the expulsion or destruction of images on their home grounds, the prevention of images from having a chance to migrate at all, the purification of images as "indigenous aliens." This is the most radical form of the destruction of images, the most thorough iconoclasm, and it comes up in biblical texts repeatedly when a kind of ethnic cleansing of images is performed.

A famous passage in the book of Numbers expresses this doctrine most explicitly: "When you cross the Jordan into Canaan, drive out all the inhabitants of the land before you. Destroy all their carved images and their cast idols, and demolish all their high places. Take possession of the land and settle in it, for I have given you the land to possess" (33:52–53). Here the destruction of images is directly linked to the production of immigrants somewhere else, to forced emigration, or what we now call "ethnic cleansing." The removal of images, sacred sites, and persons is all one process. This is a militantly proactive interpretation of the second commandment, as if the commandment were not simply a prohibition on the making of graven images but also a positive mandate to destroy images wherever they may be found—to cleanse the world of these images and of the "inhabitants" for whom they are important signs of identity and belonging to a place.

In their book *Idolatry*, Avishai Margalit and Moshe Halbertal describe the second commandment as a kind of territorial legislation: the mandate against making images and the command to destroy graven images is, they

write, actually an effort to dictate exclusive control of a territory.[4] The destruction of the Baalim, of gods of the place, local deities, the *genius loci*, as the Romans called them, the destruction of the local gods and the objects and images in which they appear—this is not merely a religious mandate; it is also a territorial mandate involving conquest of land and iconoclasm as an instrument of racial purification.[5] Iconoclasm, the prohibition and destruction of idols, is thus the "degree zero" of the migration of images. That is, it figures iconoclasm as extermination or annihilation, as a form of ethnic cleansing, and the destruction of images as a way of controlling a place and conquering a territory.

The conjunction of images and migration, then, inevitably brings up the question of imperialism, and specifically of empires of conquest and territorial expansion. But certain images (idols, most notably) clearly play a very special role in the ideology of settler colonization and native expulsion. I want to place them within a framework that we might call "imperial objectivity," a framework that singles out certain "special" things as "bad objects," or "objects of the other." I'm loosely adapting Melanie Klein's notion of the split "part-object," more precisely "imagos, which are a phantastically distorted picture of the real objects upon which they are based."[6] "Bad objects," then, are not simply bad in some straightforward moral sense. They are objects of ambivalence and anxiety that can as easily be associated with fascination as with aversion.

Bad objects are not, at least to start with, the commodities (e.g., spices, gold, sugar, tobacco) that lure colonial expeditions, nor the symbolic gifts that are exchanged between emperors. (See Tony Cutler on the "empire of things" that passed between the Byzantine and Islamic emperors to impress the recipient with the donor's wealth and refinement.[7]) Bad objects

4. Halbertal and Margalit, *Idolatry* (Cambridge, MA: Harvard University Press, 1998). See also my essay "Idolatry: Nietzsche, Blake, Poussin," in *Idol Anxiety*, ed. Joshua Ellenbogen and Aaron Tugendhaft (Stanford, CA: Stanford University Press, 2011), 56–73.

5. Ibid., 5. See also my article "Holy Landscape: Israel, Palestine, and the American Wilderness," in *Landscape and Power*, 2nd ed. (Chicago: University of Chicago Press, 2002), 261–90.

6. J. La Planche and J. B. Pontalis, *The Language of Psychoanalysis* (London: Hogarth Press, 1973), 188.

7. "The Empire of Things" is an unpublished book manuscript, but some of the essential points are made in Cutler's article "Gifts and Gift Exchange as Aspects of the Byzantine, Arab, and Related Economies," *Dumbarton Oaks Papers* 55 (2001), 247–78.

are, by contrast, objects generally seen as worthless or disgusting from the imperial perspective, but which are understood to be of great and no doubt excessive value to the "native inhabitants," to the aborigines, or to the colonial other.[8] These objects usually have some kind of religious or magical aura and a living, animated character, which is seen from the objective imperial perspective as the product of "merely subjective" and superstitious beliefs. Although these objects are given many different names in the languages of colonized peoples, I want to focus on three categories of objects that have had a remarkably durable life in the history of European imperialism, and that have a further life in imperialism's picture of its own "proper" objects, especially its works of art. I will not have space in this chapter to deal with this thoroughly, but of course the "coming home" of all these objects, especially fetishism—most notably in the Marxist theory of the commodity, the Freudian symptom, and, of course, the modernist work of art—is a big part of the story.

The names of these image-objects, the classes of migratory images, are *fetishes*, *idols*, and *totems*, terms that are often confused with one another or given special meanings in technical discussions—in theology, anthropology, economic theory, psychoanalysis—thing-concepts that are located in terms of disciplinary territories. But to my knowledge, they have never been put together or triangulated as a set of objects and images that resonate with one another or that derive their logic from one another and from their historical position within discourses of imperialism.

These three objects are exactly the sort of things that tend to throw the distinction between "objectivity" and "objectiv*ism*" into crisis. By objectivity, I mean a kind of critical, neutral, dispassionate, rational attitude. Objectivism, by contrast, is the ideological parody of objectivity, when a certainty about your position has been established and cannot be questioned; this is an attitude that is quite alien to the spirit of objectivity, at least in its scientific sense. These objects—fetishes, idols, and totems—are uncanny things that we should be able to dismiss as naïve, superstitious objects of primitive mentalities, but which at the same time awaken a certain suspicion or doubt about the reliability of our own categories. We—and I think I'm speaking here as a white man—know that the voodoo doll impaled with pins cannot *really* hurt us; its power is totally psychological and depends upon the gullibility of a believer, not on any forces in

8. See my essay "The Surplus Value of Images," *Mosaic* 35, no. 3 (September 2002), for more on the over- and underestimation of the image of the other.

the real, objective world. And yet we hesitate to dismiss it outright.[9] The statue of Virgin Mary does not really weep, but the staunchest unbeliever will hesitate to desecrate her image. The child's doll cannot really feel pain, but the wise parent will refrain from abusing or destroying this object out of respect for the child's feelings, knowing also that the child herself will very rapidly tear the magical object to pieces. These benign constructions of the bad object, then, correspond to what D. W. Winnicott called the "transitional objects" of childhood, in the sense of objects of imaginative play that help to unfold cognitive and moral sentiments.[10]

Both the history and logic of empire can be, in a sense, "told" by the triad of the idol, fetish, and totem. Idols correspond to the old territorial form of imperialism that moves by conquest and colonization, physically occupying someone else's lands and either enslaving or displacing the inhabitants. The idol has two quite contradictory functions in this process, depending on whether it is the ideal of the inhabitants or the image of the conquest. On the one hand, it is a territorial marker that is to be erected or eradicated, as with the Baalim of nomadic tribes, a god of the place.[11] On the other hand, it is the figurehead or image that "goes before" the conquering colonizers, the function of images invoked by the Israelites when they urge Aaron to "make us a God to go before us," the image of the Golden Calf that will (it is hoped) take the place of the lost leader, Moses. When the emperor himself plays the role of a god, and his image is circulated in statues and coins (or on television wearing a flight jacket?), he becomes the center of a military cult, and imperial idolatry in its classic, Roman form is achieved.[12]

As symbols or actual incarnations of a god, idols are the most powerful of imperial images, presenting the greatest dangers and making the greatest demands. Idols characteristically want a human sacrifice, and the punishment for idolatry in the Judeo-Christian tradition is death. Not every idolatrous people is, of course, imperialist. In principle, a tiny tribal unit could worship idols, and a family could have its household gods. The consolidation of idolatry into an imperial imaginary comes, I suspect, with

9. See Bruno Latour, "Notes toward an Anthropology of the Iconoclastic Gesture," in *Science in Context* 10 (1997): 63–83, for an excellent account of iconoclastic hesitation in the face of the sacred object.

10. Winnicott, *Playing and Reality* (London: Routledge, 1971).

11. See my discussion of the Baalim as gods of the place or genius loci, in "Holy Landscape," in *Landscape and Power*, 2nd ed., 277.

12. I'm grateful to my colleague Richard Neer for his help with the question of the cult of the Roman emperor.

the rise of monotheism, coupled with sufficient technical resources to give it military force. Either the empire is ruled by a god, a living idol, or, conversely, the empire sets its face against idolatry in all its local forms and makes iconoclasm a central feature of colonial conquest.

Ironically enough, this phase of imperialism corresponds to what the economist Joseph Schumpeter called "an objectless disposition on the part of a state to unlimited forcible expansion." A warrior culture, plus an infinitely voracious, jealous, and bloodthirsty deity who will tolerate "no other gods before him" and demands destruction of all idols, is the formula for empire without limits, empire for the hell of it, a variation that Schumpeter traces from the Assyrians and Egyptians right down to Louis XIV.[13]

Fetishism, as William Pietz has shown, is a much later development, emerging in early modern Europe as a buzzword among the mercantile, seafaring empires, Holland, Portugal, Genoa, and the seventeenth-century phase of the British empire. The word *fetish* comes from the Portuguese and means simply a "made thing" (compare "facture").[14] The typical European attitude toward fetishes is a complex mixture of aversion and fascination. Sometimes they were regarded as native deities, and equated with idols, but more often they were regarded as less important and powerful than idols, and were seen as connected to the private interests of individuals. Fetishes were almost invariably regarded with contempt as crude, inert, smelly, obscene, and basely material objects that could only acquire magical power in an incredibly backward, primitive, and savage mind. A contrast is sometimes drawn between the idol—a relatively refined iconic or imagistic symbol of a deity who lives elsewhere—and the fetish, re-

13. See Schumpeter, *Imperialism and Social Classes* (New York: A. M. Kelley, 1951), 7.
14. Pietz, "The Problem of the Fetish," pts. 1–3, *Res*, no. 9 (Spring 1985), 5–17; no. 13 (Spring 1987), 23–45; and no. 16 (Autumn 1988), 105–23. In contrast to the all-powerful image of the idol, fetishism (or "making fetish") treats the object as a prop in a ritual performance rather than as a freestanding, self-authorizing thing. Compare David Simpson's *Fetishism and Imagination* (Baltimore: Johns Hopkins University Press, 1982) on Herman Melville's descriptions of the fragility and ephemerality of sacred objects in Polynesia, holy one minute, on the trash heap the next. Fetishism, Pietz argues, refers originally to the sacred objects and rituals of West Africa encountered by Portuguese sailors, and fetish objects were used by Africans in a variety of ways: as power objects, talismans, medicinal charms, and commemoration devices to record important events, such as marriages, deaths, and contractual agreements. Fetishism rapidly became a term of art in the African trade, and the trinkets and gadgets that the Europeans brought to Africa also took on the name of fetishes.

garded not as symbolic but as the place of the real presence of the animating spirit; hence fetishism is often equated with crude materialism in contrast to the relative refinement and sophistication of idolatry.[15] Seventeenth-century empires made a distinction between idolatry and fetishism, locating fetishism in Africa and idolatry in Rome and Greece. For the Protestant empires of northern Europe, the idolatry of the savages was readily associated with the Roman Catholic empires, so fetishism immediately became associated with idolatry and the holy crusade against popery, right alongside the missionary effort to stamp out heathen idolatry all over the world. Nevertheless, European traders to Africa found it necessary to tolerate the fetishes, and even to accept their social and cultural currency among the tribes they encountered. Swearing an oath on a fetish object, or driving a nail into a power figure in order to commemorate an agreement, was often the only way to secure a bargain. Given this background in commerce, it seems only appropriate that when Marx looks about for a figure to define the magical character of Western *modern* capitalist commodities, he adopts the fetish-character as the appropriate figure for our rationalized and objective measures of exchange value.

Totems, finally, are the latest in the sequence of objects of the other, emerging in the nineteenth century mainly in the writings of anthropologists in North America and the South Pacific. Less threatening than idols, less offensive than fetishes, totems are generally natural objects or their representations, and they are rarely seen as having godlike powers. They are, rather, "identity" objects associated with tribes or clans, and sometimes with their individual members as tutelary or guardian spirits. The word *totem* comes, as Claude Lévi-Strauss noted, "from the Ojibwa, an Algonquin language of the region to the north of the Great Lakes of North America,"[16] and it is usually translated as equivalent to the expression "he is a relative of mine." Of all the imperial objects, totems are the most benign. While idolatry and fetishism were generally condemned as obscene, demonic belief systems to be stamped out, totemism is usually characterized as a kind of childish naïveté, based in an innocent oneness with nature. Hegel's discussion of the "flower" and "animal" religions in *Phenomenology of Spirit* stresses the harmless character of these early intu-

15. See my essay "The Rhetoric of Iconoclasm," in *Iconology: Image, Text, Ideology* (Chicago: University of Chicago Press, 1987), for more on this distinction.
16. Lévi-Strauss, *Totemism*, trans. Rodney Needham (Boston: Beacon Press, 1963), 18.

itions of spirit in nature. Totem objects, therefore, are rarely the target of iconoclastic fervor. On the contrary, the characteristic imperial attitude to totems is one of curiosity and curatorial solicitude. Totemism represents what Sir James Frazer and others regarded as "the childhood of the human species," and thus it is treated with tolerance and condescension. Frazer, in fact, sent out questionnaires to missionaries, doctors, and government administrators throughout the British empire in order to gather the information for his first book, *Totemism* (1887).[17]

It is crucial to remind ourselves at this point of what is probably obvious: these objects—totems, fetishes, and idols—are anything but objective. They are really objectiv*ist* projections of a kind of collective imperial subject, fantasies about other people, specifically, other people's beliefs about certain kinds of objects. Totemism, fetishism, and idolatry are thus "secondary beliefs,"[18] beliefs about the beliefs of other people, inseparable from (in fact, constitutive of) systems of racial or collective prejudice. They involve quite general notions about the operations of a "savage" or "primitive" mentality: that the natives are invariably gullible and superstitious; that they live in a world of fear and ignorance where these objects compensate for their weakness; and that they lack the ability to make distinctions between animate and inanimate objects—that is, between the living image and whatever is considered to be the dead sign or the dead letter. They are, moreover, firmly held, collective, and official imperial belief systems, axioms within scientific discourses of ethnography and comparative religion, not just private opinions. Beliefs about idolaters—for instance, that they believe the idol hears their prayers and that it will intercede on their behalf and be pleased with their sacrifices—are articles of faith for the iconoclast, held so firmly that they justify the extermination of idolaters as subhuman creatures.

What then, do these premodern migrations of images have to do with our present situation? We have seen in our time two very striking phenomena in global political economy and culture: the first, described in many ways by postcolonial theory but also more recently by Michael Hardt and Antonio Negri's book *Empire*, is the passing of something called im-

17. Sir James Frazer, *Totemism* (Edinburgh: A. & C. Black, 1887); see *The Golden Bough: A New Abridgement from the Second and Third Editions*, ed. Robert Fraser (New York: Oxford University Press, 1994), esp. xlvii, "A Chronology of Sir James George Frazer," for an account of Frazer's methods.
18. See the discussion of secondary beliefs in "The Surplus Value of Images," *What Do Pictures Want?*, chapter 4.

perialism and its replacement by something called the postcolonial condition and the rise of what Hardt and Negri call empire and others call globalization. This process, by whatever name, is undeniably a dominant narrative that we tell ourselves about the present. Whether it is true or not is debatable.

The other phenomenon is the migration of images, the global circulation of images in media and the dematerializing of the image, accompanied by its dialectical contrary, the rise of a new materialism, the obsession with thingness, materiality, and objecthood.

This leads me to what I think of as the essential contradiction of my topic here. On the one hand, we have a world in which we observe everywhere around us the mobility, free migration, and unlimited circulation of images, as if they could pass through walls and leap great distances, instantaneously from one side of the planet to the other. Although they may bear traces of dislocation, they nevertheless circulate with incredible rapidity as if we lived in one world, Marshall McLuhan's "global village." On the other hand, there is the stubborn immobility and recalcitrance of bodies and material things; there is the fact that material commodities still move around the world in container vessels in much the same way they did in 1900.[19] While images and information move incredibly rapidly, we haven't passed beyond the age of the steamship in the sense of the speed of movement of material commodities.

We glimpse this paradox in the universal cinematic myth of our time, *The Matrix* (1999), which shows us a world characterized, at the level of the image, by total mobility, and yet, at the level of the body, by complete immobility—with no one moving anything but their thumbs and fingers, the "digital" world in its physical and literal sense. What does it mean that we live in this world of radical contradiction between the mobility of images and the immobility of things and bodies? Of course, people at academic conferences move around the world, they "circulate," along with their ideas; they are a part of a global elite of intellectuals, but we mustn't think that that is somehow the typical state of bodies on this planet.

Does this mean that the old categories of imperialism—the idolatry to be eradicated, the fetishism to be negotiated, the totemism to be curated—are no longer relevant? Are all images now merely totemic, that is, passing or transitional sites of communal identification? Or have images become

19. See Allan Sekula's *Fish Stories* for a discussion of the unchanging rate of movement of the shipping trade in the last century.

more powerful than ever, and is the deepest meaning of the second commandment only now coming to pass in films like *Clone Wars* (the latest episode of *Star Wars*), where the circulation of images and of actual bodies is identified with the armies of the new empire and the new emperors that rule the world?

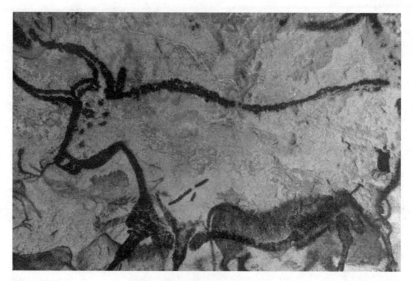

7.1 Anonymous, Lascaux Caves, Perigord, Dordogne, France. Photograph: Art Resource, New York.

7: THE FUTURE OF THE IMAGE

Rancière's Road Not Taken

The following was originally written for a dialogue with Jacques Rancière at Columbia University in the spring of 2008.[1] I am embarrassed to admit that it is only in the last four years, driven largely by my students, that I really became aware of Rancière's late work. I of course knew about his early writings on philosophy and politics, and was dimly conscious of his participation in the events of May 1968 in Paris, and particularly of his break with Louis Althusser over the question of Communist Party control over the workers and students in that momentous period. But Rancière's more recent turn to questions of image theory and aesthetics had eluded me. Like Gottfried Boehm's pathbreaking work in image theory, Rancière's inquiries into the question of the image, its relation to language, and the implications for aesthetics and politics had been conducted as a kind of distant thunder over the horizon of disciplinary and language barriers.

So it was immediately striking to me how many points of commonality there are in our approaches to these questions. We share a belief in the deep imbrication of words and images, and a conviction that their relationship is one of dialectical interchange rather than a strict separation into binary oppositions. This has led us both to investigate relations between literature and the visual arts, and the mixtures of elements that make up forms of media. We came independently to focus on what Rancière calls "the distribution of the sensible" and what I (following Marshall McLuhan) describe as the "ratio of senses and signs" in media. From the earliest moments of my aesthetic research, I had been convinced by William Blake's claim that the function of art is to "cleanse the doors of perception" and to overturn the hierarchies of sensibility, as well as of wealth and power, that separate people into classes. Imagine my excitement when I encountered a philosopher who had adapted the classical economic and political questions of human inequality and found a way to translate them into the unequal distribution of things like the ability or the right to see

1. I am grateful to Akeel Bilgrami, the director of the Columbia University Humanities Institute, for organizing this event.

and hear, to be seen and to speak, to have time and space for thought and movement. My own efforts to unpack the relations of the eye and the ear, vision and voice in the aesthetic and political writings of Edmund Burke, or the territories of literary time and graphic-sculptural space in G. E. Lessing's *Laocoön,* seemed to encounter in Rancière's work the adventure of a kindred spirit.[2] And of course, we are also destined to discover differences of emphasis, method, and sensibility. The following pages are an attempt to register both the commonalities and the differences.

Our assigned topic at the Columbia colloquium was "the future of the image," and our basic task was to unfold our respective positions on this question while stressing the common concerns that bring us together and offering some comments on the differences between our methods and objects of study. I want to begin, then, with a few basic reflections on this question, before turning to an inventory of the topics and questions that resonate for me in Rancière's work, especially his recent book, which provided the title for the colloquium, *The Future of the Image* (2007).

This title, as I'm sure Rancière would agree, is not an especially felicitous translation of his French text, which might be more literally translated as "the destiny of the image." As if conscious of this mistranslation, Rancière opens his book by declining to provide a panoramic survey or "odyssey," "taking us from the Aurorean glory of Lascaux's paintings to the contemporary twilight of a reality devoured by media images and an art doomed to monitors and synthetic images." Instead, he offers reflections on "the labour of art" on the images that provide its raw materials. The nonartistic image is, for Rancière, a simple copy—"what will suffice as a substitute" for whatever it represents.[3]

I want to follow the path that Rancière declines to take, and trace the odyssey from the cavernous gloom of Lascaux to the contemporary twilight of synthetic images. And for the sake of consistency in subject matter, I want to follow this as an *animal* trail that begins with the familiar bison and horses of Lascaux (figure 7.1) and ends with a futuristic image of a futuristic animal, a digital dinosaur from the film *Jurassic Park* (figure 3.1). You might ask why the long journey of the image from the deep, primeval

2. See the chapters on Burke and Lessing in my *Iconology: Image, Text, Ideology* (Chicago: University of Chicago Press, 1987).
3. Rancière, *The Future of the Image,* trans. Gregory Elliot (New York: Verso, 2009), 1. As will become evident in what follows, Rancière's notion of the image as a sufficient substitute is one place where we part company. In my view, the image is never *sufficient* as a substitute, but always slightly "off"—displaying either a deficiency or a surplus, too little or too much.

past to the contemporary moment of virtual, imaginary futures should be exemplified, not by the "image of man," the human fabricator and implied beholder of these images, but by images of animals. What is it about animal images that provides a clue to the entire odyssey of the image and allows us to glimpse the future of the image?

Before I address this question, I want to consider the situations of the images themselves. Among the many speculations about the function of the Lascaux cave paintings is the notion that they were a ritualistic "teaching machine" in which a quasi-Platonic cinema was staged prior to the hunt, in order to familiarize the hunters with their prey, producing a virtual rehearsal that would, by means of an iconic, homeopathic magic, ensure the success of the hunt.[4] No doubt the smoky atmosphere and the ingestion of appropriate stimulants would help to heighten the hallucinogenic, dreamlike atmosphere of the cave, which became a place for using images to project and control an immediate and possible future. Similarly, the scene in *Jurassic Park* is in the control room of the park, which has just been invaded by a real, not imaginary, velociraptor, which has accidentally turned on the film projector showing the park's orientation film. The raptor is caught in the projector beam at the moment when the film is showing the DNA sequence that made it possible to clone a real live dinosaur from its fossilized remains. If we imagine a real bison galloping into the caves of Lascaux and threatening to trample the stoned-out hunters, we would have a Paleolithic version of the effect produced in the projection room of Jurassic Park.

Consider these two images, then, as an allegory of the beginning and end of the odyssey of the image. They exemplify many of our common assumptions about the past and future of this narrative, moving from hand-painted, primitive likenesses that still "suffice to stand in" for the objects they represent, to a highly technical object, a product of high-speed computing and genetic engineering that is then represented filmically by the latest development in the cinematic image, namely, digital animation. Many more contrasts could be elaborated: the image of primitive magic with the technoscientific artifact; the mythic ritual of the deep past and the science fiction narrative of a possible future; and the beast to be pursued in the wild, with the cloned organism to be produced as a theme park attraction.

And yet, the longer we contemplate these two images, the more evident

4. Bertram Lewin, *The Image and the Past* (New York: International Universities Press, 1968).

it becomes that the binary oppositions between past and future, nature and technology, wild and domesticated, and hunting and zookeeping will not stand up to scrutiny. Both images are technical productions, located in quasi-cinematic "control rooms"; both are present objects of visual consumption to be "captured" by their images. Most interesting is the temporal inversion that the two images demand: the image that stands for the past in this pairing turns out to be much younger than the image that represents the future. The digital dinosaur is not, like the Paleolithic bison, an actual existing animal in the present; it is a hybrid scientific-fictional creature, a living, fleshly reanimation of an animal that existed on this planet long before the bison or the primitive artists who painted their images. In this sense, our futuristic animal, if not its image, is much more ancient than the animals depicted in Lascaux. Perhaps the only contrast, then, that really stands up to deconstruction is the most literal natural fact about the objects represented by these images: Lascaux is about herbivores, and Jurassic Park features its carnivores as the main attraction. The positions of predator and prey have been reversed. In the primitive image, it is we who hope to kill the wild object represented; in the contemporary, futuristic image, the artificial object we have created has gone wild and threatens to kill us.

I want to return now to the question with which I began. Why should the odyssey of the image be adumbrated by the animal, and why does the animal image provide such a crucial clue to the future, if not the destiny, of the image? Why, moreover, does the animal image appear at both the beginning and the end, and in the past and the future, of this narrative?

Let us just briefly recall some of the leading arguments about the temporal status of images and imagination, and its intimate association with the animal as a figure of futurity. Animals have, of course, been associated since time immemorial with divination, augury, and prophecy. If there is a future to be predicted, about images or about anything else, it is adumbrated by the image or the reality of the animal. Whatever is done to animals will, as John Berger noted, predictably be done to human beings in the future: domestication, enslavement, the mass industrialization of death, extermination, and extinction are all tried out on animals before they are used on human beings, who are thus reduced to the status of animals.[5] Experiments are conducted on animals in order to predict what their effects will be on the human organism. And most notably, the cloning

5. See Berger, "Why We Look at Animals," in *About Looking* (New York: Pantheon, 1980), 11.

of animals (sheep, mice, frogs, and horses) is widely understood to be a prelude to the cloning of human beings, either as superhuman creatures, cleansed of all birth defects, or as subhuman organ donors and cannon fodder in the "cloned armies" envisioned by the *Star Wars* saga.

We should also recall here John Berger's claim that "the first subject matter for painting was animal. Probably the first paint was animal blood. Prior to that, it is not unreasonable to assume [as Rousseau did as well] that the first metaphor was animal."[6] There is the biblical creation myth, in which the animals precede the fabrication of the human image from clay. There are Jacques Derrida's playful conjurings with the early form of writing known as "zoographia" (1974) and with the image of the animal as that which the human "follows" (2002), in the sense of "coming after," in the odyssey of evolution as well as predatorlike pursuit.[7] There is, more ominously, the ur-narrative of idolatry, the production of an animal image that serves as an idol, designed (as the Israelites specify) to "go before" them in their quest for the Promised Land.[8] The image of the Golden Calf is "what will suffice as a substitute" (to echo Rancière) for the lost leader, Moses, who promises to lead the Hebrews into the promised future, at the same time that it is immediately denounced by Moses as a return to the past of Egyptian captivity and idolatry.

The temporality of the animal image, then, embraces both past and future, both what precedes the human and what leads it on or "goes before us," to a time to come, either in a narrative of a return to a utopian Eden, where human nature finally achieves its potential, or in a return (via the "worship of brutes") to the nasty, brutish, and short existence of *zoe* rather than *bios*.[9] This is why the specific genre of the animal image

6. Berger, 5.

7. Derrida, *Of Grammatology*, trans. Gayatri Spivak (Baltimore: Johns Hopkins Press, 1976), on zoographia or "animal writing," 292. See also "The Animal That Therefore I Am (More to Follow)," trans. David Wills, *Critical Inquiry* 28, no. 2 (Winter 2002): 369–419.

8. "And when the people saw that Moses delayed to come down out of the mount, the people gathered themselves together unto Aaron, and said unto him, Up, make us gods, which shall go before us" (Exodus 32:1, KJV). This scene, so often denounced as the prime example of idolatry, might also be read as a good example of populist democracy in action, with "the people" self-consciously commissioning a visible sign of their sacred unity as a nation.

9. I am echoing here Giorgio Agamben's distinction between "qualified life" (*bios*) and "bare life" (*zoe*), in *Homo Sacer:Sovereign Power and Bare Life*, trans. Daniel Heller-Roazen (Stanford, CA: Stanford University Press, 1998).

is so crucial to understanding the question of the future of the image as a general concept, and beyond that, the entire question of the temporality of the image. The image as such always engages temporality, either as the memory of a lost past to be recalled and re-presented as the perceived present of a "real-time" representation—such as a shadow, a reflection, a dramatic performance, or a "live" telecast—or as the imagination of a hoped-for or dreaded future. When we talk about the "future of the image," then, we have to notice that we are conjuring with a double image or "metapicture": the image of an image *to come*. An image of what has not yet arrived but is on the horizon, like the "rough beast" William Butler Yeats spied slouching toward Bethlehem in his poem "The Second Coming." Thus, the future of the image is always *now*, in the latest and newest form of the image, whether it is the marvelous apparitions of Lascaux or the contemporary technological realization of the ancient dream of producing not just a "lifelike" image of a living thing, but an image that is simultaneously a copy, a reproduction, and itself a living thing.

In our correspondence leading up to our colloquium, Jacques Rancière rightly identified this element of my approach to images as a kind of vitalism, and contrasted it to his own emphasis on "artistic operations" that "produce beings whose appeal relies precisely on the fact that they do nothing and want nothing."[10] He calls this a "difference of sensibility," and no doubt it stems from a difference of formation. As a boy raised in the Catholic church, I was unquestionably indoctrinated with the whole repertoire of animated images, from the poetics of the eucharist to the icons and relics of saints, to the figure of the human as itself an *imago dei*. I sense in Rancière's remark a deep skepticism about the notion of a "life of images." In fact, I share this skepticism, even as I indulge in its opposite, a "willing suspension of disbelief" in animist and vitalist accounts of the image. In *What Do Pictures Want?* (2005), I even suggested that one way of describing the ultimate goal of the labor of art on images might be to produce a picture that wanted nothing at all, producing a kind of aesthetic utopia beyond desire, a field of play and (in Rancière's terms) an emancipatory "re-distribution of the sensible."

But what could account for Rancière's suspicion of a vitalist approach to the image? The closest I can come to a diagnosis is in the concluding

10. E-mail message, April 8, 2008. See also Rancière's essay "Do Pictures Really Want to Live?" in *The Pictorial Turn*, ed. Neal Curtis (New York: Routledge, 2010), 27–36.

pages of his essay "The Future of the Image," in the book by that title.[11] In his survey of "the images exhibited in our museums and galleries today," Rancière identifies three major categories: (1) the "naked image," exemplified by Holocaust photographs and other images of abjection and atrocity, which "excludes the prestige of dissemblance" associated with the "labour of art" (this kind of image demands, I take it, an ethical and political rather than an aesthetic response); (2) the "ostensive image," which insists on "its power as sheer presence" and employs aesthetic means to produce an effect modeled on that of the religious icon; and (3) the "metaphoric image," which engages in critical "play with the forms and products of imagery," that cuts across the boundaries between artistic and nonartistic images in a "double metamorphosis" that makes meaningful images "into opaque, stupid images," thus "interrupting the media flow," on the one hand, and, on the other, "reviving dulled utilitarian objects . . . so as to create the power of a shared history contained in them." The principal examples of the metaphoric image come from installation art and from the montage of Godard, especially his encyclopedic and poetic film *Histoire(s) du cinema* (1997–1998).

Two things strike me about Rancière's "three ways of sealing or refusing the relationship between art and image" (26). The first is, as he notes, that "each of them encounters a point of undecidability . . . that compels it to borrow something from the others." Even the anti-artistic "dehumanization" presented by the "naked image" strays into the aesthetic "because we see it with eyes that have already contemplated Rembrandt's skinned ox . . . and equated the power of art with obliteration of the boundaries between the human and the inhuman, the living and the dead, the animal and the mineral" (27).

The second thing that strikes one is that these results of the operations of art can hardly be said to produce objects that "do nothing and want nothing." The language of power, desire, and vitalism runs throughout Rancière's own descriptions of these categories: the naked image (already a personification) refuses the separation of art and life; the ostensive brings its images to life in the manner of sacred icons; and the metaphoric produces "metamorphoses." My best guess is that Rancière is citing this way of talking, which is certainly common in contemporary discussions of art, without endorsing it. Indeed, if we pursued this question back into earlier periods of art history, we would find the language of life, if not of vitalism, everywhere. Rancière himself traces the genealogy of the mod-

11. *Future of the Image*, 22–30.

ern ostensive image back to "Manet's dead Christ" with his "eyes open," an image that causes "the dead Christ" to come "back to life in the pure immanence of pictorial presence" (29). And the discourse of ancient and early modern art is riddled with variations on the imperative to produce "lifelike" images.

Perhaps Rancière wants to see the "labour of art" on images as a way of calming their incorrigible tendency to take on lives of their own, their habit of behaving like viruses that spread and mutate faster than our immune systems can evolve to fight them off. An art that would "produce beings whose appeal relies precisely on the fact that they do nothing and want nothing" is perhaps a strategy of demystification, a cure for the "plague of images," including the fetishism of commodities and the idolatry of the spectacle.[12] It would be a concept of art that not only worked against the vitalist and animist tendencies within aesthetic discourse, but also resisted those parallel narratives drawn from religion, magic, and science that conjure with the notion of a *literally* living image, from the creation

12. Here it may be worth recalling Walter Benjamin's 1919–1920 essay "Categories of Aesthetics," in which, as Judith Butler argues, he distinguishes the seductive, living "semblance" or mythic sign from the magical "mark." As Butler puts it, 'To the extent that a work of art is living, it becomes semblance, but as semblance it loses its status as a work of art for Benjamin. The task of the work of art, at least at this point in Benjamin's career, is precisely to break through this semblance or, indeed, to petrify and still its life. Only through a certain violence against life is the work of art constituted, and so it is only through a certain violence that we might be able to see its organizing principle and hence, what is true about the work of art" (68). See Butler, "Beyond Seduction and Morality: Benjamin's Early Aesthetics," in *The Life and Death of Images*, ed. Diarmud Costello and Dominic Willsdon (London: Tate Publishing, 2008), 63–81. I would reformulate the issue as follows: insofar as an image takes on the properties of a life-form, it becomes necessary to ask what sort of life it manifests. Is it a kind of viral, infectious life? An inhuman, or parahuman mimicry of life, on a scale reaching from the cancer cell to the higher primates? We might then be in a position to examine the work—or, more precisely—the "labour" of art on such an image, which might take as many forms as the varieties of life it encounters, from the cellular level of immunization and antibody, to conjuring with the aid of the totemic animal, the image of animism. The point might then be that the work of art is not so much to *kill* the living image as to *still* it, to put it in a state of suspended animation. See my discussion of the logical permutations of the living image in *What Do Pictures Want? On the Lives and Loves of Images* (Chicago: University of Chicago Press, 2005), where I posit three contraries to the notion of the "living" object: the dead, the inanimate, and the *undead* (54).

of Adam out of the inert clay of the ground, to the medieval Jewish *golem*, to the myth of Frankenstein's monster, to the robots and cyborgs of the twentieth century. The twenty-first-century version of the living image is the clone, which is not merely the literalization of the living image but also its actual, scientific realization, at least at the level of the animal. The human clone has yet to make its appearance, except in scores of Hollywood movies and in ominous works of art, such as Paul McCarthy's *The Clone*, which portrays it as the anonymous, hooded figure of the organ donor, an image that has been in circulation at least since Jean Baudrillard's (2000) reflections on what he called the "acephalic clone." In a variety of guises, from Abu Ghraib's famous "Hooded Man" to Hans Haacke's *Star Gazing* (featuring a hood made out of the American flag), this hooded, faceless figure has become the contemporary icon of "facingness" that Rancière associates with the contemporary "obtuse image."

If there is common ground between Rancière and me, then, it is perhaps located in a certain ambivalence about the concept of the living image and the vitalist discourse of iconology and art history. We both want to resist it, but I also want to explore it, to see where it leads, following (with Roland Barthes) a thread into the center of the labyrinth of images, where the Minotaur (half man, half bull) is waiting. This entails a certain yielding to the spell of images, artistic or not. Rancière and I share an aversion to the fundamental assumption of iconoclasm, that an image can be destroyed. Images, in my view, can neither be created nor destroyed. The attempt to destroy or kill an image only makes it more powerful and virulent.[13] This, among other things, is why "iconoclastic,", destructive criticism wins such easy victories over bad images. I prefer the Nietzschean strategy with idols: strike them with a hammer, not to destroy them, but to make them ring and divulge their resonant hollowness. Even better, we should play the idols with a tuning fork so the sound of the image is transmitted to the hand and the ear of the beholder.[14]

Rancière and I clearly share a fascination with the relation of literature and the visual arts, but I think we see the flow of influence and agency going in opposite directions. I get the sense that he regards literature, especially the realist novel, as producing a new "distribution of the sensible" that precedes and determines the devices of film narrative. His remarks on media and the absolute independence of the image from medium specific-

13. For a brilliant treatment of this point, see Michael Taussig, *Defacement: Public Secrecy and the Labor of the Negative* (Stanford, CA: Stanford University Press, 1999).
14. Nietzsche, *Twilight of the Idols* (New York: Oxford University Press, 1998), 3.

ity will scandalize media theorists, but they make the crucial point. An image is a configuration or convergence of what Foucault called "the seeable and the sayable."[15] The Golden Calf appears in both text and image, circulating across the media of sculpture, painting, and verbal narrative. Every image is really an "image/text," or a "sentence image," as Rancière would put it. The question is: which term takes priority, and in what sense? For Rancière, it is the word; for me, the image. Rancière believes that Dutch painting became "visible" in a new and modern way in the nineteenth century, that something became seeable in these paintings as a result of a new discourse, principally Hegelian. My sense is that something was in the painting, waiting to be described in a new way, waiting for language to catch up with a compelling picture. In that sense, the image (as always) goes before the word, foreshadowing the future if only we knew how to read it. It is the older sign, the archaic sign, the "first" sign, as C. S. Peirce would put it. That is why images not only "have" a future related to technology and social change, but *are* the future, seen through a glass darkly.

I want to conclude with a concrete example of a work of art that explores another area of common ground between Rancière's and my approaches, and that is the relation of aesthetics and politics. Mark Wallinger's marvelous installation *State Britain* is a work that crosses the line between art and politics in the most literal way possible. Wallinger and his collective fabricated handmade replicas of propaganda posters that had been removed by the police from Parliament Square (and subsequently destroyed) as a result of a new law prohibiting political demonstrations within a one-mile radius of Parliament. Wallinger had noted that the circumference of this circle passed right through the central hall of Tate Britain, and so he installed the posters to straddle this line in defiance of the law.

The effect of this work is, however, deeply disturbing to a vitalist like me. The removal of the images from their proper location has the effect of anesthetizing them, putting the whole thing in a kind of trance or cryogenic sleep. There is something haunting and melancholy about this displacement, as if the function of Tate Britain is now to serve as a mausoleum for the forlorn relics of British liberty.

So I would prefer to conclude with a living image, a recent work of art at Tate Modern by Tania Bruguera that brought two mounted policemen onto the bridge across the turbine hall, where they proceeded to herd the audience about, demonstrating their crowd-control techniques.[16] Why do

15. Foucault, *This Is Not a Pipe*.
16. Tania Bruguera, *Tatlin's Whispers #5* (2008).

I call this an image when the artist declares that her intention was to resist the image as a distancing operation, a separation of the viewer from what is beheld? Because it is an awakening and enlivening of an image that has been "anesthetized" in its media circulation by being dislocated "from TV to real life" (as Bruguera puts it). Or better, a *place* between TV and real life: the space of Tate Modern and the regime of the aesthetic image. Although Bruguera wanted the audience "not to know" that this was art, she knew that they *had* to know, at least in the sense that they were prepared to see this, not as a serious police action, but as an artistic event. They understood it as a picture, a representation, but one that they had entered as an environment. In the background, we see that people are already taking pictures.

As with the Wallinger, I find it difficult to specify the precise effect of this piece. It shares with *State Britain* a staging of the encounter between police power and the primal source of the authentically political, the gathering of people who may or may not resist the power that controls their lives. Neither Wallinger nor Bruguera are engaged in what might be called "directly political" protest art, or agitprop. They are instead removing that kind of art and action to a space of contemplation. They could be interpreted, then, as engaging in mourning for a time of revolutionary resistance and dissent that is no longer available, or in a redistributing of our sense of where the proper boundaries of art and life, aesthetics and politics, are located (the title of Bruguera's piece is *Tatlin's Whispers*, a sotto voce evocation of revolutionary monumentalism). The aesthetic regime is now a shelter for an endangered, vanishing sense of the political, and perhaps a Petri dish for nurturing it back to life. Tate Britain is hospitable to images that are refugees from their proper home in Parliament Square; the mounted police are benign and well behaved in the Tate Modern, the horses well trained, good shepherds to the sheep they are herding. This may not be directly political or revolutionary art but rather, to use Bruguera's phrase, "useful art"—useful for making one of the most common images of public space today available to experience in a new way. It is also an image of an increasingly probable future in social spaces marked, not by fixed, legislated "police lines," but by flexible, animated boundaries, like the "flying checkpoints" that spring up unpredictably all over the countryside of the occupied Palestinian territories. This, therefore, is one "future of the image" that is already upon us.

Finally, in discussion of the future of the image, especially its political future, it would seem strange not to mention the emergence of a new political and cultural icon that has marked the onset of a new political epoch

in our time, signaling the close, not just of a political administration, but perhaps the whole "age of terror" and the "war on terror" that dominated the world from 2001 to 2008—the era of the Bush administration.

I'm speaking, of course, of Barack Obama and the remarkable iconography that has evolved around his face, his body, and even his family. The omnipresent "Hope" poster by Shepard Fairey deploys techniques familiar from the history of propaganda: a solarized photographic image, reduced to areas of primary colors (red, white, and blue), coupled with a simple verbal slogan. The stylistic similarity to Soviet-era posters of Lenin was mobilized within days of Obama's election (in a blog by Peggy Shapiro in the *American Thinker*) to reinforce the right-wing labeling of Obama as a socialist, maybe even a communist.[17] I doubt very much that this "guilt by association" will work any better than did the imagistic attempts to link Obama with the so-called terrorist Bill Ayers. It will be overwhelmed, at least for the time being, by images like the postelection cover of *Time* magazine, which Photoshops Obama into the famous iconography of an ebullient Franklin Roosevelt riding in the back of a convertible on inauguration day. The historical comparison with FDR's image will, I think, have more legs than the Lenin poster, if only for the prosaic reason that Obama took power in a democratic election, not a violent revolution or military coup, and did so at the moment of the worst financial crisis since the Great Depression, the "Great Recession" of 2008. In contrast to George W. Bush, for instance, who exploited the national tragedy of 9-11 to fuel "fear itself" and declared an endless war on terror as the justification for a state of emergency and unprecedented executive powers, Obama has taken power with a message of hope and the unambiguous support of the voters. Bush's most famous effort to enhance his image is the famous "Mission Accomplished" photo-op, when he appeared in jet-pilot drag to declare victory in Iraq.

But another reason the guilt by association strategy will not work is that the public has been educated and immunized to this sort of image-tactic over the yearlong war of images that has punctuated every stage of the presidential campaign. One notable moment of immunization was July 21, 2008, when the *New Yorker* released a cover portraying Barack Obama as a Muslim and Michelle Obama as an Angela Davis–style revolutionary, complete with Afro hairdo and an AK-47.

Most of my leftist friends were horrified by this image, but I welcomed it

17. See www.americanthinker.com/blog/2008/04/obamas_posters_message_in _the.html (accessed 30 April 2009).

as a kind of iconographic immunization, a measured dose of the image viruses circulating in the mediasphere. It had the effect of rendering visible and manifestly ridiculous the sly innuendos of right-wing propaganda. Some images (like Bush as a jet pilot) gain their power by only being half visible and easily disavowed, avoiding direct manifestation. To me, it was clear that the joke in this image was *not* on the Obamas but on the idiots who believe in this sort of slander, *and* on left-wing critics who think that most American citizens are idiots who cannot be trusted to discern irony and satire. The joke was aimed, most specifically, at Fox News and their coy speculations about whether the gesture exchanged by Michelle and Barack on his winning the nomination was a "terrorist fist-pump."

The *New Yorker* was well aware, I suspect, that its intentions would be misconstrued, that it would outrage its own liberal, politically correct, sophisticated readers. In effect, the magazine offered itself up as a substitute victim for the Obamas, by making its own elitist Knickerbocker avatar into a punching bag for its readers, as the cartoonist for the *Nation* magazine immediately saw, when he parodied the *New Yorker* by showing the Knickerbocker knocked to the floor, and the offending magazine burning in the fireplace as the Obamas celebrate their victory in round number one. The *New Yorker* foresaw the future of its own image, inviting and welcoming it. One cannot say the same thing about the evolutionary mutation of Bush's "Mission Accomplished" photo-op, which quickly degenerated into an image of puerile phoniness and false promises that haunted his presidency right down to its ignominious conclusion. Or the despicable cartoon in the *New York Post* (February 18, 2009) that showed two police officers standing over a bullet-riddled ape, who is characterized as the author of the Obama economic stimulus bill, an image that returns us to the domain of the animal, this time as an avatar of past, present, and future images of racism.

Of course, the *Post* cartoonist, Sean Delonas, and the publisher, Rupert Murdoch, vehemently denied any racist intentions. Apparently they didn't know that black people have been caricatured as apes since time immemorial, or that the actual author of the stimulus bill is also the nation's first African American president, or that this image joins the growing gallery of images that predict the assassination of this president. These people must come from a planet where animals do not exist, and where their images do not predict or produce the possible futures of human beings.

8.1 William Blake, *The Book of Urizen* (1794), plate 17. Lessing J. Rosenwald Collection, Library of Congress. © 2015 William Blake Archive. Used with permission.

8: WORLD PICTURES

Globalization and Visual Culture[1]

Fellow Labourers! The Great Vintage & Harvest is now upon Earth
The whole extent of the Globe is explored: Every scattered Atom
Of Human Intellect is now flocking to the sound of the Trumpet.

WILLIAM BLAKE, *Milton: A Poem* (1803)

I have to confess that I find the very idea of "globalization" somewhat intimidating. There is something overwhelming about the concept itself, as if it had become synonymous with totality and universality. And then there is the scope and variety of the numerous disciplines and bottomless archives that are mustered to describe it, as well as the objective reality it claims to describe. There is no doubt that, in our time, an intensified, accelerated process of "worlding" and what Jacques Derrida called "mondialization" has taken place. The forces of media, capital, and culture swirl about us like massive storms of images. We know more about the world now than ever before, just as it seems to be more than ever escaping our comprehension, much less control. Edward Said could call for a *worldly*— that is, a secular and cosmopolitan criticism—at the same time that he recognized the undeniable fact that the twenty-first-century world is descending into religious wars motivated largely by perceived violations of sacred spaces and places. Globalism and localism seem, in this light, not really alternatives but contradictions that grow out of one another—as if the very idea of the local had been generated by the global. It is this paradox in the concept of the global that I would like to ponder—the emergence of a "world picture" that has become incredibly clear, realistic, and information-saturated (every inch of the world has now been scanned and is searchable), at the same time that it seems to be facing a growing crisis that can only be described as apocalyptic. Projections of a catastrophic

1. This chapter was written as the keynote address for the Conference on Globalization and Cultural Translation, Tsinghua University, Beijing (August 13, 2006). Many thanks to Professor Wang Ning for organizing this memorable occasion.

future are no longer the province of Hollywood; now it is the domain of realistic documentary, based in empirical research, archival work, and punctuated by the mass media spectacles of disaster—tsunami, hurricane, plague, and (last but not least) war.

There is a temptation to indulge in presentist thinking at a time when apocalyptic predictions are made on every side. That is why I began by quoting the words of William Blake, who expressed very similar sentiments more than two hundred years ago in a time of war, revolution, and counterrevolution. Of all the English poets and painters, Blake probably had the most vivid sense of what was entailed in the image of the globe and globalization, which plays a major role in both his words and his images. Blake's work was situated in the transition period from the first, mercantilist phase of the British empire to its second phase of colonization and conquest. We occupy a similar transitional moment, from the breakup of the European empires, commonly known as the "postcolonial" period, to a new historical formation after the fall of the Soviet Union that is called globalization, neoliberal hegemony, or (in the words of Michael Hardt and Antonio Negri) simply "Empire."[2]

So Blake, the prophet against empire, seems especially apt at this time. I invoke his work, not to deny the novelty of globalization in our time, but to place that novelty in a larger framework, one that attends to the *longue durée* of globalizing processes, and to the history of the central image of "the global" as such. So much has been written about globalization that the term has become overfamiliar, an unexamined cliché. When this topic has been scrutinized from the standpoint of visual culture, media, and image theory, the general tendency has been to talk about the global *distribution* of images, their circulation in forms of mass media such as cinema, television, advertising, and the Internet. My approach is somewhat different, emphasizing not the "world circulation" of images but images *of* the world and the global as such. I want to pay special attention to what Heidegger called "world pictures," the metaphors, figures, and pictures that constitute discourses of globalization, ancient, modern, and postmodern. We need to begin, then, by asking ourselves: How do we imagine, depict, or *know* the global?

First, we might enumerate some of ways that we *name* the global, starting with the figure of the "globe" or "sphere" as such, and going on to terms like the planet and the planetary, the cosmos and the cosmopolitan,

2. Hardt and Negri, *Empire* (Cambridge, MA: Harvard University Press, 2001).

the world and worldliness, and, finally, the earth, which doubles as the name of the planet, the global, and as the concrete ground on which we stand, or into which we burrow.

1. The OED tells us that the Latin word *globus* designates "a round body or mass; a ball, sphere, etc." The Middle English *glob(be)*, *glub(be)*, GLUB, is used by Wyclif (in the first English Bible) to render the Latin word *globus* in the sense "body of men." So the name condenses the singular and multiple object in the same way that "body" can denote an individual or a collective. The contemporary idea of globalization is probably traceable to Marshall McLuhan's image of the global village produced by instantaneous electronic communication. McLuhan's catachresis of the large and small captures the fundamental point of the global as a figure of the concrete universal, the gigantic miniature. The globe is both the model or map, and the thing that is mapped and circumnavigated. It is the object that holds us in its gravitational field, while also appearing as a handheld object, as in the images of Christ (or the Christian emperor) as *salvator mundi*, cradling the Christianized world as a crystalline sphere in his hand. When the weight of the world grows (as it does for us today), the world may seem to crush the body that supports it, as in the famous emblems of Atlas holding up the globe. Spherical models of the universe predate the early modern navigation of the globe, as the ancient doctrine of the music of the spheres attests. If "the earth was without form and void" in the biblical account of creation, it was easy to predict that the first created form would be the simplest, a Platonic object like a sphere or globe. Hence the rendering of creation as the inscription of a sphere in space, as in William Blake's depiction of the creator as Jehovah-Urizen with his compasses, as a Vulcan-figure contemplating his fiery work, or (in a more radically original image) as a demiurge giving birth to a gigantic womb or "globe of blood."

Figures 8.1, 8.2, and 8.3 capture three major ways of thinking the global, three "aspects," as Wittgenstein would have put it, or ways of "seeing as":

A. As a geometric, measurable construction, whether in terms of physical space or mappable, calculable quantities, from geographical regions, topographies, and routes, to "flows" of capital, populations, and transitory cultural and atmospheric conditions—the passing weather of the mediasphere or the meteorological sphere. In the terms of Henri Lefebvre's classic discussion, *The Production of Space,* this is the designed, adminis-

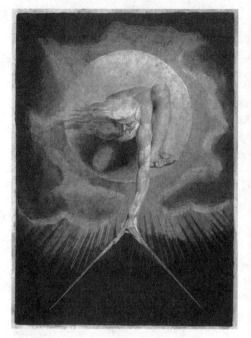 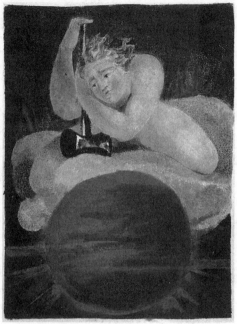

8.2 William Blake, frontispiece to *Europe: A Prophecy* (1794). Lessing J. Rosenwald Collection, Library of Congress. © 2015 William Blake Archive. Used with permission.

8.3 William Blake, *The Song of Los* (1795). Lessing J. Rosenwald Collection, Library of Congress. © 2015 William Blake Archive. Used with permission.

tered, "represented" space of the architect, urban planner, and landscapist (figure 8.2).[3]

B. As a produced, made object, an artifice involving materials and technology, the "man-made" worlds of physical models, the virtual worlds of digital technology, or the shaped, physical features of cultivation, urbanization, and planetary deformation, from Chinese walls to dikes and dams to global climactic effects (global warming, most notably). This corresponds to Lefebvre's notion of "practiced" space, the built environment of the engineer, the ploughman, or the worker (figure 8.3).

C. As a *reproduced* organic form, seen simultaneously as an organism and as the environment inhabited by that organism (figure 8.1). Thus, this final image can be read as a kind of embryonic form nourished by a placental network of veins and fibers descending from the body of its progenitor.

3. Lefebvre, *The Production of Space* (London: Wiley-Blackwell, 1982).

The globe is thus, as environment, a kind of womb in which life-forms are gestating, or a biomedial[4] "culture" like a Petri dish. As a singular *body*, on the other hand, it is the *globus* or "collective body," as in the "body politic" of a nation; only in this case the political unity is that of *species* being, the "body of humanity" as such. This organic image of the global is surely the most fantastic and far-reaching in its implications. Globalization, in this view, becomes a totalizing biopicture of a "life-world" rendered in the most literal, corporeal terms, as if we were observing a spectacle of a birth-trauma, a multistable image of wounding and bleeding, reproduction, nourishing, and parturition. This corresponds to Lefebvre's perceived or "secreted" space, the world as an embryonic and evolutionary eco-system.

2. *Planet.* The word *planet* comes from the ancient Greek for "wanderer," applied to wandering stars, planets (cf. classical Latin *stellae errant*—to lead astray, [in passive] to wander, of uncertain origin), as opposed to the "fixed stars," which guarantee a sense of cosmic order, harmony in the spherical structure of the cosmos. When the globe is seen within a larger framework, the wider perspective of astronomy, from the standpoint of the sun or Uranus, it becomes the wanderer through space, a "globe rolling through voidness," as Blake describes it. From this standpoint, the world becomes "a grain of sand" or a fragile island in the Sea of Time and Space, and the nomadism and fluid errancy sometimes attributed to globalization is applied to the globe itself. All three of Blake's images of the globe render it as a planet still tethered to its creator: by surveillance, mapping, and modeling; by productive activity and artifice; or by bodily, biological dependence. But all of these images suggest as well a moment of distancing, detachment, and parturition, as if at some point the globe, the totality of the human life-world, comes to recognize its autonomous "island" status, its unique, rare status in a mainly lifeless universe. The moment of the first astronauts' perception of the world from outer space is certainly a key moment in the planetary reframing of the global.

3. *Cosmos.* "The greater World is called Cosmos from the beauty thereof," according to *Humboldt's Cosmos* I.53 (1848). It is "the assemblage of all things in heaven and earth, the universality of created things, constitut-

4. On the concept of "biomedia," see Eugene Thacker in *Critical Terms for Media Studies*, ed. W. J. T. Mitchell and Mark B. N. Hansen (Chicago: University of Chicago Press, 2010).

ing the perceptible world." Humboldt continues: "The Pythagoreans conceived the Kosmos, or the universe, as one single system, generated out of numbers" (a view that undermines Heidegger's notion that the Greeks had no world picture). Perhaps this explains why the "cosmopolitan" figure often stands outside or above the "global," holding the globe in his hand, framing it in a larger Olympian perspective—the very perspective that informs international conferences on globalization, where cosmopolitan men and women of the world gather to ponder the "global," as if they held "the whole world in their hands," as the African American hymn expresses it.[5] The cosmos is depicted, generally, in highly abstract, schematic, even diagrammatic figures that leave all particularity to the sublunary realm of earthbound creatures. The world becomes an abstract form held in the mind, hand, or eye of a sovereign, imperial intelligence. Its contradictions are reduced to a figure of "harmony in opposition" or dialectics, and its complexity is rendered as a labyrinth seen from above. The cosmos is, as Alexander Pope imagines it, "a mighty maze, but not without a plan," and the creation of actual mazes and landscape gardens is an attempt to depict, in the human scale of terrestrial spaces, the structure of the imperial, global totality. Thus Pope's description of Windsor Forest treats it as a miniature emblem of the British empire (as well as of the original divine landscape, the "Groves of Eden") and as a dialectical landscape that both embodies and resolves contradiction: "Here hills and vales, the woodland and the plain / Here earth and water seem to strive again / Not chaos-like, together crushed and bruised / But as the world, harmoniously confused."[6]

It is striking, in this regard, to note that the very first sentence of Hardt and Negri's *Empire* is a similar declaration: "The problematic of Empire is determined in the first place by one simple fact: that there is world order." Hardt and Negri seem almost conscious of the neoclassical resonance of their claim, and quickly set out to correct it by insisting that this order is neither natural nor divine, but "juridical," neither a "spontaneous" result "of the interactions of radically heterogeneous world forces," nor "dictated by a single power."[7] This third notion of world order as juridical, as a product of human consciousness and agency, is one thing that links

5. That hymn moves from the hand-held world to the "little bitty baby," a shift that offers an uncanny echoing of Blake's vision of the globe as a fetus at the moment of birth.

6. *Windsor Forest* ll.11–13 (1713), from *Alexander Pope: Selected Poetry and Prose*, ed. William K. Wimsatt Jr. (New York: Holt, Rinehart, and Winston, 1964).

7. Hardt and Negri, *Empire*, 1.

their thought to the precedent of Blake, who shares their conviction that globalization and the world order are historical products of the human imagination, if not their "juridical" notion of it as governed by one law.

4. *World*, according to the OED, is "a formation peculiar to Germanic, f. *wer-* man, *WERE n.*1 + *al-* age (cf. *OLD a.*, *ELD n.*2), the etymological meaning being, therefore, 'age' or 'life of man.'" "World" expands to the universal and contracts to the particular—"this world" as opposed to the next; the lower, secular, earthly, and worldly, as opposed to the heavens. It is also a temporal state, not just spatial, a condition, not just a location. The world is another catachresis of part and whole, specific singularity and general totality. "The world is all that is the case," says Wittgenstein,[8] but it is also a small subset of what is the case. "The world, the flesh, and the devil" are situated in a middle region, below heaven, but above the underworld of Hell or Hades, the subterranean realm where a universe of fire, torment, and destruction is to be found. A world can also denote a social or ethnographic region, as in "the Arab World," or even the domain of a species, as in the concept of a "life-world." Worlds, unlike the Kosmos, easily take the plural: there are many worlds, possible worlds, wars of the worlds, and different ways of world-making, as Nelson Goodman teaches us.[9] There is one cosmic order, one juridical law that governs the numerous worlds. One suspects that Derrida's sensitivity to language made him prefer the term *mondialization* to globalization. Mondialization does not translate well, however, as "worlding"—perhaps we need a new term like "mundanization" or "mundanity" (though that would come perilously close to equating globalization with an epidemic of boredom and inanity).

The world as a planet is also "whirled," if you will permit a Joycean pun, through space, rotating through the seasons and lives of its denizens. The spherical overtones of the global and the errant wandering of the planetary converge in the figure of the vortex or helix, the spiral trace left by any point on a globe as it wanders through space, or the track of the artist-creator's inscribing hand as he draws a New World into existence. Saul Steinberg's cartoon *New World* illustrates this scenario perfectly, as well as Heidegger's notion of a "world picture" that is not a depiction of the world, but the world itself constituted as a picture.

8. This is the first line of Wittgenstein's *Tractatus Logico-Philosophicus* (1921), trans. D. F. Pears and B. F. McGuinness, intro. Bertrand Russell (London: Routledge & Kegan Paul, 1961), 5.

9. Goodman, *Ways of World Making* (Indianapolis: Hackett, 1978).

5. *Earth*, or *terra*. Again, the OED: "on the ground; no other non-Teutonic cognates are known to exist, the plausible connexion with the Aryan root *ar*, to plough, being open to serious objection." The ground, nevertheless, the place of burial and digging. But also the "whole earth" (as cataloged) and "middle earth" (as imagined), or the place where "earthlings" live (in science fiction). Earth's version of the global dialectic is to vacillate between the proper and the common noun, the name of the planet and the name of that which covers its surface with a nourishing, fertile, and fecund substance.

Since I have been invoking the cosmology of William Blake as a framework for the poetics and iconology of globalization, perhaps it would be helpful to put his most comprehensive statement on the structure of the universe into the record. His fundamental principle is, as I hope is evident at this point, to bring out the dialectical character of the whole concept of the world, the global, and the cosmic, to insist on the catachresis of part and whole, particular and general, the small "Minute Particular" and the "Infinite": "To see a world in a grain of sand." But here is his statement on the matter of the infinite:

> The nature of infinity is this: That every thing has its
> Own Vortex; and when once a traveller thro Eternity
> Has passd that Vortex, he percieves it roll backward behind
> His path, into a globe itself infolding; like a sun:
> Or like a moon, or like a universe of starry majesty,
> While he keeps onwards in his wondrous journey on the earth
> Or like a human form, a friend with whom he livd benevolent.
> As the eye of man views both the east & west encompassing
> Its vortex; and the north & south, with all their starry host;
> Also the rising sun & setting moon he views surrounding
> His corn-fields and his valleys of five hundred acres square.
> Thus is the earth one infinite plane, and not as apparent
> To the weak traveller confin'd beneath the moony shade.
> Thus is the heaven a vortex passd already, and the earth
> A vortex not yet pass'd by the traveler thro' Eternity.
> BLAKE, *Milton: A Poem* (1803), plate 15, ll.21–35[10]

10. *The Poetry and Prose of William Blake*, ed. David V. Erdman (Garden City, NY: Anchor Doubleday, 1965), 108–9.

This passage has attracted a large amount of commentary, but I only want to emphasize a couple of major points in this context. As an account of globalization, it suggests that the figure of totality as a globe is itself a transitional phase, not an endpoint. The globe is merely another "thing" that human consciousness encounters, and like all things, it "has its / Own Vortex," which is to say, its own spiraling, doubled, dialectical identity, which alternates between opposite perceptions—singular objects such as "a globe itself infolding," or an outward directing radiance like "a sun," or "a moon" reflecting light; or an array of collective objects, a mass gathering, "a universe of starry majesty." Or (and this is the final visionary version of the nature of infinity) a "human form," the Other, who contains, as a sovereign subject, all these worlds, these infinities, within himself. If there is a lesson in this passage for students of globalization, it is not to be fixated on the figure of the global as the privileged icon of the world, the earth, or the cosmos. As Blake puts it, "As to that false appearance which appears to the reasoner, / As of a Globe rolling thro voidness, it is a delusion." The earth is rather to be seen as "one infinite plane" in which every particular object, and every living thing, contains a vortex that opens into yet another infinity.

The journalist Thomas Friedman has notoriously concluded that "the earth is flat," that globalization means, paradoxically, that we have moved beyond Columbus's discovery that the world is round into a wired universe of instantaneous virtual community—a community, as Friedman neglects to mention, of increasingly drastic economic inequality.[11] Blake's conclusion exactly opposes Friedman's blasé neoliberal confidence in the homogeneous flatness of a world of cosmopolitan entrepreneurs flying business class from one world city to another, circulating along with images, information, and commodities. For Blake, it is the Minute Particular that is infinite, individual, and singular. The infinity of globalization is not to be found in the homogeneous air-conditioned world of neoliberalism, but in the sweatshops and dirty wars it administers, and in the unique human forms that inhabit all its levels.

One of the favorite scapegoats for the abstract character of globalization is technology and science. This is Heidegger's argument in his famous 1938 essay "The Age of the World Picture," which argues that the modern

11. Friedman, *The World Is Flat: A Brief History of the Twenty-First Century* (New York: Farrar, Straus, Giroux, 2005).

era has been a time in which the world itself has become a picture.[12] It is not merely that modern cultures create pictures *of* the world, but that the world they present to themselves has been constituted *as* a picture, by which Heidegger means the measurable, calculable universe of mathematics and physics, of scientific research in its modern sense. For Heidegger, the ancient Greeks and medieval man did not have a world picture in this sense, one that splits Being into a totalizing object, on the one hand, and a totally perspicuous subject, on the other, who "gets the picture," as if all the world were depicted "before" it, and yet also finds itself "in the picture," as its total situation. "As soon as the world becomes picture," argues Heidegger, "the position of man is conceived as a world view" (133–34).

I'm going to leave aside the question of whether Heidegger is right that other ages had no world picture and therefore no world view.[13] I'm more interested in whether he is correct about the modern, putatively scientific *Weltanschauung*. Interestingly, the exact opposite to Heidegger's claim was argued just six years earlier by Freud in one of his last essays, "The Question of a *Weltanschauung*." Freud argued that scientific thought was inherently hostile to the notion of a comprehensive world picture or world view: it cannot "even draw us a coherent picture of the universe. . . . It gives us fragments of alleged discovery, which it cannot bring into harmony with one another. . . . Everything it teaches is only provisionally true: what is praised today as the highest wisdom will be rejected to-morrow and replaced by something else, though once more only tentatively."[14] Freud did not, of course, exempt the mind of man itself from this conclusion, arguing that, as one of the sciences, psychoanalysis could not claim to have a *Weltanschauung*, and that it must renounce any claim to provide a world picture.

Which of these views is correct? My own sense is that they are both wrong and need to be understood as expressions of deeply connected ideological fixations. Freud is attempting to overcome magical thinking and religion, which he understands to be the source of dogmatic world pictures and world views, an infantile stage in the evolution of human thought. Heidegger's antagonist is precisely the opposite. He wants to blame technoscience and instrumental reason for the modern disenchantment of

12. Heidegger, "The Age of the World Picture," in *The Question Concerning Technology*, trans. William Levitt (New York: Harper & Row, 1977).

13. But as one raised on E. M. W. Tillyard's classic of intellectual history, *The Elizabethan World Picture* (New York: Vintage, 1959), I can hardly accept it at face value.

14. "Lecture XXXV: The Question of a *Weltanschauung*," in *The Freud Reader*, ed. Peter Gay (New York: W. W. Norton, 1989), 790.

the world, and with it the construction of a comprehensive world picture. The one thing Heidegger and Freud agree on is that world pictures are bad things, though for completely opposite reasons.

My own sense of world pictures is that they are necessary, unavoidable, and always limited in one way or another. The question is, What are the limits? A good illustration might be provided by Google Earth's marvelous satellite photographs, which produce a digital and virtualized answer to the traditional spherical representation of the world as globe. With a mouse click, I can zoom in from thousands of miles out in space to a spot a few hundred feet above the earth's surface, watching in amazement as continents and regions come into focus, followed by distinctive geographical formations like coastlines, until we find ourselves coming to rest above recognizable city streets and buildings. Like the crystalline sphere of the Salvator Mundi, everything is clear, transparent, and highly defined—that is, until we come too close, and then the world picture dissolves into pixels. This is the moment of Blake's Minute Particular, the moment when the global image dissolves into the local, the passage into the vortex of dissolution and reframing of the image. This is also very like that moment when aerial surveillance convinces us of the certainty of a target, and we watch that target explode in the crosshairs, a "surgical strike" that almost invariably turns out to be a mistake, a catastrophic incident of "collateral damage."

There is no way to "zoom" smoothly and precisely from the global to the local, in other words, or from the heights of abstract infinity to the minute particular; the perspective must pass through a vortex that imposes a new regime of observation—up close and personal—on the spectator. The dangerous illusion of the contemporary world picture of neoliberal economics and militaristic adventurism is that technoscience has made this "smooth" zooming possible. That is the side on which Heidegger is correct. The fact that this *Weltanschauung* is always provisional and fragmentary is the side on which Freud is correct.

But there are other kinds of parallax views or jumps in the global perspective that need to be recognized. It is not just a question of scale, of the gigantic and miniature, but also the fundamental coding of the world picture as such. A perfect illustration may be found in the cover image of Hardt and Negri's pathbreaking book *Empire*. Why should a book that insists on a resolutely political, economic, and social construction of world order, the "juridical" formation of state, corporate, and NGO agents that constitute what they call "Empire" with a capital E, have a meteorological event like a hurricane as the totalizing emblem of its message? The

image is radically inappropriate to the text it illustrates. It would make much more sense as the cover of Al Gore's *An Inconvenient Truth*, which treats globalization as an ecological and environmental process that (on its present course) is leading toward a global catastrophe. Global warming, as Gore argues (with the unanimous support of what can only be called the "world picture" of contemporary science), is threatening the entire life-world of the human species. It is as if Hardt and Negri were led, almost unconsciously, to the limiting breakdown of their world picture, a turbulent form of order *and* disorder, what Heidegger calls the "shadow" that haunts the world picture in the form of that ancient figure of transformation, the vortex.[15]

Rather than conclude, however, with the relatively abstract and cosmological image of the vortex as the turbulent passage between world pictures, I want to leave you with a few thoughts on the intermediate concept of the *region*, the "excluded middle" that tends to be left out in the polarizing concepts of the global and local. I think it is no accident that Hardt and Negri discount the importance of "geographical regions," and Marx's figure of the "Old Mole" of proletarian revolution that burrows through the earth, in favor of a highly virtualized Empire whose center is everywhere and circumference is nowhere. For them, all the different struggles against Empire are "incommunicable" one to another, an abstract "multitude" that resists an equally abstract "Empire" whose "virtual center . . . can be attacked from any point"(59).

If we learn any lesson from contemporary politics (in the Middle East, but also in the Americas and in Africa and Asia, for instance) it is that the *region* is a more potent factor in global politics than ever before. The military nightmare of our moment turns out to be not the ICBMs of the Cold War, which were genuinely global in their reach, but the short- and intermediate-range missile that may travel only ten or twenty miles but can be launched from the back of a pickup truck or the backyard of a cottage. All warfare is now regional warfare, by which I mean it is almost never fought between nations with armies arrayed against one another; rather, it is a complex war of position fought over uncertain and shifting borders, contested terrains, and demilitarized zones with smuggled or improvised weapons. It is important in this regard to note that the notion of a "war on terror" with a shadowy enemy (al Qaeda) that has no determinate center in any nation state, but circulates as a global ideology that can strike any-

15. Of course I am assuming here that they chose their cover image, which may have been imposed on them by the book's designer.

where, is now being supplanted by the phenomenon of ISIL (the Islamic State in the Levant), which is waging a classic war of territorial conquest aimed at creating a new regional nation-state.

And these developments are entirely in keeping with the concept of the region. The word comes from *regere*, "to rule," a sense echoed in related words such as "regime," "regency," and "reign"—something very like the "juridical" order postulated for Empire by Hardt and Negri. But the actual use of the term belies this image of a space ruled by law. The "regional imaginary" is likely to be constructed in terms of images of emancipation from political and governmental boundaries, and in general it denotes an area of relatively weak, contested, or divided jurisdiction. In American culture, regionalism is the name for forms of cultural resistance to what is seen as the oppressive dominance of the metropolitan regions. Thus, "Southern" or "Western" or even "Midwestern" literature provide alternatives to the cosmopolitan centers of New York and New England in American literary histories.

Like world pictures, regional imaginaries always display a double, dialectical face. The region is what is "ruled," but it is also what is free of central rule, contesting the power centers, often in a struggle between the country and the city. Regions are ambiguous with respect to their status as *parts* or *wholes,* fragments or totalities: North America is a gigantic (almost) continental region that contains just two nations, the United States and Canada, yet each of these countries contains numerous regions within itself. China, located in the region known as East Asia, is itself composed of radically distinct geographical and cultural regions. I call these regional *imaginaries* in contrast to world *pictures*, however, because the region is a much more tentative and provisional entity than a nation or country. No one has ever been called upon to die for his region, but dying for one's country or nation is absolutely commonplace.[16]

The regional imaginary does resolve into a picture, however, when it is exemplified in a specific site. The most vivid regional pictures are thus of zones of conflict and contestation, border areas, demilitarized zones, or set-aside spaces (what Foucault called "heterotopias") that flaunt their double role as places or localities, on the one hand, and symbolic spaces

16. On further reflection, I would want to qualify this claim. A powerful example of regional loyalty is the American South, which aspired to independent nationhood. Many southerners still believe that "the South shall rise again" and are therefore determined to save their Confederate money. Nevertheless, even this exception confirms the rule: the Southern aspiration was to escape from its "regional" condition and to attain sovereignty as a nation.

that represent larger regional and even global meanings, on the other. Pope's Windsor Forest is just such a heterotopia, a region set aside from use to transform a specific place into an emblem of the world, subject simultaneously to imperial rule and to a kind of public openness that is the predecessor of the modern institution of the public park.

From a global perspective, especially one driven by the rational calculation of cartography, the region emerges as the most stable, permanent feature of the earth, especially in its manifestation in the great regional landmasses known as continents. A vivid demonstration of this point is provided by Chinese artist Hung Hao in his fictional map entitled *New Political World*. This map shows us a world in which all the familiar continents and regions remain in the usual places, but all the names of political entities, such as cities and nation-states, have been *dis*placed. Hung Hao's map provides a useful way of thinking about the relations of spatial categories from the global to the regional to the local. At its most general level, it reminds us of the contingency and fragility of our national entities and their life-world (a point that could also be made by looking at a political map of the Balkans over the last century), while at the same time stressing the relative durability of continents and regions. "Continental drift" is one aspect of global reality that (unlike global warming) seems beyond human intervention. The volatility of the borders and national identities in Hung Hao's map serves to remind us, at a moment when the United States is touted as "the lone superpower" and globalization is routinely equated with "Americanization," that empires and superpowers may be even more ephemeral than tiny nation-states.

But the wit of *New Political World* lies in the details of displacement and dislocation as much as in this general point. Hung Hao moves the name "London" to a region of the north coast of Australia and relocates "Israel" to Canada, where presumably it will have plenty of room to spread out. China has been split up into many parts, Australia taking over its eastern seaboard, and Beijing seems now to be located in Algeria, while Portugal has taken over the western reaches of the Gobi desert. Only India retains its "proper" location in the subcontinent, with Lithuania moving into Sri Lanka.

The most striking displacement is of the People's Republic of China, which finds itself in sole possession of the territorial United States (Alaska, evidently, has been added to Uganda). What does this mean? Is it a not so subtle prediction that China is now in position to become the world's largest economy and the dominant superpower of the twenty-first century? Or could it be a sly prediction that the US will become *like* China in a political

sense, a "one-party democracy" in which the Republican party abolishes all opposition?[17] What does it mean that the United States seems to have been dispersed over what looks like the outlying islands of the Philippines, an archipelago that housed its former colony? And what are we to make of a world where oceans are traversed by sailing ships, tanks, and jet fighters, while carefree divers launch themselves into the South Atlantic from the coast of what was once Brazil but is now the Netherlands? Like all marvelous works of art, Hung Hao's *New Political World* is capable of generating an infinity of propositions and questions. And like all provocative world pictures, it produces a vortex of displacements and reorientations, drawing the beholder into a vertiginous reassessment of just what this world is, or is becoming.

17. This was written in August of 2006, just before the elections that drove the Republican Party from power. As I make final revisions in late 2014, when the Republicans have taken firm control of both the Supreme Court and Congress, it once again looks like an all too possible future.

PART TWO *Grounds*

9.1 Ferdinand de Saussure, "Linguistic Sign," from *Cours de linguistique générale* (1916).

9: MEDIA AESTHETICS

For those of us who like to think with our ears (as Adorno once put it), the phrase "media aesthetics" has a slightly jarring quality.[1] It is not just the awkward conjunction of Latin and Greek; it is the forcing together of modern and ancient concepts, one term associated with mass society and information theory, while the other evokes the world of elite taste and fine art. As McLuhan would have put it, medium implies "message," while aesthetics is about the *massage* of the body, its extensions, and its senses. Of course McLuhan went on to write and design a graphically experimental book entitled *The Medium Is the Massage*.[2] He was not bothered by the shocking little pun; in fact puns, with their foregrounding of the nonsensical and hypersensuous character of speech itself, may well have been his favorite figure of speech. Aesthetics, the study of the senses and the arts that massage them, constituted the central hub around which issues such as communication, technology, and social forms circulated in his unified field theory of media. He thought that the only people who could really comprehend the impact of a new medium would be artists who were willing to play with and upon its sensory capabilities—to think with their ears, their fingers and toes. Those concerned primarily with content or messages, by contrast, would never be able to see (or hear or feel) how the medium was altering the ratio of their senses. And feeling, for McLuhan, was never merely a matter of sensuous apprehension, but rather of emotional and affective *com*prehension, of a body bathed in hot and cool media. Never mind which medium (television, radio, newspapers) is labeled hot or cool: the point is to take the temperature of a medium, which is to say the temperature of a body—individual or collective—in a world of sensory ratios.

McLuhan's visionary legacy was, I think, largely forgotten in the de-

1. This was the opening observation of Adorno's essay, "Cultural Criticism," and of course he was much more emphatic, describing this phrase as a barbarism.
2. *The Medium Is the Massage*, coauthored and designed with Quentin Fiore (New York: Random House, 1967).

cades after his death. McLuhan himself was debunked as a crank who had been seduced into nonsensical proclamations by his rise as a media celebrity who could upstage the likes of Truman Capote on the Dick Cavett show. Filmmaker David Cronenberg, who had been in McLuhan's classes at the University of Toronto, pronounced the epitaph for the father of media studies in his classic horror film *Videodrome.* The great media theorist, Dr. Brian Oblivion, a transparent caricature of McLuhan, is portrayed as the only person in the world who truly understands what media are doing to the human sensorium ("the television screen has become the retina of the mind's eye; therefore, television is reality, and reality is less than television"). Dr. Oblivion is therefore singled out by the evil Videodrome corporation as "its first victim."

After McLuhan, media studies were quickly balkanized into academic specialties that had little awareness of or interest in each other. Schools of communication, ruled by quantitative sociological discourse, paradigms of mass media advertising and journalism, and technical gadgetry did not talk to departments of art history; art history turned its back on philosophical aesthetics in favor of historicism, and only grudgingly came to acknowledge its constitutive relation to language and literature; and literary studies, driven to distraction by overly literal readings of Derridean sayings such as "there is nothing outside the text," settled into a linguistically centered semiotics that began to rival Renaissance rhetoric in its proliferation of technical terms and distinctions. Meanwhile, McLuhan was eclipsed by the rising star of Walter Benjamin, whose concept of "mechanical reproduction"[3] took over the humanities at precisely the moment that mechanistic paradigms were being replaced (as McLuhan foresaw) by electronic and biocybernetic models. One could say of media studies in the wake of McLuhan what the evil prison warden says of the stubborn inmate played by Paul Newman in *Cool Hand Luke*: "What we have here is a failure to communicate."

A new synthesis in media studies seemed to be offered, however, in the 1990s by the appearance of Friedrich Kittler's magnum opus, *Gramaphone Film Typewriter*, a lively, experimental collage of stories, jokes, songs, and gadgets, woven into a dark narrative of the end of humanity and the

3. I am aware, of course, that this translation of Benjamin's concept has subsequently been revised as "technical," not "mechanical," reproduction. Nevertheless, it was the metaphorics of mechanism that dominated discussions of Benjamin and media in the 1970s and 1980s.

rise of the computer.[4] Kittler offered media theory as Gothic romance, a tale of media history driven by war, "the mother of invention," of "situation rooms" in which Dr. Strangeloves ponder the calculus of destruction and McLuhan's sensory ratios are wired up to keyboard interfaces, headphones, and optical scanners.

Kittler's brilliant intervention in media studies had the effect of opening up a whole new media archaeology for historical investigation. It reoriented attention to computer software and hardware, and (to a lesser extent) to the new networks of interactive machines. Arriving along with the rise of the Internet, it provoked a wave of studies in so-called new media (led by Peter Lunenfeld and Lev Manovich, among others) that announced a "digital turn" in which the old analog-based "mechanical" media (especially photography and cinema) were to be replaced by binary codes, data bases, and self-executing algorithms. Reality, especially the kind delivered by analog photography with its supposedly "indexical" relation to the referent, along with notions of representation and mimesis, were all to be consigned to the dustbin of history.[5] As Kittler put it, the sensory outputs provided by computers were to be regarded merely as "eyewash" and "entertainment" for the stunned survivors of humanity, something to keep them distracted "in the meantime" as they approach their final replacement by the machines they had built.

While this story, popularized by films like *The Matrix* and *Johnny Mnemonic*, was beguiling, one can see immediately how it tended to minimize the question of aesthetics as a merely superficial matter that conceals the Real (understood in the Lacanian sense as trauma) of ones and zeros, of alphanumeric code. The return of something called "media aesthetics" to our attention, might be understood, then, as a refocusing on the superficial "eyewash" that was so central to McLuhan's vision of media. One could already see this return coming in the key moment of *The Matrix*, when Neo ("the One" sent to save us from the Matrix) sees through the eyewash into the Real world of streaming alphanumeric code. As the still from this

4. Kittler's book was first published in German (Berlin: Brinkman and Bose, 1986). The English translation, with an excellent introduction by Geoffrey Winthrop-Young, was published by Stanford University Press in 1999.

5. For an argument that digital photography has lost the indexical relation with the real offered by chemical-based photography, see William J. Mitchell (no relation), *The Reconfigured Eye: Visual Truth in the Post-Photographic Era* (Cambridge, MA: MIT Press, 1992). For a critique of this view, see chapter 5, "Realism and the Digital Image."

moment reveals, however, this revelation is simultaneously a return to the analog. The agents of the Matrix are *not* merely programs or amorphous clusters of digits: they have recognizable human forms.

The digital turn will never be properly understood if it is not placed in a dialectic with the analog, and with what Brian Massumi has called "the superiority of the analog."[6] The digital is *not* an invention of the twentieth century, nor is it equivalent to computer codes. The digital has always been with us in the form of finite sets of discrete characters (e.g., alphabets and number systems) and in the graphic media, in everything from the Ben-Day dots of newspaper photos, to the medium of mosaic tile, to the granular and material equivalent of pixels in Australian sand painting. Eyewashing and brainwashing, sensory feeling and thought, have to be understood in their mutual interactivity. Every turn toward new media is simultaneously a turn toward a new form of *immediacy*. The obscure, un-readable ciphers of code are most often mobilized, not to encrypt a secret, but to produce a new form of transparency.

Another problem with Kittler's narrative is launched in the opening sentence of his book: "Media determine our situation." This is followed by a detour into the "situation room" of the German high command in World War II, plotting the trajectories of air strikes in the Battle of Britain. When Mark Hansen and I were writing the introduction to *Critical Terms for Media Studies*, we immediately thought of using Kittler's sentence as the opening epigraph.[7] But our first *second* thought was to introduce a strategic revision, to insist that "media *are* our situation." The implicit aim of this revision was to put into question the seductive rhetoric of media as outside agencies that cause things, the language of determinism and determination. Are media really the "determining instance" of a situation? Or are they better pictured as themselves *the* situation, the environment within which human experience and (inter)action take place? Would it not be better to see media, rather than as the determining factor in a cause-and-effect scenario, as an ecosystem in which processes may or may not take place? Like the old notion of God as the element "in which we live and move and have our being," media surround us on every side. But it is a "we" that inhabits them, a "we" that experiences every medium as the vehicle of some form of immediacy or opacity.

6. See the chapter with this title in Massumi's *Parables for the Virtual: Movement, Affect, Sensation* (Durham, NC: Duke University Press, 2002).
7. *Critical Terms for Media Studies*, ed. W. J. T. Mitchell and Mark B. N. Hansen (Chicago: University of Chicago Press, 2010).

I would want to qualify the notion of medium-as-situation or environment even further by suggesting that it is never *all* of a situation. One of the deepest temptations of the concept of media is its tendency toward totalization. Even the old model of media as communication device had this as a built-in tendency. Like an accordion, the model of sender-medium-receiver (call this the "telephonic" image) immediately expands to include the sender/receiver function as components of the medium.[8] Pretty soon everything is a medium, the old Derridean mantra comes back to haunt us, and there is nothing outside the media. I would prefer to say that there is *always* something outside the medium, namely, the zone of immediacy and the unmediated that it both produces and encounters. McLuhan, again, was a wise guide to this aspect of media, noting that the new media of his time, television especially, were arriving in a wide variety of cultural, political, and social situations. Television in Africa, he noted, did not produce or encounter the same situation that it did in the United States in the 1960s (for one thing, collective viewing situations were much more common, as distinct from the private domestic sphere of American households). Today the Internet encounters quite a different set of circumstances as it crosses national borders, at the same time that it facilitates McLuhan's long anticipated "global village." What people failed to understand in McLuhan's time (and our own) is that a village is not necessarily a utopia. Real villages, as those of us who grew up in rural America can testify, can be very nasty places.

Media aesthetics, then, promises to provide a salutary resistance to the all-or-nothing tendencies of media theory, and of that form of media history that treats everything as a consequence of some media invention. My version of media aesthetics would not treat the widely heralded "digital turn," for instance, as a jettisoning of the analog, or a reduction to dematerialized and disembodied experiences. The digital is experienced in the ten fingers tapping on a QWERTY keyboard interface and moving a mouse, or brushing across a touch-pad or touch-screen. The computer introduces a new form of tactility, accompanied by new maladies such as carpal tunnel syndrome. The codes and algorithms of informatics are also encoded in the molecular structure of living organisms, so that the cybernetic model of "control" and the figure of the cyber as "steersman" is resisted by the stormy seas of life itself. The technical revolution of our time is not merely

8. For a further account of the accordion effect in media theory, see my chapter "Addressing Media," in *What Do Pictures Want? The Lives and Loves of Images* (Chicago: University of Chicago Press, 2005).

cybernetic but biocybernetic, producing a world of machines infected with viruses and engineered life-forms tethered to increasingly complex prostheses.[9] Smart bombs and suicide bombers, drones and clones populate our imaginary universe of "extensions of man," and of highly ambiguous models of "agency." What counts as a "free agent" in the age of biocybernetics? Consider, for instance, that one of the dominant espionage narratives of our time portrays the secret agent as an orphan (James Bond in *Skyfall*) or as an amnesiac who has escaped the control of his agency, as in the Jason Bourne films. Or that the Cold War figure of the brainwashed automaton deployed as an assassin (Laurence Harvey in *the Manchurian Candidate*), has been replaced in the war on terror by the religious convert motivated by moral outrage and true blue patriotism (Sergeant Brody's suicide video, in *Homeland*, shows him affirming his identity as a US Marine, festooned with all his decorations). *Homeland* transfers the position of madness to the prescient, Cassandra-like CIA agent, whose bipolar paranoia and mania allow her to see impending threats that are invisible to everyone else. She is herself a medium, in the old sense of the seer at a séance, in the grip of intuitions that she cannot prove but that hold her with obsessive certainty.

The model of the free agent versus the agent of a higher power, free will versus determinism, shimmers with ambiguity in the environment of contemporary media systems, which is why it is so difficult to settle the question of whether (to re-cite Kittler) "media determine our situation," or whether media serve as a passive, neutral background of potentials, as Nicklas Luhmann would argue.[10] But perhaps contemporary media, the "extended sensorium" or global nervous system that McLuhan predicted, is simply the latest version of that image of the divinity in which "we live and move." Perhaps that is why the rhetoric of religion is so deeply woven into the discourse on media, why concepts like media and mediation so easily turn into god-terms even in secular, technical contexts, why the concrete materiality of a medium is so easily abstracted and spiritualized by the terminology of media and mediation.

Media aesthetics, finally, produces an interesting convergence of the problem of singularity and multiplicity. We see this in everyday parlance in our tendency to describe "the media" as if they were a kind of collective

9. For further development of this idea, see my chapter, "The Work of Art in the Age of Biocybernetics," in *What Do Pictures Want?*

10. See Luhmann, "Medium and Form," in *Art as a Social System*, trans. Eva M. Knodt (Stanford, CA: Stanford University Press, 2000).

body, like Hobbes's image of the sovereign as a single monstrous body containing multitudes. In mass media, the figures of "talking heads" speak as agents of radically heterogeneous interests—corporate sponsors, administrative hierarchies, journalistic canons, market shares. All this condenses into something called "the media," or (more prejudicially) the "Liberal Media." Meanwhile, each medium is spoken of as if it were a unique, essential constellation of materials, techniques, and practices—its "medium specificity." This singular concept of the medium, a central feature of modernist aesthetics from Clement Greenberg to Michael Fried, is widely regarded now as a relic of the time when media aesthetics was a quest for purity—pure painting, music, poetry—and a rigorous avoidance of hybridity and multimedia interplay among the arts. "What lies between the arts is theater," insisted Fried,[11] and that sort of theatricality is the enemy of any art form that aims to remain faithful to and compete with the great aesthetic achievements of the past. Postmodernism in the arts, then, was a movement that renounced the medium as a singular, essential formation in favor of the media understood precisely as the spaces between the arts, and as artistic practices that situated themselves between images and words and music, between concepts and performances, between bodies and spaces. That is why postmodernism was so deeply linked to the rise of interdisciplinarity, the emergence of new relations between the disciplines that study the arts and sciences. All the more paradoxical, then, that media studies itself was so balkanized, with so little communication between the study of mass media, artistic media, and technology. When Mark Hansen and I set out to produce *Critical Terms for Media Studies*, then, one of our central aims was to produce a conversation among the different disciplines that engage with media. We wanted to imagine a universe where Noam Chomsky's *Manufacturing Consent* would be read alongside Paul Starr's *The Creation of the Media* alongside Adorno and Horkheimer on the culture industry alongside David Graeber's analysis of the history of money and exchange alongside Rosalind Krauss's account of the "post-medium" condition in the arts.[12] Media aesthetics would be, we hoped, a catalyst for that conversation.

The concept of media aesthetics has a personal resonance for me as a landmark in my evolution as a scholar. In the early 1990s I began to teach

11. Fried, "Art and Objecthood," first published in ArtForum, 1967. Reprinted along with other essays and reviews in *Art and Objecthood* (Chicago: University of Chicago Press, 1998).

12. See Graeber, "Exchange," in Mitchell and Hansen, *Critical Terms for Media Studies*.

a course entitled "Visual Culture" and to write about this nascent field as a kind of "indiscipline" that would link art history to film, media studies, physical and psychological optics, and anthropology. Starting with a review essay entitled "The Pictorial Turn" (prompted by the appearance of Jonathan Crary's *Techniques of the Observer* at the same time as the first English publication of Erwin Panofsky's classic "Perspective as Symbolic Form") I found myself working directly against the tendency to "linguistify" art history led by Norman Bryson and Mieke Bal in the 1980s.[13] As an alternative to Richard Rorty's "linguistic turn," I turned in exactly the opposite direction, by way of a rereading of philosophy and theory grounded in an obsession with—and fear of—the image. My ambition for art history was to promote its primary theoretical object, the visual image, from its status as a secondary and subordinate element of culture, always to be explained by reference to language, into a primary datum of the human sciences. Rather than colonize art history with methods derived from the textual disciplines, I wanted to strike back at the empire of language, to insist on the image or icon as a "firstness" (as Charles Sanders Peirce called it) in the production of meaning and emotion.

Around 2000 I began to reorient this initiative around the concepts of media, medium, and mediation, and to teach a course entitled "Theories of Media" that aimed to trace the specific development of media studies from Marshall McLuhan to Friedrich Kittler, with ample representation of earlier key texts on media, from Aristotle and Plato to Walter Benjamin and the Frankfurt School. Several things motivated this transition. First, it had become increasingly clear to me that the emphasis on *vision* and *visuality* (which I still find very productive for the study of culture) needed to be extended with a consideration of the other senses, particularly hearing and touch. Second, it had struck me that the role of visual culture all along had been to produce a series of mediations among disciplines that would ordinarily not be talking to each other. Since I had come to the study of the visual arts from the sphere of literature and literary theory, spurred, on the one hand, by a general interest in theory and, on the other, by a particular interest in the composite art of painter-poet William Blake, it began to be increasingly obvious to me that the real subject of my work

13. Crary, *Techniques of the Observer: On Vision and Modernity in the Nineteenth Century* (Cambridge, MA: MIT Press, 1990); Panofsky's, *Perspective as Symbolic Form* was published by Zone Books in 1991 in an excellent translation by Christopher S. Wood. My review essay, "The Pictorial Turn," appeared in *Artforum* in March 1992. For my discussion of visual culture as an indiscipline, see "Interdisciplinarity and Visual Culture," *Art Bulletin* 77, no. 4 (December 1995): 540–44.

was the relations among different media, art forms, sensory modalities, and codes of signification, as well as the disciplines that addressed them.

As for theory as such, I was mindful of Fredric Jameson's canny remark that theory is nothing more than a form of philosophy that is conscious of its own embeddness in language, including rhetoric and poetics. But it quickly dawned on me that one could extend Jameson's observation by postulating a notion of *medium theory*, a form of philosophical reflection that is conscious of its embeddness in nonlinguistic media, such as music and the graphic arts. Medium theory is not the same as media theory. It does not come at media from outside, as an explanatory metalanguage. It is an immanent metalanguage—or more to the point—a set of "metapictures" that show us what pictures are, how they work, what they want. Instead of a "theory of pictures," medium theory requires a *picture theory*,[14] in which "picture" is ambiguously both an adjective and a verb.

It became clear to a group of my colleagues at the University of Chicago that media, understood in this sort of interdisciplinary framework, were essential to the fabric of a liberal education as well. As a result, around 2005 we set about designing a new "common core" curriculum based precisely in the concept of media aesthetics. The idea of a common core of "great books" has been a fixture of undergraduate education at Chicago for many years, one that has been modified periodically to reflect new movements in the humanities. For instance, during the rise of cultural studies in the 1990s, a new freshman core called "Reading Cultures," developed by a group of young faculty members, specified as thematic emphases for the three terms of the academic year "Travel, Collecting, and Capitalist Cultures." "Media Aesthetics" emerged in a similar way, as a collaboration among literary scholars, art historians, film scholars, philosophers, and musicologists. The thematic triad for the freshman year was now "Image/Sound/Text," the fall term focusing on visual culture, the winter on music and orality, and the spring on reading and textuality.

Needless to say, every term involved reading, listening, and looking. It is probably also needless to say that there was something deeply inevitable about the specific triangulation of media aesthetics that emerged, that it was not merely an artifact of Chicago's three-term quarter system. One hears immediately the echo of Roland Barthes's classic *Image/Music/Text*, with "music" demoted to the status of a medium (sound) rather than

14. See my *Picture Theory: Essays on Verbal and Visual Representation* (Chicago: University of Chicago Press, 1994), especially the chapter "Metapictures."

an art form, putting it at the same level with images and words. But the logic of this triad goes deeper: it also echoes Kittler's *Gramaphone Film Typewriter*—which divides the new technical media of the late nineteenth century into sound recording, optical recording, and the tactile/textual keyboard interface for the recording of writing—and even more deeply, perhaps, Aristotle's division of the "means" or "media" of drama into the elements of *melos* (music), *opsis* (spectacle), and *lexis* (words).

There is something deeply conservative, then, about the logical divisions generated by media aesthetics. Instead of an endlessly proliferating list of "new media" accompanied by a breathless (and presentist) enumeration of all the new sensations offered by the new gadgets, we find a continual process of remediation of older forms. The great orders of aesthetics, classically represented in painting, poetry, and music, persist even in the most hypermediated digital worlds: videogames consist of spectacular visual images, sound effects, and verbal elements such as speech and writing. The proportions of these elements of media aesthetics may vary, but their necessary co-presence does not. For media to change fundamentally, to move outside these persistent aesthetic registers, would require a radical transformation in the sensuous universe that we inhabit. We would have to become creatures with an entirely different kind of sensorium, blind, deaf, and mute or illiterate, but capable of communicating in other modalities—perhaps by means of heat impulses (a variation of McLuhan's hot and cool media?) and ultraviolet rays. Even the most exotic aliens in the wildest science fiction fantasies, however, seem to use media remarkably similar to our own. The ferocious mother of the *Aliens* saga recognizes that she shares DNA with Ripley (Sigourney Weaver) by means of her sense of smell.

We would also have to be creatures with entirely different ways of making meaning and feeling emotion. The image/sound/text triad is not only grounded in fundamental sensory/aesthetic modalities but in basic semiotic and psychological registers. Consider, for instance, that Kittler grounds his gramophone/film/typewriter triad in the Lacanian registers of the Real, Imaginary, and Symbolic. The Imaginary and Symbolic are, of course, the domains of the visual and verbal media: the phenomena of the mirror stage and the scopic (seeing/showing) drive, on the one hand, and the law of the Symbolic, the "non/nom" of the father and the vocative (hearing/speaking) drive on the other. But why should music be associated with the Real? Is it because, like the Real, it is the least articulate and representational of the arts, expressing a longing for meaning that can never be

fully satisfied?[15] Or does it have to do, as Kittler argues, with the physiology of the ear and the physics of sound recording as a direct physical trace or index, an automatic writing in which the stylus traces sense and nonsense, music, speech, and noise with the same slavish fidelity.

Kittler's emphasis on the indexical quality of sound recording leads us inevitably into the great triad of semiotics mapped out by Charles Sanders Peirce: icon, index, and symbol.[16] Here the sensory and aesthetic modalities have been replaced by relations of signification and the production of meaning. Thus, the icon is *not* restricted to the sphere of *visual* imagery but covers all sign-functions of likeness, similitude, resemblance, and analogy. So a metaphor, a simile, or an algebraic expression of equivalence or congruence can be an icon as well as a picture. The index includes the physical trace, the sign by cause and effect, like tracks in the snow, but it also circulates in the domain of language in the form of deixis, signs by pointing that depend upon the "existential context" of the utterance. Thus, the temporal indices "now" and "then," and the spatial indices "here" and "there," join the demonstrative pronouns "this" and "that" and the personal pronouns "I" and "you" as *shifters* whose meaning depends on who is speaking to whom at what time and place. The verbal index, like the physical trace, the wound inflicted on the body, is the closest that language comes to the Real. Peirce's symbol, by contrast, is an artificial, arbitrary, and conventional sign. Like the signifier in Saussure's linguistics, it has no basis of resemblance to what it stands for (the word "tree" does not resemble a tree in any respect). It is what Peirce calls a "legisign," a sign produced by a law or code, and thus a premonition of the Lacanian Symbolic as Law.

A Peircean reading of Saussure's famous diagram of the linguistic sign, then, would reveal that language itself is a mixed medium, constructed out of the three elements of all possible signs. The signifier is a symbol, the word *tree*; the signified is an icon, the picture of a tree; and the entire structure is held together by a system of indices, including the arrows that

15. This is the basic claim of Michael Steinberg's marvelous essay "Music and Melancholy," *Critical Inquiry* 40, no. 2 (Winter 2014): 288–310.

16. Peirce, "Icon, Index, and Symbol," in *Philosophical Writings of Peirce,* ed. Justus Buchler (New York: Dover Publications, 1955). Peirce's famous remark that a photograph is both an index and an icon, since it is a sign by cause and effect as well as a sign by resemblance to what it represents, has been cited ad nauseum as his most important contribution to aesthetics. It is arguably his least important contribution.

Aristotle	*opsis*	*melos*	*lexis*
Barthes	image	music	text
Lacan	Imaginary	Real	Symbolic
Kittler	film	gramophone	typewriter
Goodman	sketch	score	script
Peirce	icon	index	symbol
Foucault	seeable	[X]	sayable
Hume	similarity	cause and effect	convention
Saussure	🌳	bar	arbor
	(signified)		(signifier)

indicate the circuit of meaning between the symbolic signifier and the mental image or signified, and the bar between them.

Media aesthetics, then, may have the potential to reveal a transhistorical structure that is congruent with the insights of media semiotics, not to mention Aristotle's *Poetics*, Lacan's psychic registers, and Kittler's technical media. It has not escaped my notice, as I type these words on my computer, that the interface in front of me consists of words and typographic symbols, visual images and icons, and an ever-elusive pointer (the index) that shows me where I am located in the text. None of this would have surprised David Hume, who codified the fundamental laws of the association of ideas in terms of resemblance, cause and effect, and arbitrary connectedness. Or the philosopher Nelson Goodman, who rigorously restricted himself to a description of notational systems in his *Languages of Art*, and came up with the alliterative triad "Score, Script, and Sketch."[17] We return, then, to the table introduced in chapter 4 ("Image X Text"), now understood as a way of showing at a glance the triangulation of media aesthetics, semiotics, and psychology. Of course I recognize that these terms have their life in radically different systems of thought, articulated by thinkers who could not be more different in their ambitions. For me, the strong elements are the horizontal rows laying out the basic elements of these systems. The weak elements are the columns, each of which would require much more thorough argumentation to stand up as the supports of a theoretical architecture.

I recognize that the claim to have uncovered a transcendental schema underlying media aesthetics will be deeply unpopular in an age when we are admonished to "always historicize" and to respect the diversity, particularity, and specificity of cultures. I confess that I have never under-

17. Goodman, *Languages of Art* (Indianapolis: Hackett, 1976).

stood this fetishization of historical particularity and that, as a theorist, my deliberately perverse advice is "always anachronize." We cannot see or sort particulars, in media or anything else, without generalities and universals. We cannot analyze mixtures and hybrid formations without an understanding of the elements that go into them. And we cannot historicize, much less respect cultural diversity, or the multiplicity of media aesthetics, without some framework of differentiation and comparison, some way of thinking the relation of now and then, here and there. If you find this degree of systematic schematization toxic, consider it nothing more than a McLuhanesque "probe."

10.1 René Descartes, engraving from *Optics* (seventeenth century). Photograph: Special Collections Research Center, University of Chicago Library.

10: THERE ARE NO VISUAL MEDIA

"Visual media" is a colloquial expression used to designate things like TV, movies, photography, painting, and so on. But it is highly inexact and misleading. All the so-called visual media turn out, on closer inspection, to involve the other senses (especially touch and hearing). All media are, from the standpoint of sensory modality, "mixed media." The obviousness of this raises two questions: (1) Why do we persist in talking about some media as if they were exclusively visual? Is this just a shorthand for talking about visual *predominance*? And if so, what does "predominance" mean? Is it a quantitative issue (*more* visual information than aural or tactile)? Or a question of qualitative perception, the sense of things reported by a beholder, audience, viewer/listener? (2) Why does it matter what we call "visual media"? Why should we care about straightening out this confusion? What is at stake?

First, let me belabor the obvious. Can it really be the case that there are no visual media despite our incorrigible habit of talking as if there were? My claim can, of course, be refuted with just a single counterexample. So let me anticipate this move with a roundup of the usual suspects, commonly proposed as examples of purely or exclusively visual media. Let's rule out, first, the whole arena of mass media—television, movies, radio—as well as performance media (dance, theater). From Aristotle's observation that drama combines the three orders of *lexis*, *melos*, and *opsis* (words, music, and spectacle) to Barthes' survey of the "image/music/text" divisions of the semiotic field, the mixed character of media has been a central postulate. Any notion of purity seems out of the question with these ancient and modern media, from the standpoint both of the sensory and semiotic elements internal to them and of what is external in their promiscuous audience composition. And if it is argued that silent film was a "purely visual" medium, we need only remind ourselves of a simple fact of film history—that the silents were always accompanied by music and speech, and the film texts themselves often had written or printed words inscribed on them. Subtitles, intertitles, and spoken and musical accompaniment made "silent" film anything but.

If we are looking for the best case of a purely visual medium, painting seems like the obvious candidate. It is, after all, the central, canonical medium of art history. And after an early history tainted by literary considerations, we do have a canonical story of purification, in which painting emancipates itself from language, narrative, allegory, figuration, and even the representation of nameable objects in order to explore something called "pure painting," characterized by "pure opticality." This argument, most famously circulated by Clement Greenberg, and sometimes echoed by Michael Fried, insists on the purity and specificity of media, rejecting hybrid forms, mixed media, and anything that lies "between the arts" as a form of "theater" or rhetoric, dooming them to inauthenticity and second-rate aesthetic status.[1] It is one of the most familiar and threadbare myths of modernism, and it is time now to lay it to rest. The fact is that even at its purest and most single-mindedly optical, modernist painting was always, to echo Tom Wolfe's phrase, "painted words."[2] The words were not those of history painting or poetic landscape or myth or religious allegory, but the discourse of theory, of idealist and critical philosophy. This critical discourse was just as crucial to the comprehension of modernist painting as the Bible or history or the classics were to traditional narrative painting. Without the latter, a beholder would be left standing in front of Guido Reni's *Beatrice Cenci the Day before Her Execution*, in the situation of Mark Twain, who noted that an uninstructed viewer who did not know the title and the story would have to conclude that this was a picture of a young girl with a cold, or young girl about to have a nosebleed. Without the former, the uninstructed viewer would (and did) see the paintings of Jackson Pollock as "nothing but wallpaper."

Some will object that the "words" that make it possible to appreciate and understand painting are not *in* the painting in the same way that the words of Ovid are illustrated in a Claude Lorrain. And you might be right; it would be important to distinguish the different ways language enters painting. But that is not my aim here. My present task is only to show that the painting we have habitually called "purely optical," exemplifying a purely visual use of the medium, is anything but. The question of precisely

1. Greenberg's arguments appear in his classic essays "Toward a Newer Laocoon," *Partisan Review* (1940), and "Avant Garde and Kitsch," *Partisan Review* (1939), reprinted in *Clement Greenberg: The Collected Essays and Criticism*, ed. John O'Brian, 2 vols. (Chicago: University of Chicago Press, 1986). Fried's antitheatrical polemic first appeared in "Art and Objecthood," *Artforum* (June 1967), reprinted in *Art and Objecthood: Essays and Reviews* (Chicago: University of Chicago Press, 1998).
2. Wolfe, *The Painted Word* (New York: Bantam Books, 1976).

how language enters into the perception of these pure objects will have to wait for another occasion.

Suppose it were the case that language could be absolutely banished from painting? I don't deny that this was a characteristic desire of modernist painting, symptomatized by the ritualistic refusal of titles for pictures, the enigmatic challenge of the "untitled" to the viewer. Suppose for a moment that the viewer could look without verbalizing, could see without (even silently, internally) subvocalizing associations, judgments, and observations. What would be left? Well, one thing that would obviously be left is the observation that a painting is a handmade object, one of the crucial things that differentiates it from, say, the medium of photography, where the look of mechanical production is often foregrounded. (I leave aside for the moment the fact that a painter can do an excellent job of imitating the machinic look of a glossy photo and that a photographer with the right techniques can, similarly, imitate the painterly surface and *sfumato* of a painter). But what is the perception of the painting as handmade if not a recognition that a nonvisual sense is encoded, manifested, and indicated in every detail of its material existence? (Robert Morris's *Blind Time Drawings*, drawn by hand with powdered graphite on paper, according to rigorous procedures of temporal and spatial targeting that are duly recorded in hand-inscribed texts on the lower margin, would be powerful cases for reflection on the quite literally nonvisual character of drawing). The nonvisual sense in play is, of course, the sense of touch, which is foregrounded in some kinds of painting (when "handling," impasto, and the materiality of the paint is emphasized) and backgrounded in others (when a smooth surface and clear, transparent forms produce the miraculous effect of rendering the painter's manual activity invisible). Either way, the beholder who knows nothing about the theory behind the painting, or the story or the allegory, need only understand that this is a painting, a handmade object, to understand that it is a trace of manual production, that everything one sees is the trace of a brush or a hand touching a canvas. Seeing painting is seeing touching, seeing the hand gestures of the artist, which is why we are so rigorously prohibited from touching the canvas ourselves.

This argument is not, by the way, intended to consign the notion of pure opticality to the dustbin of history. The point is, rather, to assess what its historical role in fact was, and why the purely visual character of modernist painting was elevated to the status of a fetish concept, despite abundant evidence that it was a myth. What was the purification of the visual medium all about? What form of contamination was being attacked? In the

name of what form of sensory hygiene and (as Jacques Rancière would put it) "redistribution of the sensible"?[3]

The other media that occupy the attention of art history seem even less likely to sustain a case for pure opticality. Architecture, the impurest medium of all, incorporates all the other arts in a *gesamstkunstwerk*, and it is typically not even "looked at" with any concentrated attention, but rather perceived, as Walter Benjamin noted, in a state of distraction.[4] Architecture is not primarily about seeing but about dwelling and inhabiting. Sculpture is so clearly an art of the tactile that it seems superfluous to argue about it. This is the one so-called visual medium, in fact, that has a kind of direct accessibility to the blind. Photography, the latecomer to art history's media repertoire, is typically so riddled with language, as theorists from Barthes to Victor Burgin have shown, that it is hard to imagine what it would mean to call it a purely visual medium. Its specific role in what Joel Snyder has called "picturing the invisible"—showing us what we do not or cannot see with the "naked eye" (rapid body motions, the behavior of matter, the ordinary and everyday) makes it difficult to think of it as a visual medium in any straightforward sense.[5] Photography of this sort might be better understood as a device for translating the unseen or unseeable into something that looks like a picture of something we could see if we had incredibly keen eyesight or different habits of attention.

From the standpoint of art history in the wake of postmodernism, it seems clear that the last half century has decisively undermined any notion of purely visual art. Installations, mixed media, performance art, conceptual art, site specific art, minimalism, and the often-remarked return to pictorial representation have rendered the notion of pure opticality a mirage that is retreating in the rear-view mirror. For art historians today, the safest conclusion would be that the notion of a purely visual work of art was a temporary anomaly, a deviation from the much more durable tradition of mixed and hybrid media.

Of course this argument can go so far that it seems to defeat itself. How, you will object, can there be any mixed media or multimedia productions

3. Rancière, "The Distribution of the Sensible," in *The Future of the Image* (New York: Verso, 2009); Caroline Jones, *Eyesight Alone: Clement Greenberg and the Bureaucratization of the Senses* (University of Chicago Press, 2008).

4. "Architecture has always offered the prototype of an artwork that is received in a state of distraction." "The Work of Art in the Age of Its Reproducibility," in *Walter Benjamin: Selected Writings* (Cambridge, MA: Harvard University Press, 2002), 3:119.

5. Snyder, "Picturing Vision," *Critical Inquiry* 6, no. 3 (Spring 1980): 499–526.

unless there are elemental, pure, distinct media out there to go into the mix? If all media are always and already mixed media, then the notion of mixed media is emptied of importance, since it would not distinguish any specific mixture from any purely elemental instance. Here, I think, we must take hold of the conundrum from both ends and recognize that one corollary of the claim that "there are no visual media" is that *all media are mixed media.* That is, the very notion of a medium and of mediation already entails some mixture of sensory, perceptual, and semiotic elements. There are no purely auditory, tactile, or olfactory media either. This conclusion does not lead, however, to the impossibility of distinguishing one medium from another. What it makes possible is a more precise differentiation of mixtures. If all media are mixed media, they are not all mixed in the same way, with the same proportions of elements. A medium, as Raymond Williams puts it, is a "material social practice," not a specifiable essence dictated by some elemental materiality (paint, stone, metal) or by technique or technology.[6] Materials and technologies go into a medium, but so do skills, habits, social spaces, institutions, and markets. The notion of "medium specificity," then, is never derived from a singular, elemental essence: it is more like the specificity (and plural singularity) associated with recipes in cooking: many ingredients, combined in a specific order in specific proportions, mixed in particular ways, and cooked at specific temperatures for a specific amount of time. One can, in short, affirm that there are no "visual media," that all media are mixed media, without losing the concept of medium specificity.[7]

With regard to the senses and media, Marshall McLuhan glimpsed this point long ago when he posited different "sensory ratios" for different media.[8] As a shorthand, McLuhan was happy to use terms like "visual" and "tactile" media, but his surprising claim (which has been mostly forgotten or ignored) was that television (usually taken to be the paradigmatically visual medium) is actually a *tactile* medium: "The TV image . . . is an extension of touch" (334), in contrast to the printed word, which in McLuhan's view, was the closest any medium has come to isolating the visual sense. McLuhan's larger point, however, was definitely not to remain content with

6. Williams, "From Medium to Social Practice," in *Marxism and Literature* (New York: Oxford University Press, 1977), 158–64.

7. Rosalind Krauss comes close to this account when she describes a medium as a "self-differentiating" entity in "The Post-Medium Condition." Krauss, *Voyage on the North Sea: Art in the Age of the Post-Medium Condition* (New York: Thames and Hudson, 2000), 53.

8. *Understanding Media* (1964; Cambridge, MA: MIT Press, 1994), 18.

identifying specific media with isolated, reified sensory channels, but to assess the specific mixtures of specific media. He may call the media "extensions" of the sensorium, but it is important to remember that he also thought of these extensions as "amputations" and continually stressed the dynamic, interactive character of mediated sensuousness. His famous claim that electricity was making possible an extension (and amputation) of the "sensory nervous system" was really an argument for an extended version of the Aristotelian concept of a *sensus communis*, a coordinated (or deranged) "community" of sensation in the individual, extrapolated as the condition for a globally extended social community, the "global village."

The specificity of media, then, is a much more complex issue than reified sensory labels such as "visual," "aural," and "tactile." It is, rather, a question of specific sensory ratios that are embedded in practice, experience, tradition, and technical inventions. And we also need to be mindful that media are not *only* extensions of the senses, calibrations of sensory ratios. They are also symbolic or semiotic operators, complexes of sign-functions. If we come at media from the standpoint of sign theory, using Peirce's elementary triad of icon, index, and symbol (signs by resemblance, signs by cause and effect or "existential connection," and conventional signs dictated by a rule), then we also find that there is no sign that exists in a "pure state," no pure icon, index, or symbol. Every icon or image takes on a symbolic dimension the moment we attach a name to it, an indexical component the moment we ask how it was made. Every symbolic expression, down to the individual letter of the phonetic alphabet, must also resemble every other inscription of the same letter sufficiently to allow iterability, a repeatable code. The symbolic depends upon the iconic in this instance. McLuhan's notion of media as "sensory ratios" needs to be supplemented with a concept of "semiotic ratios," specific mixtures of sign-functions that make a medium what it is. Cinema, then, is not just a ratio of sight and sound, but of images and words and of other differentiable parameters such as speech, music, and noise.

The claim that there are no visual media is thus really just the opening gambit in the pursuit of a new concept of *media taxonomy*, one that would leave behind the reified stereotypes of "visual" or "verbal" media and produce a much more nuanced, highly differentiated survey of types of media. A full consideration of such a taxonomy is beyond the scope of this paper, but a few preliminary observations are in order. First, the sensory or semiotic elements need much further analysis, both at an empirical or phenomenological level and in terms of their logical relations. It will not have escaped the alert reader that two triadic structures have

emerged as the primitive elements of media: the first is what Hegel called the "theoretic senses"—sight, hearing, and touch—as the primary building blocks of any sensuous mediation; the second is the Peircean triad of sign-functions.[9] Whatever sorts of sensory/semiotic "ratios" are deployed will be complexes of at least these six variables.

The other issue that would need further analysis is the question of "ratio" itself. What do we mean by a sensory or semiotic ratio? McLuhan never really developed this question, but he seems to have meant several things by it. First, the notion that there is a relation of dominance/subordination, a kind of literal realization of the "numerator/denominator" relation in a mathematical ratio.[10] Second, that one sense seems to activate or lead to another, most dramatically in the phenomenon of synesthesia, but far more pervasively in the way, for instance, that the written word appeals directly to the sense of sight but immediately activates audition (in subvocalization) and secondary impressions of spatial extension that may be either tactile or visual—or involve other, "subtheoretic" senses such as taste and smell. Third, there is the closely related phenomenon I would call "nesting," in which one medium appears inside another as its content (television, notoriously, treated as the content of film, as in movies like *Network*, *Quiz Show*, *Bamboozled*, and *Wag the Dog*).

McLuhan's aphorism, "the content of a medium is always an earlier medium," gestured toward the phenomenon of nesting, but unduly restricted it as a historical sequence.[11] In fact, it is entirely possible for a later medium (TV) to appear as the content of an earlier one (movies), and it is even possible for a purely speculative, futuristic medium, some as yet unrealized technical possibility (like teleportation or matter transfer) to appear as the content of an earlier medium (I consider David Cronenberg's *The Fly* the classic example of this fantasy, but the ritual request "Beam me up Scottie," on almost every episode of *Star Trek*, renders this purely imaginary medium almost as familiar as walking through a door). Our

9. Hegel, *Lectures on Fine Art*, trans. T.M. Knox 2 vols. (New York: Oxford University Press, 1998), Vol. 2, 622. Charles Sanders Peirce, "Logic as Semiotic: The Theory of Signs," *Philosopohical Writings of Peirce*, ed. Justus Buchler (New York: Dover, 1955).
10. The numerator is, of course, the subordinate element in a ratio. It is the denominator that (as the word indicates) names the *kind* of fraction (thirds, fourths, fifths, etc.); the numerator simply tells you how many of those fractional elements are to be counted.
11. The most thorough exploration of this aspect of McLuhan's thought is Jay David Bolter and Richard Grusin's *Remediation: Understanding New Media* (Cambridge, MA: MIT Press, 2000).

principle here should be: any medium may be nested inside another, and this includes the moment when a medium is nested inside itself—a form of self-reference that I have elsewhere discussed as a "metapicture" and that is crucial to theories of enframing in narrative.

Fourth, there is a phenomenon I would call "braiding," when one sensory channel or semiotic function is woven together with another more or less seamlessly, most notably in the cinematic technique of synchronized sound. The concept of "suture" that film theorists have employed to describe the method for stitching together disjunctive shots into a seemingly continuous narrative is also at work whenever sound and sight are fused in a cinematic presentation. Of course, a braid or suture can be unraveled, and a gap or bar can be introduced into a sensory/semiotic ratio, which leads us to a fifth possibility: signs and senses moving on parallel tracks that never meet but are kept rigorously apart, leaving the reader/viewer/beholder with the task of "jumping the tracks" and forging connections subjectively. Experimental cinema in the 1960s and 1970s explored the desynchronization of sound and sight, and literary genres such as ekphrastic poetry evoke the visual arts in what we loosely call a "verbal" medium. Ekphrasis is a verbal representation of visual representation—typically a poetic description of a work of visual art (Homer's description of Achilles's shield being the canonical example). The crucial rule of ekphrasis, however, is that the "other" medium, the visual, graphic, or plastic object, is never made visible or tangible *except* by way of the medium of language.[12] One might call ekphrasis a form of nesting without touching or suturing, a kind of action-at-distance between two rigorously separated sensory and semiotic tracks, one that requires completion in the mind of the reader. This is why poetry remains the most subtle, agile master-medium of the *sensus communis*, no matter how many spectacular multimedia inventions are devised to assault our collective sensibilities.

If there is any shred of doubt lingering that there are no visual media, that this phrase needs to be retired from our vocabulary or completely redefined, let me clinch the case with a brief remark on unmediated vision itself, the "purely visual" realm of eyesight and seeing the world around us. What if it turned out that vision itself was not a visual medium? What if, as Gombrich noted long ago, the "innocent eye," the pure, untutored optical organ, was in fact *blind*.[13] This, in fact, is not an idle thought but a firmly

12. See my "Ekphrasis and the Other," in *Picture Theory* (Chicago: University of Chicago Press, 1994), chapter 5.
13. Gombrich, *Art and Illusion* (Princeton, NJ: Princeton University Press, 1956).

established doctrine in the analysis of the visual process as such. Ancient optical theory treated vision as a thoroughly tactile and material process, a stream of "visual fire" and phantom *eidola* flowing back and forth between the eye and the object. Descartes famously compared seeing to touching in his analogy of the blind man with two walking sticks. (See figure 10.1). Vision, he argued, must be understood as simply a more refined, subtle, and extended form of touch, as if a blind man had very sensitive walking sticks that could reach for miles. Bishop Berkeley's *New Theory of Vision* argued that vision is not a purely optical process but involves a "visual language" requiring the coordination of optical and tactile impressions in order to construct a coherent, stable visual field.[14] Berkeley's theory was based in the empirical results of cataract operations that revealed the inability of blind persons whose sight had been restored after an extended period to recognize objects until they had done extensive coordination of their visual impressions with touch. These results have been confirmed by contemporary neuroscience, most famously by Oliver Sacks's revisiting of the whole question in "To See and Not See," a study of restored sight that exposes just how difficult it is to learn to see after an extended period of blindness.[15] Natural vision itself is a braiding and nesting of the optical and the tactile.

The sensory ratio of vision as such becomes even more complicated when it enters into the region of emotion, affect, and intersubjective encounters in the visual field—the region of the "gaze" and the scopic drive. Here we learn (from Sartre, for instance) that the gaze (as the feeling of being seen) is typically activated not by the eye of the other, or by any visual object, but by the invisible space (the empty, darkened window) or even more emphatically by sound—the creaking board that startles the voyeur, the "hey you" that calls to the Althusserean subject.[16] Lacan further complicates this issue by rejecting even the Cartesian model of tactility in "The Line and the Light," replacing it with a model of fluids and overflow, one in which pictures, for instance, are to be drunk rather than seen, painting is likened to the shedding of feathers and the smearing of shit, and the principal function of the eye is to overflow with tears, or (in the case of "invidia" or the evil eye) to dry up the breasts of a nursing mother.[17] There

14. Berkeley, *A New Theory of Vision* (Dublin: J. Pepyat, 1709).

15. Sacks, "To See and Not See," *New Yorker*, May 10, 1993.

16. Sartre, "The Look," in *Being and Nothingness*, trans. Hazel E. Barnes (New York: Washington Square Press, 1966).

17. Lacan, in *Four Fundamental Concepts of Psychoanalysis*, trans. Alan Sheridan (New York: W. W. Norton, 1998).

are no purely visual media because there is no such thing as pure visual perception, no "eye" that can be completely detached from the sensorium, in the first place.

Why does all this matter? Why quibble about an expression, "visual media," that seems to pick out a general class of things in the world, however imprecisely? Isn't this like someone objecting to lumping bread, cake, and cookies under the rubric of "baked goods." Actually, no. It's more like someone objecting to putting bread, cake, chicken, a quiche, and a cassoulet into the category "baked goods" because they all happen to go into the oven. The problem with the phrase "visual media" is that it gives the illusion of picking out a class of things about as coherent as "things you can put in an oven." Writing, printing, painting, hand gestures, winks, nods, and comic strips are all "visual media," and this tells us next to nothing about them. So my proposal is to put this phrase into quotation marks for a while, to preface it with "so-called," in order to open it up to fresh investigation. And in fact that is exactly what I think the emergent field of visual culture has been all about in its best moments. Visual culture is the field of study that refuses to take vision for granted, that insists on problematizing, theorizing, critiquing, and historicizing the visual process as such. It is not merely the hitching of an unexamined concept of "the visual" onto an only slightly more reflective notion of culture—that is, visual culture as the "spectacle" wing of cultural studies. A more important feature of visual culture has been the sense in which this topic requires an examination of resistances to purely culturalist explanations, to inquiries into the nature of visual *nature*—the sciences of optics, the intricacies of visual technology, the hardware and software of seeing.

Some time ago Tom Crow had a good laugh at the expense of visual culture by suggesting that it has the same relation to art history as popular fads such as New Age healing, "Psychic Studies," or "Mental Culture" have to philosophy.[18] Not only does this seem a bit harsh; it also rather inflates the pedigree of a relatively young discipline like art history to compare it with the ancient lineage of philosophy. But Crow's remark might have a tonic effect, if only to warn visual culture against lapsing into a faddish pseuedoscience, or even worse, into a prematurely bureaucratized academic department complete with letterhead, office space, and a secretary. Fortunately, we have plenty of disciplinarians around (Mieke Bal, Nicholas Mirzoeff, and Jim Elkins come to mind) who are committed to making

18. Tom Crow, response to questionnaire on visual culture, *October*, no. 77 (Summer 1996), 34–36.

things difficult for us, so there is hope that we will not settle into the intellectual equivalent of astrology or alchemy.

The breakup of the concept of "visual media" is surely one way of being tougher on ourselves. And it offers a couple of positive benefits. I have already suggested that it opens the way to a more nuanced taxonomy of media based in sensory and semiotic ratios. But most fundamentally, it puts "the visual" at the center of the analytic spotlight rather than treating it as foundational concept that can be taken for granted. Among other things it encourages us to ask why and how "the visual" became so potent as a reified concept. How did it acquire its status as the "sovereign" sense, and its equally important role as the universal scapegoat, from the "downcast eyes" that Martin Jay has traced, to Debord's "society of the spectacle," Foucauldian "scopic regimes," Virilian "surveillance," and Baudrillardian "simulacra." Like all fetish objects, the eye and the gaze have been both over- and underestimated, idolized and demonized. Visual culture at its most promising offers a way to get beyond these "scopic wars" into a more productive critical space, one in which we would study the intricate braiding and nesting of the visual with the other senses, reopen art history to the expanded field of images and visual practices that was the prospect envisioned by Warburgean art history, and find something more interesting to do with the offending eye than plucking it out. It is because there are no visual media that we need a concept of visual culture.

11.1 Anne-Louis Girodet de Roussy-Trioson, *The Origin of Drawing* (1819). Engraving from *Oeuvres posthumes*. Photograph: Special Collections Research Center, University of Chicago Library.

11: BACK TO THE DRAWING BOARD

Architecture, Sculpture, and the Digital Image

Walter Benjamin remarks at the conclusion of his classic essay "Kunstwerk" that "architecture has always offered the prototype of a work of art that is received in a state of distraction."[1] Count me among that distracted collectivity that recognizes, with Benjamin, that architecture's history "is more ancient than that of any other art," and that it is a "living force" that has importance in "every attempt to comprehend the relationship of the masses to art," at the same time that I have to confess a fair amount of ignorance about the inner world of professional architectural practice. I write here as a consumer, a spectator and user of architecture, not as an expert.[2]

The fundamental question asked at the 2008 Bauhaus symposium was what the effects of digital imaging have been on the production and reception of architecture. One hears on every side grand, utopian claims about the unlimited possibilities offered by "paperless studios" and direct translation of computer design into the production of materials and modular units for construction. It seems, if one can trust the architecture magazines, that we have entered a brave new world where everything is possible and nothing is out of bounds: if it can be imagined, and "imagineered" on a computer terminal, then it can be built.

I think there are good reasons for being skeptical about the more euphoric claims that surround architecture in the so-called digital age. Although it's clear that the computer has made an enormous difference in certain aspects of architectural design and construction, it may not always be the emancipatory, progressive difference that it is often portrayed to be. Liberation from the material resistance of a medium may lead to a kind of architectural flatulence, a throwing up of ornamental effects and spectacle as nothing more than a manner or automatism of conspicuous

1. "The Work of Art in the Age of Its Reproducibility," in *Walter Benjamin: Selected Writings* (Cambridge, MA: Harvard University Press, 2002), 3:119.
2. I am very grateful to architectural historian Katherine Taylor of the University of Chicago Deparment of Art History for invaluable advice, and to Anthony Raynsford for the key reminder that architecture is basically drawing.

consumption. I am reminded of the moment in the evolution of electronic music when the "classic studio" of wave-form generators and manually controlled tape decks was replaced by the Moog Synthesizer, which made all sorts of preprogrammed "special effects" available at the touch of a key, a breakthrough that led to the production of a great many predictable, cliché-ridden sound-effects. Sometimes the resistance of a medium is a good thing, and it may be (as copperplate engraving once showed us) the very condition of certain kinds of hard-won virtuosity and inventiveness.

So: my aim here will be to slow down the discussion a bit, and to urge a more patient analysis of claims that we live in a "digital age," and that certain consequences flow ineluctably from this supposed fact. Since I speak as a nonexpert, and an outsider to the professional concerns of the architectural community, I offer these comments with considerable hesitation, and subject to correction. My own expertise is in the areas of image theory, media, and visual culture. My strategy, therefore, will be to reflect on some notable features of spectacular, attention-getting architecture in our time, especially as it engages with two closely related media, the graphic and sculptural arts. These two media seem necessarily connected to the problem of architecture, if only because, on the one hand, so much contemporary architecture seems to aspire to the condition of sculpture and, on the other, architecture "proper" is primarily a graphic, imaging activity, and not the actual activity of erecting buildings. Even before the onset of the digital image, Thomas Creighton, the editor of *Progressive Architecture*, could argue that a "new sensualism" in architecture was being driven by the model of sculpture, with abandonment of "restraint" and its freedom to produce forms "that can be warped and twisted at will."[3] "This is not the application of sculpture to architecture," argued Creighton, "but rather the handling of architecture as sculpture."

On the other flank of architectural practice is drawing and draftsmanship, now undergoing the technical transformation summed up by the concept of the digital image and the techniques of computer-aided drawing (CAD). But what is the digital image? The easiest answer is: an image that can be produced, manipulated, stored, and retrieved by a computer. But what does this really mean? How does this affect the quality of the image, any image? Is it the easy manipulability of the image? The possibility of morphing and transforming it in innumerable ways? Or is it the portability of the image, the ease with which it can be transmitted

3. Quoted in Joseph Rosa, *Folds, Blobs, and Boxes: Architecture in the Digital Era* (Heinz Architectural Center, Pittsburgh, 2001), 9.

instantaneously around the globe? Is it the metadata that accompanies the image, making it a self-archiving bundle of information that carries with it not only the graphic analog content but a string of second-order information about its provenance and modifications?

All these are undoubtedly momentous changes in the way images function for us, but it is important to keep in mind one equally important way in which images have not changed under the digital regime: they are still images *for us*, for embodied human beings with standard sensory and perceptual equipment. It doesn't matter whether they are representational or abstract, artistic or popular, technoscientific displays or children's drawings. At the end of the day, they are still dense, iconic signs that acquire their meaning within the framework of an analogical, not a digital code. (In a more extended discussion we would have to question in fact whether the analogical sign is "coded" at all, recalling Roland Barthes's famous observation that photography produces "images without a code").[4] No matter how many computational transformations it goes through inside a computer, the digital image is, at the beginning and end of the day, an *image*, an analog presentation. Unless we are programmers, we are not really interested in the digits in the digital image. We are interested in the analogical input and output, the image, as a sensuous presentation that employs an infinitely gradated set of signs, marks, and colors (or, for that matter, sounds, tones, beats). Digitization betrays the same ineluctable tendency toward the "return of the analog" in the realm of both visual and sound images.[5]

So the phrase "digital image" is in a very precise sense a kind of oxymoron: insofar as an image is *perceived* as digital, it is not an image at all but an array of arbitrary symbolic elements, alphanumeric signs that belong to a finite set of rigorously differentiated characters. At the simplest level, the digital is merely a string of ones and zeros that forms a statement or operation in a machine language; this is not an image, but a string of ones and zeros that can be translated into an image. The image is formed by, carried by, translated into digits, but it is not itself digital. One can see this clearly in the climactic scene of the mythic cinematic treatment of the digital age, *The Matrix*. When Neo sees through the veil of illusory

4. Barthes, *Camera Lucida* trans. Richard Howard (New York: Hill & Wang, 1981), 88; see also my discussion of the uncoded "wildness" of the iconic sign in *What Do Pictures Want? On the Lives and Loves of Images* (Chicago: University of Chicago Press, 2005), 9–10.

5. See Brian Massumi, "On the Superiority of the Analog," in *Parables for the Virtual* (Durham, NC: Duke University Press, 2002).

virtual images to the underlying digital reality, he understands that all those bodies and buildings were nothing but a flux of numbers and letters. But at the moment of this understanding there is a ghostly return of the displaced illusion in the form of the analog images of the agents, and the spectral traces of their illusory bullets. This is also the return of the image as such, the analog sign, the cinematic sign, that can never go all the way over to the digital without ceasing to be an image.[6]

This is also why we have to admit that, from a phenomenological standpoint that pays attention to the perceptual flutter of digital and analogic representations, digital images existed long before the invention of the computer or binary code. Images have been digitized since Australian Aboriginal painters developed a binary dot and line vocabulary of graphic characters suitable for sand painting. Grains of sand are the predecessors of pixels, with their indefinitely expanded reservoir of finitely differentiated elements. In a similar way, the warp and woof of weaving processes the image-appearance through a grid of binary choices. Digitization of the image is a consistent technical feature from mosaic tile to the mezzotint to the Ben-Day dots of newspaper photographs. But when we look at the graphic image, we do not look—at least for a moment—at the grains of sand, or the threads, tiles, or dots or pixels: we look at the image, the analog sign that magically appears out of the digital matrix. This is the duck-rabbit effect of the digital image in its extended sense.[7]

It is important, then, to exert some pressure on the commonplace notion that we live in a "digital age," as if digitization and binary codes were unknown before the invention of the Turing Machine. Right alongside the Turing Machine is an equally powerful invention/discovery: the architecture of the DNA molecule. The technical impact of the computer is not simply its capacity to reduce everything to ones and zeros, but its equally powerful capacity to *unreduce* or expand those ones and zeros to analog appearances. The computer does not represent a "victory of the digital" but a new mechanism for coordinating the digital and the analog. And it is crucial to stress this point at the level of tactility as well as visuality: a moment's reflection on the role of the human *hand* in relation to the computer should remind us of Bill Brown's tellingly nonredundant aphorism: "the digital age is the *digital* age," the era of carpal tunnel syndrome and er-

6. One could say, however, that this would be an image of the digital as such, a spectacularizing of the look of code.
7. See the discussion of the digital image in "Image Science" and "Realism and the Digital Image," chapters 3 and 5 above.

gonomic keyboards. Obsessive text messagers live in the age of the *thumb*, and of a generation that is "all thumbs."[8] We have invented in our time new forms of clumsiness along with new skill sets, automatisms, and habitual subroutines. What Friedrich Kittler has predicted as a "general digitization of channels and information" that will "erase the differences among individual media" has in fact produced just the opposite: a new Tower of Babel populated by machines that cannot communicate with other machines.[9] As is well known, for any two machines, a third is required to translate, adapt, or coordinate them. How many useless adapters and power transformers are cluttering your utility closet? How many remote controls that are supposed to be programmable to exert control (remotely) over other remote controls? How long does it take before the sense of control gives way to its opposite? How long before the copy and paste functions go mad and generate a virus or autoimmune disorder?

I have been speaking of machines, but (as the metaphor of the virus suggests) they are really stalking horses for something more like artificial life-forms—robots, cyborgs, and complex autopoetic systems as large as the Internet itself. If the digital age is the age of calculation, control, and programmability, it must be recognized equally as the age of incalculability, loss of control, and unprogrammability. That is why, right alongside the rhetoric of cybernetics, the "science of control," we are encountering the uncanny return of the archaic language of vitalism and animism in contemporary image theory. The digital age is the convergence of technoscience with magic—with new forms of totemism, fetishism, and idolatry, with what Bruno Latour has called "factishes."[10] The technoscientific dominant of our time, then, is not simply cybernetics but *biocybernetics*, the twin revolutions of information and life. The cultural icons of this double revolution are the computer and the clone, and, no doubt, the biomorphic forms of the architectural spaces they inhabit.[11]

One may question, of course, whether in the age of what has been called the "post-medium condition," when all media are mixed, hybrid, and remediated by digital technologies, there really is any such thing as a distinct medium. Hasn't architecture always been a hybrid, mixed medium, and

8. "All Thumbs," *Critical Inquiry* 30, no. 2 (Winter 2004): 452.

9. Kittler, *Gramaphone Film Typewriter* (Stanford, CA: Stanford University Press, 1999)., 1.

10. Latour, *On the Modern Cult of the Factish Gods* (Durham, NC: Duke University Press, 2010).

11. See my essay "The Work of Art in the Age of Biocybernetic Reproduction," in *What Do Pictures Want?*

hasn't it now gone completely virtual, existing as much in speculative, notional, and graphic or modular form as it does in actual building? And do not the buildings reflect this virtualization and liquidation, with the seemingly absolute malleability of shapes, materials, surfaces, and spaces? And does this not make for a convergence of architecture, so that structures like Frank Gehry's Bilbao Museum, or Daniel Libeskind's Jewish Museum in Berlin become a kind of expanded field of sculptural gestures, while Peter Eisenmann's Holocaust Memorial goes all the way over to the field of public sculpture, but in this case as *plaza*, a place of labyrinthine chasms and rolling contours, a landscape of monolithic gravestones, a social space of mourning and sunbathing, solemn contemplation and frivolous hide and seek.

As for drawing, with its connotations of manual production, primal "first steps" toward the fabrication of three-dimensional, material objects, or its secondary role as the trace, the image "drawn after" objects made by nature or art: drawing remains closest to the center of the vortex of image production, the "fissure" in which Henri Focillon saw "crowds of images aspiring to birth."[12] Drawing is the crossroads of architecture and sculpture, emanating from and returning to the body. It remains linked directly to the hand/eye circuit, the scopic drive, and the Imaginary, even in the sphere of digital imaging and MacPaint. Think of Saul Steinberg's world-making draftsmen, delineating their own environments. Or of William Blake's Urizen, the divine, rational architect drawing the line between light and darkness as the fundamental structure of the visible universe. (See figure 8.2). Think of the legendary origin of drawing and its relation to sculpture in Pliny's *Natural History*: the Maid of Corinth traces the silhouette of her departing lover on the wall, thus inventing drawing, a medium grounded in desire, eros, and fantasy.[13] But then her father, Butades the potter, goes on to invent sculpture by making a three-dimensional relief portrait out of the sketch as a gift to his daughter. Both the drawing and the sculpture, however, depend upon two prior conditions: (1) the presence of architecture in its minimal form—the silent, blank wall on which the two-dimensional image is cast, traced, and then sculpted in three dimensions of "relief" from flatness—and (2) the human body, as both the center and periphery of architecture, what envisions it from without and inhabits it from within.

12. Focillon, *The Life of Forms in Art,* trans. Charles B. Hogan and George Kubler (New York: Zone Books, 1992) 11; original French publication, 1934.
13. See my essay "Drawing Desire," in *What Do Pictures Want* (Chicago: University of Chicago Press, 2005).

The body is not only what draws, but also what is drawn, both to sculpture and to architecture. The body is itself both building and statue, the temple and the statue of the god within. Whether body as building (as in the metaphor of the temple of the spirit) or building as body (complete with skeletal framework, outer skin, interiority, and orifices), whether clothed or naked, draped and ornamented or exposed and transparent, the body is both the thing that draws and what draws sculpture and architecture together.

The more these distinct media—architecture, drawing, and sculpture—seem to merge in these practices, the more indispensable becomes the invocation of their names, as though the ghosts of the traditional artistic media refused to be laid to rest. Architecture may now be nothing more than sculpture plus plumbing, and sculpture may be the homeless art, a superfluous ornament, or an annoying distraction. Ad Reinhardt famously defined sculpture as the thing you back into when you are trying to get a better view of a painting. Civic, public sculpture may now be reduced to a filigree, like the parsley next to the roast beef, or consigned to one of those aesthetic sanatoria known as the "sculpture park," while architecture muscles into the place formerly held by sculpture, establishing itself as an art of images, of iconic monuments that dominate the spaces around them, eye-catchers to the world.

But meanwhile above them all, drawing *rules*—in both senses of the word—as in the traditional rendering of the image of the divine architect, designing and ruling the world with his compasses. Architecture in its most archaic imaging was always more about drawing than building, and this drawing was from the first "digital" in both senses of the word—that is, a question of the fingers, of counting and measuring, and of a binary operation that divides the light from the darkness, inside from outside, the one from the zero. Even though critics have continued to claim (prematurely, as always) that painting is dead, drawing has clearly never been more virulently alive, penetrating every aspect of the production of real spaces. In its mutated form as computer-aided drawing, coupled with animation and three-dimensional simulations, graphic production dominates the world of design and construction, projecting a brave new world of supple, mobile forms that, when connected with industrial production, seem to "build themselves."[14] But before computer-aided drawing there

14. See Luis Eduardo Boza, "(Un)Intended Discoveries: Crafting the Design Process," *Journal of Architectural Education* 60, no. 2 (November 2006): 4–7, for a critique of CNC ("computer numeric controlled" fabrication machinery) and its relation to handcraft, intuition, and risk.

was another kind of CAD driven by desire and longing, a form of automatic drawing that predates the surrealists. Let us call it "Cupid-aided drawing" (see figure. 11.1).

So the truly strange thing about the ordering of contemporary media is that now, when technical instruments and codes seem to penetrate every aspect of reality, when grandiose architectural monuments rise on every side, the most archaic medium of representation, the art that is closest to the body, the one that expresses the intersection of the hand and eye in the most intimate of compositional spaces, should make a comeback as the dominant art form. And that it should be followed, as a close second, by that other archaic medium, the art of sculpture—and a style of sculpture, it should be noted, that is not especially innovative in relation to the actual practices of contemporary sculpture. Contemporary architecture most often mimics the look of Baroque and modernist painting and sculpture, either by elaborating highly modulated organic forms (Greg Lynn's Blobs), or by imitating the appearance of futurism, collage, and analytic cubism. The only thing being "rejected" by the new architecture is the modernist grid and the stable, rectilinear, perspectival structure of Cartesian space (invariably described in invidious terms as static and restrictive). Frank Gehry's Wiseman Museum in Minneapolis, for instance, is clearly a kind of analytic cubist "duck" fastened on to an interior that is fundamentally the modernist white cube, as if the sculpture and painting that would have inhabited that cube had exploded outward and fastened itself to the exterior. Compare a view of the Wiseman with a Braque composition from 1913, and you will see what I mean.

Of course architecture has always had a relationship to the graphic and sculptural arts (and to numbering, measurement, and geometry), as any tour from the Greek temple to the Gothic cathedral to the Renaissance palazzo would demonstrate. Italian Renaissance architecture and urban design would be unthinkable without the invention of artificial perspective.[15] But the ordering of the arts seemed to have a kind of stability in these styles. The walls (and even the windows) were for painting, and the atrium or apse or niche was the destined home of the statue or portrait bust. With modernism, however, something seemed to change, and a new dynamic entered into the ordering of the arts and media. Clement Greenberg, ever the proponent of "purity" in media, argued that "it is by virtue of its medium that each art is unique and strictly itself," and

15. See Marvin Trachtenberg, *Dominion of the Eye: Urbanism, Art and Power in Early Modern Florence* (Cambridge: Cambridge University Press, 1997).

Michael Fried contended with equal passion that "what lies between the arts" in the realm of "intermedia" is a kind of meretricious theatricality.[16] In this sense, modernism for these critics was a continuation of the classical values of "medium specificity" and propriety. But architecture played, for Greenberg, a strangely equivocal role in the new modernist synthesis. Greenberg argued that modern architecture had to be led out of the "eclectic historicism" of the nineteenth century into an "independent contemporary style" by painting. Cubist painting in particular was able to "reveal the new style in architecture to itself," and to emancipate it (along with sculpture) from its heavy materiality into a dynamic space of thrusts and energetic displacements. The international style of secular, rationalized spatial design, for Greenberg, united all the artistic media by treating "all *matter*, as distinguished from *space*, as two dimensional"—in short, as drawing or graphic design. All the modern arts were united, in Greenberg's view, by becoming abstract and weightless, and the new architectural materials of steel, glass, and reinforced concrete were just waiting for the visual and graphic styles of pictorial modernism to show the way to escape the gravitational field.

But each art had to become abstract in its own way. Despite the leading role played by painting in Greenberg's story of modernism, it is immediately threatened by "the architectural and social location for which [the painter] destines his product."[17] There is "a contradiction between the architectural destination of abstract art and the very, very private atmosphere in which it is produced" that "will kill ambitious painting in the end." Painting either has to become larger or smaller: the two-by-two framed easel painting is in crisis, leaving only two destinations: "the wall and the page"—in other words, the mural and the drawing. Greenberg's conclusion: "The best work of Picasso et al. in the last 20 years has been in black and white and in reduced format, the etchings and the pen and ink drawings." It is a strange Oedipal narrative of the relation between the graphic and architectural arts: modernist architecture is the prodigious offspring of modernist painting. But then the child kills the parent, or compels it to shrink down to its minimal form and play a merely ornamental role.

Are we now going through something similar with the invention of the

16. Greenberg, "Toward a Newer Laocoon," *Partisan Review* (1940); Fried, "Art and Objecthood," *Artforum* (June 1967).
17. Greenberg, "The Situation at the Moment," *Partisan Review* (January 1948); *Collected Essays*, 2:195.

digital image? Actually, I think not. Abstraction in painting, like the geo-metric grid in architecture, was a stylistic movement that had a dialectical relation to a past that had to be negated and a utopian future that was about to be realized. Contemporary architecture, however much it may be facilitated by digital imaging, has no such programmatic coherence. It is resolutely eclectic, freely appropriating every known architectural mode, from the hovel, cave, and labyrinth to the mushroom to the artichoke to the skyscraper. Digital imaging, in contrast to the role of the modernist graphic arts, has had (so far) mainly a functional, not an inspirational, role to play. It occupies two crucial niches in the architectural process: mar-keting and making. Digital imaging allows a kind of pre-viewing that was only dreamt of by the sculptural model builders, allowing the client a tour of the projected space that is almost invariably more wondrous than the actual experience of the built monument, in the sense that the consumer can enjoy an unlimited mobility and speed in relation to the architectural object, soaring between pedestrian and bird-eye views at the click of a mouse. (This reminds me of the way, in my childhood, that graphic ads for toys in catalogs and magazines always far outstripped the prosaic reality of the things themselves). Digital imaging and virtual-reality caves provide the ideal sales environment for architecture, an easy way to project a cin-ematic simulation of the proposed edifice that will, as we say in Chicago, dazzle the rubes. They are also an ideal mechanism for involving a public in critical discussion, with the aim of sending the architect back to the drawing board.

The more interesting and profound effect of digital imaging is its role in facilitating the transition from design to construction.[18] Here the in-terface is not with the consumer, but with the structural engineer and the manufacturer of materials and modular components (panels, windows, structural elements). This is perhaps where another utopian moment en-ters the picture: the sense of unbounded confidence that if something can be imagined, that is to say, drawn, it can be quantified and codified and realized materially. This is utopian, however, only in the positive sense of possibility, not in any critical sense of negation. It does not tell us what not to do, what to avoid; it only promises us freedom to do whatever we like, which is to say it tells us nothing about the most important questions: what *should* we like, and why? For that, we will have to wait until the rela-tively new media of digital graphics have some artistic accomplishments of their own to demonstrate, a possibility that will not be realized primarily

18. See Boza, op. cit., for a good discussion of this technology.

in architecture, but in cinema, video, photography, and painting, the arts of the screen and the two-dimensional surface.

This is why, when I hear cheery rhetoric about the wondrous architectural breakthroughs made possible by digital imaging, I want to reach for my wallet. And even more emphatically, when I hear that architecture has now taken over the role of sculpture, I want to reach for my gun. Consider, as an example, the hooplah in my hometown of Chicago about Santiago Calatrava's proposed (and, since 2006, suspended) "Spire" project. If this building is built, it may well achieve the (short-lived) goal of being the tallest structure in the world. It will no doubt become an iconic addition to—an exclamation point on—one of the most fabulous urban skylines in the world. But will it be a significant contribution to the world of sculpture? Or will it simply be an inflated example of the most conventional, clichéd item for sale in your local candle shop? (I will avoid the comparison to another familiar item available at your local hardware store).

Do we need digital imaging to imagine, draw, design, or build this building? Certainly digital imaging is helping to sell it, and would probably be important in producing the parts necessary to build it. But from the standpoint of imagination, invention, and drawing, it is utterly conventional and predictable, and the fact that a smaller model (less than half the size) already exists in Malmo, Sweden only underlines this point.

If contemporary architecture, liberated by digital imaging, aspires to the condition of sculpture, then, it does so mainly in relation to Baroque and modernist precedents, not in relation to contemporary sculptural practices. One need only survey some of the salient productions of sculptors over the last half century to see that sculpture has been involved in a *paragone* or debate with architecture, an ongoing deconstruction of its own history and of its inevitable architectural environment. Robert Morris's "specific objects," for instance, imitate the basic elements of architecture, such as the slab and beam, at the same time that it elevates the traditional support of sculpture (the plinth or pedestal) to the status of the primary object. Walter de Maria's *Earth Room* in New York City elevates the ground on which architecture stands, transforming architecture into the support of earth. Gordon Matta Clark literally cuts through and across architectural structures in a highly formalized demolition or vandalism, to reveal new angles on architectural spaces, what Terry Smith has called "the architecture of aftermath,"[19] and to deploy the cutout "discards" of the dem-

19. Smith, *The Architecture of Aftermath* (Chicago: University of Chicago Press, 2006).

olition process as sculptural objects in their own right. In works such as *Ghost*, Rachel Whiteread transforms the negative, empty space of a room into a solid cast object whose whiteness in turn renders this solidity as a spectral trace. Anish Kapoor's *Cloud Gate* performs a virtual deformation of the entire urban skyline of Chicago, rendering it as a crowd-pleasing anamorphic spectacle. And Richard Serra's *Tilted Arc* was designed to challenge, even to violate, the public space in which it was inserted—a violation that, far from being an accident, was essential to the ontology of the sculptural object, according to Serra. That is why removal of *Tilted Arc* from this specific site was, in his view, equivalent to its destruction.

In a tonality quite the opposite of Serra's defiance is Antony Gormley's sculptural engagement with architecture, from the elemental *Brick Man*, with its play on the reversible metaphor of building as body, to his declarations of the abasement and abjection of the body before the architectural monument (see *Close*), to his humorous *Home* as an inversion of the scalar relation of body and building, to his (usually temporary) placements of cast bodies as dramatically dislocated, out of place, and homeless (*Critical Mass*, *Total Strangers*). Gormley has also gone beyond de Maria's *Earth Room* by treating the *flooded* building as a sculptural object, or by invading architectural spaces in *Field* with thousands of tiny clay figures who remind us of a revolutionary mass pushing its way into the institutional space of the museum. He echoes Robert Gober's wall-piercing and gravity defying bodies with works such as *Edge* and *Learning to Think*, and defies the notion that sculpture is just architecture without plumbing in the disturbing cryogenic fantasy of *Sovereign State*, in which a bodily casket or pod becomes a kind of self-sustaining life support system, connected to a tangle of rubber hoses via the mouth and excretory organs. In the process photographs that accompany works like *Still Leaping*, we see the most vivid elaboration of Marshall McLuhan's observation that the architectural medium is an extension of the body, literally an outer shell serving as a kind of pod supported by a labyrinth of rafters and support beams extruded from hands and feet, head and groin. But it is probably in his *Allotment* series that Gormley comes closest to mirroring the widely acknowledged "bad object" of late modern architecture, namely Brutalism. *Allotment* is a series of concrete block castings that contain an inner negative space cast from an individual human body. This space is untouchable and invisible, except for the orifices provided for the ears, mouth, genitals, and anus. The overall impression is of a scale model Brutalist housing project, with one building per body—a body that (if one gives in to imaginative projection) has to be understood as completely paralyzed and immured in its cement

11.2 Antony Gormley, *Interior* (1991). Courtesy of the artist.

overcoat. A terrifying image, to be sure, but one that requires at the same time a calm meditation on the minimal conditions of bodily existence as mere sentience and freely imagined interiority.

Gormley renders these conditions in ink drawings—emphatically nondigital in their use of pouring and staining pigments to saturate the paper—that capture three "views" of the body/architecture relation: the view from outside the building seen as life-support pod (*Sovereign State*); from the inside out, as a prison cell (*Interior*); and from a deeper inside or transcendent outside (*Float*), as a liberated body flying like Icarus above the globe.

But I will give the final word—and the final image—on architecture's relation to drawing and sculpture to William Blake, whose figure of Urizen we have already seen, a model of the architect as divine draftsman, measuring and dividing, drawing the circumference of the world, drawing a distinction between light and darkness, the inner and the outer (see figure 8.2). Blake provides us with a pair of related images to complete our picture of the human body's production of space. One is the figure of Los,

11.3 Antony Gormley, *Sovereign State I* (1993). Courtesy of the artist.

11.4 Antony Gormley, *Float II* (1992). Courtesy of the artist.

the sculptor, resting on his hammer as he contemplates the glowing, fiery sun that he has forged on his anvil (figure 8.3). (In other compositions, Blake will transform Urizen's compass into Los's tongs, as if to enact in a graphic simile the transition from virtually drawn to materially realized form.) But the other, Blake's final image of world-making (figure 8.1), is by far the most striking, original, and disturbing: it shows the artist/architect as a maternal figure, "brooding" over a globe of blood that can be read alternately as an embryo enwombed and connected to its parent by way of its placental life-support, or as a world created by a massive wound that draws off the life of its creator.

Perhaps this is the metapicture of the architect that we need to ponder with the most concentrated attention. It reminds us of Henri Lefebvre's argument that the social production of space is not only a product of designers and draftsmen—the "conceived space" of architects and planners—and not only a product of the engineers and builders who transform those designs into hard-edged material structures. Space is also lived and blindly "secreted" by human productive and reproductive practices. We often speak innocently of a "man-made world," but there are other metaphors for the engendering of our world, as an organism and an ecosystem that has been gestating for the entire life-span of the human species, and which now seems engaged in a momentous labor to be born—or not. In an age, not of digital images but of biopictures, not of cybernetics but of biocybernetics, it would seem that architecture has a more demanding task in front of it than the erection of spectacular attractions and iconic monuments. Time to return to its original vocation of imagining a sustainable habitat for the survival and continued evolution of life-forms on this planet. Back to the drawing board!

12.1 Mahmud Hams, "Egyptian protesters carry an obelisk in Tahrir Square" (2012). Photograph: AFP/Getty Images.

12: FOUNDATIONAL SITES AND OCCUPIED SPACES

There is no way to establish fully secured, neat protocol statements as starting points of the sciences. There is no tabula rasa. We are like sailors who have to rebuild their ship on the open sea, without ever being able to dismantle it in dry-dock and reconstruct it from its best components.

OTTO NEURATH[1]

The idea of a "foundational site," or *Grundungsorte*, is in a quite literal sense the most fundamental *topos* one could imagine. For a rhetorician, the *topos*, or topic, is itself a place or site, a topographical location or "commonplace" in discourse. But a *foundational* site raises the stakes, or drives them deeper than rhetoric. At the most general level it materializes and locates the long-standing philosophical question of the "grounds" of knowledge and of being, bringing all the questions of origins, beginnings, and births "down to earth." Or perhaps placing them "up in the air" of a transcendental Absolute? Either way, the notion of a *Grundungsorte* raises the question of the *site*, of space, place, and landscape in the most basic terms, linking the commonplaces of location and site specificity to the origins of social space as such. Historical events must, as we say, "take place" somewhere, and those places are almost automatically sacralized and monumentalized as foundational sites: the "taking place," as Native Americans say, requires a totemic "keeping place" to preserve memory and continuity.[2] The three great religions of the Book, Judaism, Christianity, and Islam, all converge in the site known as Israel-Palestine, the "Holy Land" that is at the center of so many global conflicts today. The very

1. Neurath, "Protocol Statements," in *Philosophical Papers, 1913–1946*, ed. R. S. Cohen and M. Neurath (Dordrecht: Reidel, 1983), 92. Accessed in *Stanford Encyclopedia of Philosophy*, s.v. "Otto Neurath," http://plato.stanford.edu/entries/neurath/ (accessed May 1, 2012).
2. See Jonathan Bordo, "The Keeping Place, Arising from an Incident on the Land," in *Monuments and Memory, Made and Unmade*, ed. Margaret Olin and Robert Nelson (Chicago: University of Chicago Press, 2003), 157–82.

idea of democracy seems rooted in Athens. American independence and national unity have numerous symbolic founding sites: from Plymouth Rock to Independence Hall in Philadelphia to Washington, DC. The navel of the Australian aboriginal world is located at the magnificent sandstone rock called Uluru in the central desert. The delivery of the law (and Hebrew writing) occurred on Mt. Sinai. And every building of any significance requires the ritual of "groundbreaking" and the laying of a cornerstone. I was taught in catechism that a specific person is designated as the cornerstone of the Catholic church: "Thou are Peter, and upon this rock I will build my church." My seminars on space, place, and landscape always begin with an exercise in personal and private foundational sites, what I call "places in the heart," the places that come to mind when someone is asked, Where do you come from? What place do you revisit in memory and dreams? What location do you regard as crucial to your identity?

Foundational sites, then, are both public and private, sacred and secular, monumental and trivial. My birthplace and the birthplace of a nation are both sites of the basic human experience of what Hannah Arendt calls "*natality*," the appearance of newness in the world. As Arendt puts it:

> What matters in our context is less the profoundly Roman notion that all foundations are re-establishments and reconstructions than the somehow connected but different idea that men are equipped for the logically paradoxical task of making a new beginning because they themselves are new beginnings and hence beginners, that the very capacity for beginning is rooted in natality, in the fact that human beings appear in the world by virtue of birth.[3]

But birth, as we know, is an experience not only of newness, but of *trauma*, of a wounding that leaves often unreadable traces and scars, a forgetting that is sometimes beneficial, sometimes not, of the painful labor of founding. The monuments to founding thus often involve a paradoxical fusion of memory and amnesia. The "foundation," the "cornerstone" of an institution tends to erase the uncertainty and pathos of the founding process. The Wiesenthal Foundation's notorious Museum of Tolerance in Jerusalem, originally to be designed by Frank Gehry (who has now withdrawn from the project), is being built on one of the oldest Arab cemeteries in the Middle East, the burial site of the legendary Saladin, vanquisher of

3. Arendt, *On Revolution* (New York: Viking Press, 1963), 203.

Richard the Lion-Hearted's Crusade.[4] Foundational sites tend, in general, to be haunted. According to legend, the six Hawksmoor Churches in London, designed by Nicholas Hawksmoor, a student of Sir Christopher Wren, were laid out in a pattern suggestive of a Satanic diagram and had the bodies of sacrificial victims buried under their foundations.[5] The stability of the edifice erected on a "stable foundation" belies the quicksand that lies beneath it, and the struggle to establish footings. One motive, then, for studying foundational sites is the overcoming of this amnesia and the demystifying of the foundational moment, commonly presented as a historical necessity and matter of destiny or fate, and not of human struggle, sacrifice, and trauma. Every act of founding is also an act of losing; every foundation is built upon destruction, the ruins of something prior, the ground beneath the foundation. As Nietzsche puts it in the *Genealogy of Morals*, "To enable a sanctuary to be set up, a sanctuary has got to be destroyed: that is a law . . ."[6]

Some foundational sites are designed to preserve rather than erase the violence of their origins, as if the whole point were to keep the wound fresh, the trauma vividly in view. A case in point is the Israeli ritual of remembrance at Masada, the fortress overlooking the Dead Sea at which Jewish Zealots chose to commit collective suicide rather than surrender to the Roman legions. This site is commonly understood to be an emblem of modern Israel's determination to destroy itself and its enemies in a nuclear conflagration rather than surrender its claim to the ethnic and racial nationalism of the Jewish state. The foundational "memories" reproduced at this site are, of course, remarkably selective. They depend, as a young Jewish woman noted in a recent Israeli documentary, on the erasure of a crucial fact: the women and children at Masada did not commit suicide; they were murdered by their men to prevent their becoming

4. See Saree Makdisi, "The Architecture of Erasure," *Critical Inquiry* 36, no. 3 (Spring 2010), the opening statement in a debate on this project that includes responses from Gehry, Jeremy Gilbert-Rolfe, Daniel Monk, and a team of scholars representing the Wiesenthal Foundation.

5. Peter Ackroyd's novel *Hawksmoor* (New York: Harper & Row, 1985), builds upon the legend of the Hawksmoor Churches in London, in which sacrificial victims were supposed to have been buried under the foundations. See Susana Onega, *Metafiction and Myth in the Novels of Peter Ackroyd* (Columbia, SC: Camden House, 1999), 52f.

6. Nietzsche, *Genealogy of Morals*, trans. Horace B. Samuel (New York: Dover, 2003), 95 (II.24).

Roman slaves.[7] It is hard to imagine a foundational site for a more ominous national mythology, a monument to the victory of melancholia over mourning and working through.

Unless, of course, we consider the foundational site of what is sometimes called the "post-911 era." The memorial at "Ground Zero" in New York City, like Masada, is designed to keep the wound open and to facilitate melancholy rituals of selective remembrance. The event of 9-11 has been generally regarded as both a global trauma and the foundational moment of a new world order. The site itself, starting with the misnomer Ground Zero, originally coined as the term for the location of a nuclear explosion, has been hyperfetishized and sacralized. The "footprints" of the destroyed twin towers are laid bare as inverted fountains cascading into darkness, as if the wounds were to be kept bleeding forever. And below the fountains, a descent into the underworld has been excavated, down to the bedrock, deep below the Hudson River to the original footings of the Twin Towers, as if it were necessary to see their deepest foundations to grasp the depth of the trauma. The 9-11 Memorial, emblazoned with the words "Never Forget," has at the same time been the centerpiece in a narrative of national amnesia that disavows the role of the United States in arming al Qaeda and other Islamic extremists during the Cold War, as a tactic to contain the Soviet Union. The World Trade Center became the foundational site, moreover, for an entire strategic vision of a future, a "global war on terror" that by definition would never end and could never be won, but would nonetheless serve as the founding framework for American foreign policy in the twenty-first century.[8]

The foundational sites of birth trauma, of construction and destruction, building and tearing down, are most dramatically evident in that modern foundational event we call "revolution." This was the kind of site that until recently we thought had been "taken off the map," as a poet friend of mine has put it.[9] Only the monuments and empty spaces are left

7. Avi Mograbi, dir., *Avenge but One of My Two Eyes* (2005). Mograbi documents the Masada ritual, reenacted by the numerous tour guides to the site, which explicitly treats the fortress as a symbol of the modern Jewish state.

8. See Philip Bobbitt, *Terror and Consent: The Wars for the Twenty-First Century* (New York: Anchor Books, 2009). Bobbit gave the Arrow Lectures at Stanford in 2008, arguing that "the war on terror is no metaphor." http://www.law.stanford.edu /event/2008/03/06/stanford-center-on-ethics-arrow-lecture-series-on-ethics-and -leadership-philip-bobbitt-the-war-on-terror-is-no- (accessed December 24, 2014).

9. Janice Misurell-Mitchell, "ScatRap/Counterpoint" (1995), http://www.youtube .com/watch?v=ZaGm0OvxTss (accessed December 24, 2014).

on the sites of revolution, and they are generally images of the failure or betrayal of revolution, its replacement by tyrannical regimes. The statues that dominate public squares in the Arab world—of Saddam Hussein in Iraq, of Khaddafi in Libya, of Assad in Syria, of Mubarak in Egypt—are testimony to the transformation of popular revolutions into despotisms. Tiananmen Square in Beijing, Red Square in Moscow, and the vast spaces of the Hitler's Nuremberg rallies are transformed from places of public gathering into what Siegfried Kracauer called staging grounds for the "mass ornament," enormous, disciplined crowds assembled to celebrate the cult of the founding father.[10]

The foundational sites of revolution are what Robert Smithson called "non-sites," testifying to an absence. But recently, in movements such as the Arab Spring and Occupy Wall Street, new sites have been found, and acts of founding have occurred. Weddings were celebrated and babies were born in Cairo's Tahrir Square. The imagery and rhetoric of popular insurgency and revolution have been revived. Whether these events will be foundational, serving as cornerstones for new forms of life, is still in doubt. What is certain is that, as Neurath insisted, they will be imperfect rebuildings of a ship on the open sea. I will return to them presently. But first I must take a detour through a metapicture of the ground itself, the place where the foundational site reveals itself as a visual sight, a space of appearance in the most literal sense, a space that might be occupied by a lone figure or an undifferentiated mass.

GROUNDING AND FIGURING

"Foundational site" in German is *Grundungsorte*. I hear this in English, not initially as "foundational," but as "grounding" sites, places where a figure/ground relation is inaugurated. Of course much of modern art, especially abstract painting and minimal art, was devoted to the disappearance of the figure, its replacement by something that might be called "pure grounding"—a color field, for instance; a slab or plinth without a figure to use it as a base; a blankness or emptiness in which beginnings or endings of painting and picture-making and figuration could be imagined.

As an iconologist, a student of images, I am drawn to see the subject of foundational sites initially as foundational *sights*, the image of the background or blankness in which figures make their appearance. And that leads me to the classic gestalt diagram of the dialectic between figure and

10. Kracauer, *The Mass Ornament* (Cambridge, MA: Harvard University Press, 1995).

ground, the famous ambiguous picture known as "One Vase/Two Faces" (see figure 0.1). In this image, as we know, figure and ground change places. What was seen as empty space surrounding the vase suddenly "flips" and becomes the flesh of two faces confronting each other in profile. And a new space emerges between the faces. One figure disappears to be replaced by two. The location of the ground switches from outside to "between," and the mise-en-scène switches from a singular object in space to an inter-subjective encounter: one object/two subjects.

But there is one small, incidental detail, a third thing that is merely or-namental to the image of the vase, and that is the two curved decorations that accent the shape of the vase, hinting at its three-dimensional form, insinuating a slight "bulge" in what would otherwise be a flat, schematic rendering of the object. What happens to these ornamental features when the aspect of the drawing switches to the faces? My suggestion is that they become *indices* or traces of the mediation between the faces, a doubly articulated mediation in the scopic and vocative registers. In short, they connect the eyes and mouths of the faces, transforming the empty space between them into a material substance, a medium through which optical and acoustic signals may be transmitted. What was ornamental, a surface decoration, becomes central and essential, the very condition of human sociability as such. Speech and depiction, sound and light, hearing and seeing, are constituted in the emptiness between the faces.

The difference between the two ornaments, moreover, suggests a structural and sensory distinction between the scopic and the vocative channels. The mouths are connected by a smooth ribbon, while the eyes are linked by a row of segmented frames, like a film strip, punctuated by tiny dots or periods on the edge of each frame. The contrast is uncannily reminiscent of Friedrich Kittler's distinction between phonography and cinematography as, respectively, media constructed around "continuous" signaling/recording and around interrupted or punctuated signals. We might think of these as the technical expressions of the difference between the continuity of auditory perception and the blinking, jumpy character of the visual process, which sutures together numerous discrete "shots" of the visual field to produce the impression of stable visual space.[11]

And what if this was not only the constitution of the social, including

11. Kittler, *Gramaphone Film Typewriter* (Stanford, CA: Stanford University Press, 1999). See his discussion of the differentiations between typewriter, cinema, and phonography in relation to the Lacanian triad of the Symbolic, Imaginary, and Real, 167–71.

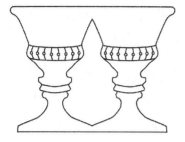

12.2 Edgar Rubin, "Rubin's Vase" (1921). One vase/two faces, multiplied.

of course so-called social media, which have been seen as central to contemporary revolutionary events, but of subjectivity as well? One can see this simply by multiplying the array of Vase/Faces, and noticing how, while the vases remain singular and stable, the faces become "two-faced" Janus figures, looking before and after simultaneously (figure 12.2). It is hard to imagine a clearer picture of what is commonly called the "split subject." We could elaborate these splits at many different levels—the public versus the private self, consciousness versus unconsciousness, perception versus memory or imagination.

I linger over the One Vase/Two Faces image because I want to consider the problem of the *Grundungsorte*, the "foundational site," as a figure/ground problem. For whenever there is a founding, the laying of a foundation, there is the clearing of a space for the construction of a figure, whether it is the erection of a monument or a building, or the clearing of a space between figures, a space of mediation in which subjects can appear to each other and communicate. One could, of course, say much more about this image of the ground, asking what it has to do with notion of "giving grounds" for an argument, establishing the ground of a philosophical position, or establishing the foundations of a discipline, a nation, a political order. For my purposes here, the aim is simply to provide a framework for thinking about the occupation of space, and more precisely, the global Occupy Movement that has sprung up in our time in a number of foundational sites. We suppose that normally the figure is what occupies the ground. But what happens when the ground itself becomes the figure?

THE SPACE OF APPEARANCE

In *The Human Condition* Hannah Arendt characterizes the foundational moment of the political as a "space of appearance" in which human beings "speak and act together":

The space of appearance comes into being wherever men are together in the manner of speech and action, and therefore predates and precedes all formal constitution of the public realm and the various forms of government. Its peculiarity is that, unlike the spaces which are the work of our hands, it does not survive the actuality of the moment which brought it into being, but disappears with the dispersal of men . . . [and] with the disappearance or arrest of the activities themselves.[12]

Arendt adds what we should have already noticed in One Vase/Two Faces: the dimension of temporality. The space of appearance is not permanent but transitory: "it does not survive the actuality of the moment." We see this when the faces give way to the vase, "the work of our hands," and vice versa. The whole point of the figure/ground image is appearance and disappearance. The power that "springs up between men when they act together . . . vanishes the moment they disperse." Or, as Arendt notes, with the "arrest of the activities themselves."

But the disappearance is never total. Something haunts the empty spaces that have hosted appearances of the political. As Michelet said of the French Revolution:

The Champ de Mars! This is the only monument that the Revolution has left. The Empire has its Column, and engrosses almost exclusively the Arch of Triumph; royalty has its Louvre, its Hospital of Invalids; the feudal church of the twelfth century is still enthroned at Notre Dame: nay, the very Romans have their Imperial Ruins, the Thermae of the Caesars! And the Revolution has for her monument: empty space.[13]

Michelet's empty space is, of course, radically ambiguous. Is the Champ de Mars a monument to failure, to the feeling that the French Revolution "devoured its own children," degenerating into a series of despotisms and left nothing behind? Or is it a testimony to the clearing of the "public space" where, as Arendt puts it, "freedom appears and becomes visible to all"? Everything depends, obviously, on the historical situation, the specific site of emptiness and potential where new foundations might be laid, and on the character of the men and women who occupy that space.

12. Arendt, *The Human Condition* (Garden City, NY: Doubleday, 1959), 199.
13. Michelet, preface to *History of the French Revolution* (1847), trans. Charles Coeks (London, 1847–1848), 1.

OCCUPATIO

It is not only nature that abhors a vacuum. An absolutely empty space is nearly inconceivable, if only because the most perfect void would still contain a few stray atoms. And in fact, most human spaces, whether potential public spaces of appearance or the private closets and public streets of everyday life, are completely occupied. Filled with things—people, automobiles, plants, animals, stones, air, water, statues, buildings.

But some spaces are set aside, are kept open, designated as "public." They are what Foucault called heterotopias: parks, squares, plazas, the agora or kiva where people gather for commerce, gossip, or entertainment. They are supposed to belong to no one, to be a kind of civic *terra nullius* that anyone may enter. In the American Constitution, the foundational document left behind by the American Revolution, the first amendment implicitly guarantees the empty space of appearance, a law against law that opens a site of freedom: "Congress shall make no law . . . abridging the freedom of speech, or of the press; or the right of the people peaceably to assemble, and to petition the government for a redress of grievances."

The public square in America generally includes some monument to foundational violence (the war memorial) or construction—the statue of a city father. But it also holds a space open for assembly of the sort envisioned in the first amendment. In practice, however, the first amendment is loaded down with secondary qualifications—asterisks and exceptions, requirements to secure a permit, and strict limitations on the activities that may occur in the public space. No loudspeakers, no camping; hence Mic Chec (in Zucotti Park) and Occupy, everywhere. The figure that appeared against the ground in Cairo, Tel Aviv, and Wall Street was the *tent*, the encampment. And this was a rhetorical figure as well as a performative spectacle, literalizing the trope of *occupatio*, the seizure of the antagonist's position, and the staging of an emptiness to be filled in later.

Occupatio generally stressed the refusal to speak of something, or the confession of an inability to describe or define. The refusal of the members of the Occupy Movement to state their demands is a precise performance of the trope of *occupatio*, which speaks by refusing to speak, opening a negative space in language itself with a form of "expressive conduct."[14]

14. See my essay "Image, Space, Revolution: The Arts of Occupation," in *Occupy: Three Inquiries in Disobedience*, coauthored with Michael Taussig and Bernard Harcourt (Chicago: University of Chicago Press, 2012).

It is just the opposite of the performative utterance in speech-act theory, which does something by saying it (blessing, cursing, administering an oath, declaring a verdict). In contrast, Occupy says something by doing it. Its refusal to delegate a sovereign, representative figure, a charismatic leader or "face" of the movement, is a declaration that real sovereignty has been redistributed for the moment in the assembled people in the space of appearance. Its refusal to describe or define the world it wants to create is accompanied by its manifestation of a nascent community, complete with differentiated roles—cooks, doctors, educators, builders, police—all assembled in a democratic, nonhierarchical polis.

Why did the tactics of Occupy go viral, spreading around the world, from Cairo to Madison, Wisconsin, from Damascus to Wall Street? The specific issues of each revolutionary site were quite distinct: authoritarian regimes in the Arab world; economic inequality in the United States. Is it not because it performed a parodic mimesis of a preexisting condition, namely the occupation of the world by a global system that has oppressed and impoverished the vast majority of the world's population and degraded the environment at the same time, threatening spaceship earth with the possibility of foundering or running aground? Occupy performed an uncanny reversal of the word "occupation," which has become a synonym for the imposition of martial law on resistant populations. It also reversed, in the spectacle of the tent city, the meaning of the most iconic and viral image of occupied space we know of today, namely the *camp* or shanty town, the spaces set aside to incarcerate refugees, illegal immigrants, displaced persons, and resident aliens. Small wonder that Zucotti Park in New York became a haven for the homeless.

MONUMENTS AND MULTITUDES

When the masses depart from the foundational sites of revolution, what is left behind? Michelet's answer is, empty space. But as he knew very well, a multitude of images, some of them memorable and monumental, remained behind in the archives and in popular memory. The Goddess of Reason, the Festival of the Supreme Being, and the ominous silhouette of the guillotine persist as icons of the Revolution. Delacroix's *Liberty Leading the People* fixes the urban legend of the bare-breasted female revolutionary storming the barricades. Is it merely a coincidence that the spirit of popular, nonviolent revolution seems inevitably to be personified in a female figure? Consider, for instance, the Goddess of Democracy in Tiananmen Square, the Ballerina on the Bull of Occupy Wall Street, and the Woman

with the Blue Brassiere in Tahrir Square (which was transformed overnight from an image of victimage to a banner of militant gathering).

Could these images be suggesting a deeper, more radical form of revolution than mere regime change, or even the foundation of a democratic constitution? Political theorist Bernard Harcourt has described the novelty of the Occupy Movement as a strategy of "political disobedience."[15] In contrast to civil disobedience, which deliberately violates laws in the name of freedom, and accepts the consequences of arrest, political disobedience involves the refusal to work within the unwritten laws of the political game—electing representatives, stating a policy agenda, forming a party, and so on. Camping in a public park may be civil disobedience, but what happened within the Occupy camps was *political* disobedience. Instead of attaching to a party, an ism, or even a social movement, it does something simpler and more fundamental: it manifests and performs the foundational site of the political as such, the space of appearance where human beings encounter each other as equals. Prior to politics in the usual sense of parties and defined social movements, Occupy was the clearing or opening before the work of foundation. It was therefore necessarily transitory and transitional, and was accurately represented by the figure of the Ballerina on the Bull. The Ballerina is not a figure of revolution; she does not seek to kill the Bull but to "take him by the horns" and use him as a support, to transform Wall Street into a foundational site for the performance of actually existing freedom and democracy.

The Egyptian Revolution, by contrast, attempted (unsuccessfully) to move from its rebellious stage to its constitutional moment. As Arendt puts it, "Revolution on the one hand, and constitution and foundation on the other, are like correlative conjunctions" (117). "The end of rebellion is liberation, while the end of revolution is the foundation of freedom" and the making of a new constitution. One could see this already in the moment when the multitude assembled in Tahrir Square attempted to erect a giant wooden obelisk with the names of the martyrs engraved on it. This act, which resonated with memories of Tiananmen Square, on the one hand, and the Washington Monument, on the other, was an uncanny image of return, given the obelisk's original home as an Egyptian monument. Given the long history of removal and dislocation of the obelisk from Egypt to Rome to Napoleonic Paris to Washington, DC, it was as if the figure of constitutional foundation had been returned to its proper

15. In *Occupy: Three Inquiries in Disobedience*, co-authored with Michael Taussig and myself. (Chicago: University of Chicago Press, 2012).

site. But instead of serving as a symbol of pharaonic and phallic power, it became, like the Washington Monument (whose individual stones are understood to represent the multitude of citizens), a symbol of the unity of a people.

CONCLUSION

The only way to conclude an essay of this sort is with the trope of *occupatio.* Since the events I have been describing are happening in the present, and are still unfolding,[16] it would be foolish to predict final outcomes. And in fact, as Otto Neurath foresaw, there are no final outcomes in human history, only temporary and imperfect repairs to that leaky boat called "spaceship earth" in which we find ourselves. If space permitted, and I had a crystal ball, here is what I would have wanted to discuss:

—I would have discussed further the contrast between foundation and founding or grounding, between the base of an architectural structure and the acts of clearing and assembling that must precede it.

—I would have explored more fully the relation of violence and foundation, particularly Walter Benjamin's notion of "law-making violence" and Giorgio Agamben's reflections on the "camp" as the enduring site of the state of exception and its place as a symptom of systemic violence that reduces populations to a condition of "bare life."

—I would have elaborated this contrast further in terms of Edward Said's distinction between "origins" and "beginnings": origin as the mythic, fetishized foundation, the completed structure with all its aura; beginning as the modest but often decisively catalytic events that launch a movement and may produce a foundation. I would have linked this further to Arendt's "space of appearance" (as beginning) and the built public space that remains empty. And of course I would have linked this back to the image of One Vase/Two Faces.

—I would have reflected on the contrast between the images of founding and foundation in terms of the architectural structure and the ship that can never reach a dry dock for total repair. Inevitably, these metaphors would have led to the language of running aground and foundering.

—I would have expanded on the totemic, fetishistic, and idolatrous character of foundational sites, their links with geomancy, sacrifice, and sacred space—the practice of idolatry of course associated with images

16. Something called "Occupy Central" flared up with attempts to occupy multinational banks in Hong Kong as recently as June 2014.

of the sovereign as a living god who contains multitudes within his body, and the rituals of mass ornament that reinforce the spectacular character of power. This would necessarily lead to a consideration of "totemic" foundational sites of communal gathering, of which Occupy is clearly an instance. Note that Occupy gatherings are not merely "demonstrations," but mini-communities; Occupy Wall Street provided food, clothing, shelter, and medical aid to visitors.

And I would have raised these questions for further discussion:

—Are "foundational sites" only to be located as physical locations in real space? Could a foundational site be virtual and movable? Is a constitution itself a foundational site, a virtual structure of laws and governmental architecture that can sustain and prolong the space of appearance? The "founding fathers" of the American Constitution regarded themselves as "framers" of an architectural structure. But was that structure grounded in abstract "bedrock principles," or was it more like the Ark of the Covenant, a ship of state launched on a voyage to a Promised Land?

—Is it possible to create foundational sites without deifying the images of "founding fathers" and initiating the inevitable Oedipal cycle that follows them? Could the spaceship earth be reframed as a *mother ship*, the womb in which a new humanity might be born?

—To what extent will be events of 2011 be remembered as revolutionary? Which of them will turn out to be foundational, and which will be remembered as merely gestural acts, performances of founding and grounding? Have cornerstones been laid for structures that will grow into durable spaces of appearance, nurseries for a rebirth of the political? Or will face-to-face encounters give way to the merely monumental, the vase as the funerary urn of failed revolutions?

13.1 Keystone 1947 photograph of the border line between the British and Russian sectors of Berlin. Photograph: Hulton Archive/Getty Images.

13: BORDER WARS

Translation and Convergence in Politics and Media

As an iconologist I cannot think about borders without conjuring up an image. The first that comes to mind is a line being painted down the middle of a Berlin street in 1947, inaugurating the fateful division of Berlin into Eastern and Western sectors. What does it show us?

We know that every border has two sides, an inside and an outside, dividing us from them, natives from aliens, friends from enemies. The "drawing of a distinction" and the inauguration of a difference is (as discussed in the preface) the fundamental rule of systems theory in its abstract form. What may be less evident is that every border has a third aspect. This is more difficult to name, but it is easy to see in this picture. It is the actual white line and the act of painting it. A line that divides the East from the West, a line that may widen to become a district, zone, or region, or contract to become a mere abstraction on a map, an ephemeral line in the sand. The Berlin Wall was both a material fact and a symbolic object, expressing in miniature the global logic of the Cold War. Note the X within the scene, the intersection between two lines, the railroad tracks and the political border.[1] In Israel-Palestine, a border hardens into a thirty-foot-high concrete wall, with killing zones, or "no man's lands," on either side. The so-called demilitarized zone that divides North and South Korea at the thirty-eighth parallel is about two and a half miles wide, a space that is (despite the name) the most heavily militarized border in the world. Sometimes an entire country can become the political equivalent of a border, as with certain "buffer states" that divide Russia from Europe.

In each of these cases the border is both a material thing—a physical place, a graphic mark on a street—and an imaginary, political-juridical concept that remains invisible to the naked eye. There are thus two basic *kinds* of borders: actual and virtual, literal and metaphoric, material and imaginary. It is important to stress, however, that these distinctions of kind, while seemingly obvious, themselves have permeable borders. Real, material borders can be erased; virtual and metaphoric borders can become actual.

1. See the discussion of the X in chapters 4 and 14.

In the following essay I want to explore the actual-virtual interface of the two kinds of borders: on the one hand, geographical-political boundaries; on the other, conceptual borders that distinguish different media and the disciplines that address them. I will also reflect on the role of convergence at the sites of borders, and translations—or as I should prefer to say, *transactions*—that take place across them.

What is the logic behind this triad of terms: borders, translation, and convergence? At first glance, their triangulation suggests a kind of progressive narrative, even a neo-Hegelian dialectic. First, the thesis of borders— between languages, cultures, nations, and geographical regions. Second, the antithesis of border *crossing* in acts of translation or, more generally, *transactions* between domains separated by borders—encounters, migrations, diplomatic and commercial relations. And finally, the happy synthesis that is convergence, in which everything becomes unified, borders are abolished, and translation becomes unnecessary since everyone speaks the same language.

A world of this sort exists only in the utopian imaginary of academia, which dreams of an interdisciplinary paradise where the sciences and the arts, history and philosophy, theoretical speculation and empirical research, lie down together in the comforting embrace of a unified uni-versity. As every academic can testify, however, this picture of a Happy Valley is belied by the realities of limited resources, competition for office space, appointments, and leave time, and more or less open conflicts between different disciplinary ideologies and what Immanuel Kant called "the contest of the faculties." The 1980s were enlivened by "culture wars" between old-fashioned humanists and new theoretical and disciplinary initiatives. Deconstruction, feminism, Marxism, New Historicism, and cultural studies constituted an affront to the old emphasis on a limited canon of mostly white male authors. At my own university, most of the transactions between the economics department and the humanities are conducted in an atmosphere of fixed borders and mutual distrust and incomprehension. The pages of *Critical Inquiry,* the journal I edit, are riddled with border wars, border crossings, and interdisciplinary convergences, not to mention frequent translations of key thinkers in a variety of languages. We have philosophers writing about film, photographers writing about philosophy, and literary scholars writing about anything and everything. But most important, we have what William Blake called "wars of intellect" that defend or contest the borders of disciplines. My own specialty of visual culture studies has been denounced, most famously by *October* magazine, as a conspiracy to undermine art history and to erase the borders between literature and the visual arts and between the

fine arts and mass culture. I have been characterized at various times as, on the one hand, an anarchist working to eliminate these borders and, on the other, a policeman trying to regulate them.

It seems best, then, not to fall into an automatic progressive or utopian narrative around the notions of borders, translation, and convergence. Sometimes borders are a good thing (good fences make good neighbors), and sometimes they are not; translation comes, as we know, from *traduire*, or treachery and betrayal. And convergence looks like a good thing mainly to the more powerful partner who absorbs the weaker into an asymmetrical synthesis. Colonization and conquest can occur among disciplines as well as countries, and we should not forget the real-world academic consequences of the cultural studies movement in some institutions, where it abolished borders between traditional disciplines in the name of a highly desirable "interdisciplinary synthesis," and in doing so became the pretext for down-sizing and eliminating traditional programs in languages and literatures other than English.

As for "English language and literature,"[2] we will certainly need to re-flect on its curious and crucial relation to the whole question of borders, translation, and convergence. English is now, in a phrase that would seem to require an apology to the Italians, the "lingua franca" of our time.[3] *Lingua anglica*, like the original lingua franca, is a pidgin tongue that has absorbed thousands of words from other languages and adds new ones everyday from the proliferation of technical jargon. English seems to cross all borders and invite all other languages to translate themselves into a monolingual conver-gence, a process that may seem infinitely desirable to "native" English speak-ers (whatever they are) but less attractive to speakers of minority languages whose existence is threatened by a linguistic version of social Darwinism.

The global hegemony of English, moreover, has to be seen as the out-growth of a whole series of historical processes involving the overcoming of borders, the forces of translation, and the dynamics of convergence. To clar-ify this point, we might contrast the global reach of "English" with the spa-

2. The original occasion of this paper was as the keynote address to the English Language and Literature Association of Korea (ELLAK) of December 2012, for which the topic was "Borders, Translations, and Convergences."

3. As Wikipedia, our universal crowd-sourcing encyclopedia informs us, "Lingua Franca was a mixed language composed mostly (80%) of Italian with a broad vo-cabulary drawn from Turkish, French, Greek, Arabic, Portuguese and Spanish. It was in use throughout the eastern Mediterranean as the language of commerce and diplomacy in and around the Renaissance era." http://en.wikipedia.org/wiki/Lingua_franca (accessed July 15, 2014).

tial reach of the British empire, which is what made possible the worldwide circulation of the omnivorous language. "Britain" itself, as many historians have shown, was a product in the first instance of the English colonization of Scotland, Ireland, and Wales, the invasive crossing of borders by the English, the enforcing of English linguistic dominance, and the convergence of four different language groups into a new English-speaking unity named Britain that would ultimately expand into a "Britannia," which would rule the waves, and many of the borders washed by them, from one end of the earth to the other. The ascendance of what the French call "perfidious Albion" is equivalent to William Blake's prophecy of humanity's convergence in a "Universal Man," whose name resonates with the pun on "All Be One" and quite literally denotes an albino-esque domination of the world by white folks. "White as an angel is the English child," is the sentiment attributed to the Little Black Boy in Blake's poem by that title.

But I want to consider here something simultaneously more abstract and more concrete than the question of English borders, translations, and convergences. I will rather reflect on the conceptual triad of borders, translation, and convergence and its application in the sphere of global politics and media. My aim here is to think through the logic that underlies this triad, why it seems like such a productive and inevitable conjunction of terms and ideational complexes.

The political meaning of borders, translation, and convergence is probably the most obvious and literal. Nation-states, by definition, have borders; it is what defines them as political-spatial entities in the first place. Transfers and transactions, whether peaceful or violent, friendly or hostile, automatically "come with the territory" of border formations, and translation must be seen as simply one special case of the "trans-"—the moment of border crossing between languages. Under the "trans-," then, we would want to include, not just words, but money, commodities, and organisms. "Trans-" relations includes commerce, diplomacy, negotiations, and migrations of living things, including but not limited to people. Even when nations share a language, the question of translation must emerge: the famous joke describes the United States and Great Britain as "divided by a common language"; on the Korean peninsula, a former colony of Japan, two nations united in language are divided by war, antagonistic political systems, and a long history of other hostile transactions.

Convergence occupies the place of the event of the "trans-," the moment of contact and encounter at the virtual or actual border between nations, states, populations, and cultures. Sometimes (rarely) convergence involves peaceful assimilation, a merging of political entities. More often it involves

conquest, colonization, and the domination of one social group by another, the decline of one language (Irish, Welsh, Icelandic) at the hands of the dominant group, and sometimes the death of a whole people and nation as a result of ethnic cleansing or genocide. "Convergence," then, is probably best seen as a euphemism for absorption, removal, and extinction, the collision between cultures or political systems, the swallowing up of the weaker by the stronger. But it may also involve the stabilization of a conflict, its reification in borders that are continually reinforced and reaffirmed, usually in the name of anxieties about another form of the "trans-," namely the "transgression" of a border. Obviously, Korea is a place that has long and painful experience of this phenomenon, whether the border is the thirty-eighth parallel, which hardened into a long-standing demilitarized zone (DMZ), or the momentary "last ditch stand" of the Allies at the "Pusan Perimeter" in 1950. Transactions across these borders have consisted mainly of violence, whether in the form of verbal polemics or actual military exchanges of gunfire.

I want to emphasize, then, the importance of seeing translation as merely a special, relatively peaceful version of a more general process of transaction, including not only the exchange of words and goods and gifts but the trading of insults, threats, blows, and bombs. This has been true even in the case of translation, as seen in the old Latin phrase for the conquest of the Rest by the West, the notorious *translatio imperii*, the "transfer of empire from East to West." The most important force in the establishment of borders, aside from natural boundaries such as mountains, rivers, and oceans, is war. Could it be that all wars are fundamentally "border wars," even when they range over a global field, as in the case of the Cold War and its contemporary successor, the global war on terror?

We see this clearly the moment we list some of the most famous border regions in modern history. The Rhine, the Maginot Line, the Mason-Dixon line, the "UN buffer zone" between Turkish and Greek Cyprus, the now-vanished border between North and South Vietnam, the Iron Curtain that divided Europe throughout the Cold War, the Green Line between Israel and the Occupied Territories of the West Bank, the border between Afghanistan and Pakistan.

Of these, the one I know best is the Green Line that divides Israel-Palestine, a boundary that may be taken as exemplary of many of the paradoxes that surround the question of borders.[4] These paradoxes may be

4. I rely here on Saree Makdisi's masterful survey of Israel-Palestine, *Palestine Inside/Out: An Everyday Occupation* (New York: W. W. Norton, 2010). See also Ilan Pappe, *The Ethnic Cleansing of Palestine* (New York: One World Publications, 2007).

glimpsed in the variety of names and contested terms for regions within what radical Zionists call "Eretz Israel" or "Greater Israel," a territory that includes the West Bank and Gaza—which they call "Judea and Samaria," imposing biblical names on a modern region. I prefer to use the hyphenated term "Israel-Palestine" to designate the contested homeland of two peoples divided by religion, race, and language but united in a their obsession with exactly the same region, the "Holy Land" that lies at the center of the three great "religions of the Book," Judaism, Christianity, and Islam.

Israel-Palestine, like Korea, is a partitioned by-product of the Cold War. Both originated in the period right after World War II. Both are sites of proxy wars, transactions of violence between the great powers that dominated the world during the last half of the twentieth century. This long stalemate produced a relatively static condition of stabilized borders and fixed enmity that, in both regions, endures long after the Cold War that created it was declared over and done with, won decisively by the "the West." There the similarity ends, of course, since Israel-Palestine, far from being a stable pair of sovereign nations in a state of hostility, is actually one country in which approximately half the population lives under the military occupation of the other half. Gaza is not an independent nation facing Israel. It is under Israeli military control, and Israel could annihilate its entire population quite easily. There is an illusion of "transaction" across an internal border that masquerades as "the peace process," based in the transparent lie that Israel and Palestine are two nation-states engaged in protracted negotiations to produce a settlement. This so-called peace process has been going on for decades, with the only tangible results being the increasing degradation of Palestinian lives and the erection of a "security fence" (called an "apartheid wall" by the Palestinians). The rigidity of this wall, while superficially expressing the fixity of the border between the Israelis and Palestinians, is a manifestly deceptive illusion, concealing the fact that over a quarter million Jewish settlers have established colonial outposts inside the occupied territories of Palestine, and a considerable number of Palestinians reside inside Israel "proper" as second-class citizens. The borders of Israel proper do not actually exist, and officially exist in a permanent state of contestation, which is why many Israelis refuse to call the West Bank the "occupied territories," preferring the legalistic evasion of the phrase "disputed territories." Palestinians live, moreover, inside their own country as if they were illegal immigrants, constantly subject to military checkpoints and border crossings where they may be detained, arrested, and searched. Palestinians live, in other words, as if they were constantly in a border zone, without any of the rights of independent citizens of a nation-state, a liminal condition in which

all the transactions of daily life converge in the intolerable condition known as military occupation, with no end in sight.

The erection of borders and the waging of border wars, along with the transactions and convergences that inevitably accompany them, seems to be such a fundamental characteristic of human societies that it might be worth reflecting on the deeper logics and structures that produce them. I want to turn now from these examples of literal, empirical borders of nation-states to a consideration of the virtual and figurative borders that divide the realm of language, the media, and representation as such. The borders of this conference,[5] for instance, are defined not just by "English" but by "literature and language," a delimitation that suggests a certain exclusion. From the standpoint of media studies, the first thing that comes to mind is that the sphere of the so-called visual media is not included: cinema, the visual arts, and, with them, the emergent discipline of cinema studies and the venerable old discipline of art history. When I first heard the title, "Borders, Translation, Convergence," my thoughts turned, not to political borders, but to their sublimated forms in the aesthetics and representational media. (I exclude music as nonrepresentational for the moment). I thought of Lessing's famous words about the relation of poetry and painting:

> Painting and poetry should be like two just and friendly neighbors, neither of whom indeed is allowed to take unseemly liberties in the heart of the other's domain, but who exercise mutual forbearance on the borders, and effect a peaceful settlement for all the petty encroachments which circumstance may compel either to make in haste on the rights of the other.[6]

Lessing's picture of the relations of verbal and visual arts is both ethical and political, fusing the personal relations of neighbors with the larger sphere of sovereign territories. The language of "domain," "peaceful settlement," and "borders" makes it clear that the arts, and indeed the verbal and visual regions of media—of language and literature, painting and image-making more generally—are something like countries, even nation-states, with distinctive political cultures. It will turn out that for Lessing, the realm of "bright eyes," florid description, and other visual incursions into the arts of language is a *French* phenomenon, and that the superiority of the verbal

5. The English Language and Literature Association of Korea (ELLAK), December 2012.
6. Lessing, *Laocoon: An Essay upon the Limits of Poetry and Painting*, trans. Edith Frothingham (New York: Farrar, Straus, and Giroux, 1969), 110.

arts is to be secured by an alliance between German and English literary cultures.

Lessing recognizes, of course, that these borders are metaphoric and playful, not absolute physical boundaries like national borders. But that does not mean they are unreal or "merely" metaphoric. In fact, Lessing will argue that they are grounded in the metaphysical categories of time and space, as well as the natural division of the senses between the visual and the auditory. And it will rapidly become evident that his ultimate aim is not to establish a border between separate but equal arts but to establish the dominance of one over the other. Poetry, Lessing will argue, has the "wider sphere" because of "the infinite range of our imagination and the intangibility of its images." All the border transgressions he worries about, therefore, are being committed by painting, in its tendency to contaminate literature with descriptive techniques and to appropriate the techniques of writing in its tendency toward allegory. Lessing writes, in other words, as the border policeman on behalf of the republic of letters, not the visual arts. His position is roughly the reverse of that of Leonardo da Vinci, who argued in the *paragone* for the superiority of painting on the basis of its powers of immediacy and vivid effects on the spectator.[7]

We encounter echoes of these border wars in Michel Foucault's ruminations on the relations of verbal and visual representation in *This Is Not a Pipe*. Analyzing Magritte's famous composition, Foucault characterizes the convergence between the text and the image as

> a whole series of intersections—or rather attacks launched by one against the other, arrows shot at the enemy target, enterprises of subversion and destruction, lance blows and wounds, a battle.[8]

Foucault emphasizes, moreover, the phenomenology of the borderline between word and image, "the small space running above the words and below the drawing, forever serving them as a common frontier" (28). But Foucault's border is much more—or less—than a line. It is more like the DMZ, a zone of indeterminacy or "no man's land":

> The slender, colorless, neutral strip, which in Magritte's drawing separates the text and the figure, must be seen as a crevasse—an uncertain, foggy

7. *Paragone: A Comparison of the Arts*, trans. Irma A. Richter (Oxford University Press, 1949).

8. Foucault, *This Is Not a Pipe*, trans. James Harkness (Berkeley: University of California Press, 2008), 26.

region now dividing the pipe floating in its imagistic heaven from the mundane tramp of words marching in their successive line. Still it is too much to claim that there is a blank or lacuna: instead, it is an absence of space, an effacement of the "common place" between the signs of writing and the lines of the image. . . . No longer can anything pass between them save the decree of divorce. (28–29)

Like Lessing, Foucault is being playful, even whimsical in his characterization of the word-image relation as a border war, perhaps even a domestic "battle of the sexes" that can only end in divorce. Lessing had also characterized the relations of poetry and painting in terms of gender, with the "larger sphere" of language associated with men, the "narrower" domain of the visual arts with feminine display. But Foucault also has a serious agenda in his reflection on the borders of the visual and the verbal. As Deleuze has shown, these distinctions play the role of something like the Kantian categories in Foucault's archaeology of knowledge, constituting the bands or "strata" of the "seeable and sayable," the "visible and the articulable."[9]

If we are in search of the logic of virtual, metaphoric borders within the realm of media and representation, however, there is no better place to turn than the classic picture of language provided by Saussure's linguistics.[10] The basic diagram of the linguistic sign is a straightforward assemblage of the three elements of borders, translation, and convergence we have been tracing. The sign is divided into two domains, the signifier and the signified, with a bar providing the borderline between them. Convergence is depicted by the bubble or egg shape that resolves the duality of the sign into a single form. Translation is imaged by bidirectional arrows suggesting the transfer of meaning from one realm of the sign to the other. But most striking, of course, are the figures of the signifier and signified as the word and the image, respectively, denoting a tree. It is not especially important what the denotation is; the important thing is that, as in Foucault and Lessing, they are represented by pictorial and verbal forms, the two fundamental dimensions of representation. The bar between them is thus a border, not between two things of the same order, but between incommensurable, mutually alien marks. They can no more be translated into one another than can Magritte's linguistic and pictorial pipes. The word for "tree" in Saussure's diagram

9. Gilles Deleuze, "Strata or Historical Formations: the Visible and the Articulable (Knowledge)," in *Foucault*, trans. Sean Hand (Minneapolis: University of Minnesota Press, 1988).
10. See the discussion in chapter 4, "Image X Text."

could as easily be written, "this is not a tree." And the arrows that we took as signs for translation could as well be seen as signs of violent transactions, Foucault's "arrows shot at an enemy target."

There is a border war, then, at the heart of media and representation. It is not that language names the world, or that the signifier names the signified, but that language launches a war for and in the world, a struggle for meaning that can never be fully delivered over the bar of difference and otherness. Lacan glimpsed the gender coding of this bar when he "replaced [Saussure's] illustration with another," a picture of the sign as a pair of doors labeled "Ladies" and "Gentlemen."[11] Two kinds of borders constitute the structure of this tableau: the linear bar between the words and the images, and the blank space between the doors. I hope by now we have learned to see this blank space as Foucault's "foggy region," in this case a no man's or woman's land of sexual difference over which nothing can pass but "a decree of divorce." And to see in what Lacan calls "urinary segregation" the primitive basis for the inescapable border built into language:

> Ladies and Gentlemen will be henceforth two countries towards which each of their souls will strive on divergent wings, and between which a truce will be the more impossible since they are actually the same country.

At the same time that Lacan elaborates the metaphor of two countries divided by a border he immediately insists on their convergence in "the same country"—but a country that can never be at peace with itself. The harshest kind of border war is, of course, the civil variety, when a people finds itself at war with itself. In this case the border can become a killing field, and the bar is a mark, not merely of "segregation" of the other on the basis of difference, but in the register of enmity.

The border, then, is not just the bar between *different* peoples, but between *enemy* peoples, which does not rule out gender difference, the battle of the sexes, and the overwhelming temptation of penetrating the border and sleeping with the enemy. I want, therefore, to conclude with a brief snapshot of the question of borders in the era of the Cold War and the contemporary war on terror, the two wars that have dominated the world, and especially the American imagination of war, for the last sixty years. This snapshot will be focused on two narratives, one cinematic and the other televisual, John Frankenheimer's *The Manchurian Candidate* (1962) and the

11. Lacan, "Agency of the Letter in the Unconscious," in *Ecrits*, trans. Alan Sheridan (New York: W. W. Norton, 1977), 151–52.

Showtime television series *Homeland* (2011–). Both stories operate from the same schematic premise: a US soldier has returned from war as a heroic public figure carrying a deadly secret. He has been brainwashed and "turned" into the service of the enemy as an assassin and terrorist. Army sergeant and sharpshooter Raymond Shaw (played by Laurence Harvey) has been subjected to behavioral conditioning that renders him a robotic cyborg who kills on the orders of his operator. Marine sergeant and sniper Nicholas Brody (played by Damian Lewis) has been tortured and converted into an Islamic jihadist who is under orders to kill the vice president in a suicide attack. Both stories conjure with the image of the enemy within, one who has infiltrated the national borders, and with the even more ominous specter of the defender transformed into an enemy attacker. Both conjure with the disturbing fantasy of "sleeping with the enemy." Sergeant Brody sleeps with the CIA agent who suspects him (Carrie Matheson, played by Claire Danes). Sergeant Shaw sleeps with the daughter of a man he is sent to assassinate and, in the even more perverse version provided by the novel, with his own mother, who turns out to be the "operator" who is giving him orders.

Most interesting, perhaps, is the common interest of *Candidate* and *Homeland* in the question of brainwashing, psychiatry, and induced psychosis. *The Manchurian Candidate* features an evil Chinese psychiatrist, Dr. Yen Lo, a wisecracking sadist who uses sleep deprivation, drugs, and other mysterious forms of "behavior modification" to turn an entire squad of American soldiers into amnesiac automatons who can be induced by the power of suggestion to experience collective hallucinations. In the film's most famous sequence, Dr. Lo inducts the film audience into this hallucination, segueing seamlessly between the soldiers' delusion that they are attending a meeting of a ladies' garden club and the reality that they are prisoners on display in a psy-ops theater somewhere deep inside North Korea.

Homeland employs a contrasting strategy. Sergeant Brody has not been brainwashed (though the word is mentioned) by modern psychiatric techniques. He has been *converted* to Islam by a combination of old-fashioned physical torture and old-fashioned love and kindness lavished on him by his captor, the terrorist chieftain Abu Nazr. The modern model of mental illness is transferred to Carrie, the female CIA agent, who suffers from bipolar disorder aggravated by the paranoia and an obsessive commitment to her work that is the occupational hazard of spying as a profession. Carrie's illness, however, leads her, not into delusion, but into an accurate intuitive grasp of what Sergeant Brody has become—a human time bomb, the key figure in a terrorist attack on the United States that will surpass 9-11. As a madwoman, Carrie is just the opposite of the madmen Raymond Shaw

and Nicholas Brody. They have been transformed by torture into merciless assassins; she has been transformed by 9-11 and the war on terror into a Cassandra who foresees the violence to come, a true prophet whose curse is that no one believes her.

Together these two fictions provide a compelling diptych of the insane border wars that have dominated the world system since 1945. On the one hand, a Cold War characterized by rigid virtual borders between two ideologies, communism and capitalism, centered in specific nation states (the US, China, and the Soviet Union). The Cold War expressed itself in a global binary opposition between "the West," or "Free World," and "the Rest," and in proxy wars in which very real borders were created (as in Korea) and destroyed (as in Vietnam). On the other hand, a war on terror that knows no borders and has no specific geographic center, no "frontlines," and no massed war machines or "arms race."

That does not mean that the concept of "border wars" has outlived its usefulness. On the contrary, the borders have now been disseminated over the entire globe; they are everywhere and nowhere at the same time, virtual borders of encryption and surveillance of the sort pioneered by the National Security Agency.[12] The borders that divide Korea and Israel-Palestine remain as material proxies for larger conflicts between great powers and social movements. But the virtual and psychological borders erected by the war on terror are, if anything, even more dangerous than those of the Cold War. They betoken a massive collective borderline psychosis, complete with the classic symptoms of anxiety, paranoia, and delusional thinking.[13] *The Manchurian Candidate* expressed what Peter Galison has called an "ontology of the enemy" as an unfeeling cyborg, the robotic manifestation of godless communism. *Homeland*, by contrast, portrays the enemy as a passionate, committed moral agent, a holy warrior bent on redemption through violence. If the appropriate acronym for the Cold War was MAD (mutually assured destruction), a product of rational game theories that guaranteed a stable equilibrium between equally powerful enemies, the war on terror possesses no such stabilizing feedback mechanism. It is more like schizophrenia, not a "split" but a *shattered* personality. Terror war produces an unstable, out-of-control feedback system that postulates as its enemy an

12. See Glenn Greenwald's *No Place to Hide* (New York: Metropolitan Books, 2014), for a masterful account of the global surveillance system of the NSA, as exposed by Edward Snowden, the greatest whistle-blowing border-transgressor of our time.
13. Greenwald's analysis of the NSA surveillance regime reveals an institution that is drowning in its own obsession with total gathering of data, and has as a result been completely impotent in preventing actual terrorist attacks.

emotion and a tactic—terror and terrorism. That is why the very idea of a war on terror is madness—specifically, paranoid schizophrenia—made operational. It creates an endless, unwinnable war in which the tactics of classical wars, the crossing of borders to invade and occupy other countries, only make things worse.

Jacques Derrida diagnosed the insanity of the war on terror as an auto-immune disorder, a syndrome in which the border defenses of the body politic are unable to distinguish friend from enemy and begin to attack themselves.[14] Terrorism has never succeeded in the military conquest of a country; it does not cross borders with invading armies. The idea is rather to set the country against itself, to induce panic, paranoia, and a self-destructive cycle of "emergency" measures that give absolute power over life and death to the sovereign. For a democracy that, by definition, locates sovereignty in the will of the people, this process can only end in the de-struction of those essential structural borders that make up the separation of powers in a constitutional government. Barack Obama retired the phrase "war on terror" from the vocabulary of national security in his first four years in office, but he retained much of the extraordinary executive authority appropriated for the presidency during the Bush era. The war on terror has already crossed the border between the metaphorical and the literal, turning a rhetorical slogan into an operational reality.[15] If it is not decisively repudi-ated it will eliminate the border between rationality and madness, between self-preservation and self-destruction.

I have been speaking throughout this essay of two kinds of borders, the virtual and the actual, the metaphoric and the literal, the ideal and the ma-terial. But I hope it is clear by now that both kinds of borders are very real, and are inseparably linked, necessary to each other. The real border is always two-sided, both virtual and actual, a product both of words and of images—and the gap or zone between them, the nonplace where an increasing num-ber of human beings actually live. Maps, measurements, descriptions, state-ments, declarations, and images clear the way for actual physical things such as walls, fences, and districts. Add to this the sets of practices and rituals that are conducted at borders, and it becomes obvious how deeply the virtual and the actual, the metaphoric and the literal, converge, and are translated into one another, at the borderlines we inhabit.

14. For a fuller discussion of Derrida's autoimmunity thesis, see my *Cloning Terror: The War of Images, 9-11 to the Present* (Chicago: University of Chicago Press, 2011). 15. See *Cloning Terror*, xviii.

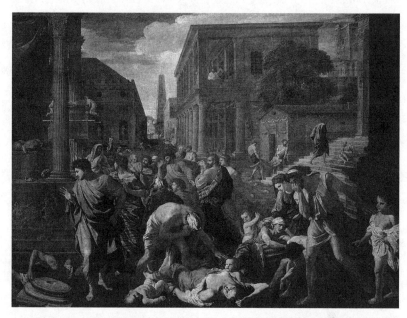

14.1 Nicolas Poussin, *The Plague at Ashdod, Palestine* (1630). Oil on canvas, 148 × 198 cm. Musée du Louvre, Paris. Photograph: Alfredo Dgli Orti/The Art Archive at Art Resource, New York.

14: ART X ENVIRONMENT

Extreme Landscapes, Poussin in Gaza

This essay began its life with an invitation to consider the relation of "Art and Environment," a topic we were told could be interpreted in the broadest possible way: "art" as the whole range of artificial means of acting upon an environment, from planting an Inuit *nukchuk* on the tundra, to the human activities that are causing the melting of the polar ice caps; "environment" as a triangulation of space, place, and landscape—that is, the dynamic interaction of a *space* or ecosystem constituted by forms, forces, and flows, with the specificity of a *place*—a particular location, region, or planetary system, with the perceptual and conceptual frameworks of representation that make that space and place come into focus as a world picture or *landscape*.[1]

But I find my attention drawn first to the word that stitches the topic together, the "and" that connects art to environment, artifice to nature, human activity to spaces, places, and landscapes. In keeping with the standard practice of the hip world of art and design, a 2008 conference on this subject at the Nevada Museum of Art replaced the "and" with a plus sign and came up with "Art + Environment."[2] The humble little conjunction "and" was thus promoted to a logical, even a mathematical operation. As the designated respondent to this conference, I urged a slight modification to this operational term, replacing the plus sign with a times sign, the + with an X.[3] My immediate concern was to question the idea that art is or should be merely an "addition" to the environment, an ornament to

1. On the concepts of space, place, and landscape, see the preface to the second edition of *Landscape and Power*, ed. W. J. T. Mitchell (Chicago: University of Chicago Press, 2002).

2. The Art + Environment Conference, held October 2–4, 2008, at the Nevada Museum of Art, Reno, Nevada, included presentations by artists, critics, and environmentalists, plus an unforgettable "field trip" to Pyramid Lake, complete with storytelling by two Paiute Indian elders. I am especially grateful to Bill Fox for his masterful orchestration of this event.

3. See chapter 4, "Image X Text," for further thoughts (some of them repeated here) on the X as Joycean verbo-voco-visual pun.

the space, place, or landscape in which it appears. I wanted to consider the more complex and dynamic relation of multiplication, manifested in forms of art that transform a place, restructure a space, and intervene in a landscape.

The X that I introduce into the relation of art and the environment, then, can take on a number of meanings. As the multiplier effect, it reflects the way the simplest intrusion of human artifice into a place can utterly transform it, as in Wallace Stevens's wonderful poem "Anecdote of a Jar," where the act of placing a jar "in Tennessee" has the effect of transforming it as profoundly as the Tennessee Valley Authority, taming the wilderness, opening a "port in air," and of reorienting the whole state around something alien to its natural order: "it did not give of bird or bush / Like nothing else in Tennessee." As a sign of crossing (as in a railroad crossing), it may remind us of arts that seem to traverse or cut across a space, disrupting and interrupting habitual patterns of behavior and perception, as in Richard Serra's notorious *Tilted Arc*, which cut across the Federal Plaza in New York City, with such dramatic effects that it was ultimately taken down. Or Robert Morris's Grand Rapids earthwork, which takes the X quite literally, transforming a natural hillside into trapezoidal support for the inscription of a giant X.

We should also bear in mind the meaning of the X as the "times sign" and the way works of art introduce the element of time into space, with monuments, memorials, temporary installations, or even (as Robert Smithson was the first to insist) the foregrounding of nature's own time arts as manifested in geological strata and fossils.[4] Alan Sonfist's *Time Landscape*, at the corner of La Guardia and Houston streets in Manhattan, might be taken as the exemplar of this temporal operation, in which a tiny environment is set aside as a natural heterotopia[5] to remind us of a time before human artifice had made its mark on this place, at the same time that the steady flow of trash tossed into Sonfist's little park produces a jarring sense of anachronism.

We should, finally, consider two other senses of the X. First, as the

4. See especially the work of Antony Gormley, which routinely insists on the temporality and temporariness of sculpture. Works such as *Event Horizon, Another Place*, and *Time Horizon* insist on the dislocation and homelessness of the sculptural object in time and space. See my "What Sculpture Wants: Placing Antony Gormley," in *What Do Pictures Want? On the Lives and Loves of Images* (Chicago: University of Chicago Press, 2005).

5. On heterotopia, see Michel Foucault, "Of Other Spaces," in *Diacritics* (Spring 1986), 22–28.

"unknown" or variable, in which case the X is less an operation than an absence, a gap or black hole in the landscape, a mysterious cipher like the X on Morris's earthwork, or the enigmatic inscription on the hillside in Thomas Cole's painting, *The Oxbow*, which turns out to be the Hebrew cypher for "Shaddai," indicating that this is God's country, a promised land for European conquest and colonization. Second, X as the sign of signing, countersigning, and the removal or destruction of signs, from the signature of the illiterate, to the marker of interest and destination on a map ("X marks the spot"), to the *erasure* of signs and inscription in the act of "crossing out."

To summarize: the relation of "Art X Environment" must be read as multiplicative, not additive; as crossing or passing through rather than dwelling; as anachronistic displacement rather than historical fixity; as a violent marking and equally violent erasing rather than the secure permanence of the monument. The inscription on Shelley's ruined statue of Ozymandias in the desert might be thought of as the total emblem of the Art X Environment relation: "My name is Ozymandias, King of Kings: / Look on my works, ye mighty, and despair" meant one thing to Ozymandias and the artist he commissioned for this work, quite another for the traveler who encounters it in the Egyptian desert in 1817.

But there is one further X that links art to the environment, and that is the notion of the outer boundary or "ex-"—the "extraordinary" landscape, the place or space of natural and social *extremity*, what I want to call "extreme environments." It is well known that, since the 1960s, many artists have felt the call to work in what might be called "extreme natural environments," and that much of the earth art movement was understood as an attempt to escape the familiar precincts of the gallery and the museum in order to explore the outback, the desert, and the polar regions. The genealogy of this movement, as William Fox has shown, could be traced back to the sublime landscape arts of the nineteenth century, which were often at the leading edge of imperial expansion. These "extreme" environments have their antithesis in what was identified at the Reno conference as the "ordinary" landscapes of Generation X, what J. B. Jackson used to call the "vernacular" landscape: the yards of the suburbs and their endless lawns. Fritz Haeg's *Take Back the Lawn* project is precisely an intervention in these sterile, depressing, and ecologically disastrous environments.[6]

But my topic in this paper is not quite covered by any of these rubrics,

6. See Haeg's website, http://www.fritzhaeg.com/studio.htmlvades, for an overview of his remarkable work.

or perhaps more precisely, it gathers all of them together in a phenomenon that I want to call "extreme social environments."[7] Instead of natural sites, earthworks, landscape or sculpture gardens, or other operations of art and artifice on environments, I want to consider zones of extreme social pressure and conflict—areas of high population density, occupied territories, and spaces under siege. Extreme social environments—slums, *favelas*, shanty towns, ghettos, DP and refugee internment camps—are among the fastest growing environments on the planet, and I cannot pretend to be an expert on them. Extreme social environments are generally sites of extreme inequality and uncertainty, often outside any government control, ruled by paramilitary gangs and supervised by a kind of feudal, patriarchal justice system of revenge and reprisal. They are, needless to add, sites of extreme violence and rampant crime, homelessness, and shattered families. The film *Slum Dog Millionaire* provides one kind of window into the massive slums of Mumbai, and the combination of extreme poverty and ethnic violence that permeate them.

The arts play a crucial role in extreme social environments, countering the notion that art is merely an ornamental addition, a luxury that depends upon economic surplus. Of course this may not be the kind of art that appears in mainstream galleries: it may take the form of street art, performance and graffiti, or (from outside) of documentary film, photography, and journalism. In Northern Ireland they say that the Protestants make the money and the Catholics make the art. The relation of rap music, fashion, and visual art to the black ghettos of the United States has been amply documented. Indeed, one is tempted to hypothesize that extreme social environments are often a seedbed for remarkable cultural and artistic achievements, and that there is no direct correlation between socioeconomic disaster areas—what used to be called "cultural wastelands." On the contrary, if there is a cultural wasteland in the US, it is probably located in suburbia and exurbia, where the rise of mall culture, architectural homogeneity, the abolition of pedestrian traffic, and the lawn fetish create a landscape that is depressing to the spirit.

One last generalization that may be pertinent to the topography of extreme social environments. They never exist in isolation from what might be thought of as their dialectical counterpart of wealth, security,

7. See Brent K. Marshall, "Sociology, Extreme Environments and Social Change," in *Current Sociology* 45, no. 3 (1997): 1–18. Marshall's concept stresses the way environmental disaster and rapid technological change disrupt communities; my emphasis is on the way already disrupted communities (refugees, immigrants, displaced persons) address their environments.

and privilege—the gated community, the affluent suburb.[8] The South African shanty town of Khayelitsha (meaning "new home" or—as I was told—"beautiful place") occupies a massive coastal region bracketed by affluent Cape Town on the north and equally affluent coastal suburbs to the south.[9] David Harvey notes the significance of the spatial adjacency of the elite neighborhood of Rowland Park in Baltimore to the black ghetto.[10] Columbia University occupies what comedian George Carlin called "White Harlem" (a.k.a. "Morningside Heights"). My neighborhood of Hyde Park in Chicago has historically been an island of middle-class contentment and racial integration in the midst of the mostly segregated and impoverished black South Side.

But these are modest and moderate versions of contradictions in social environments. The true "art" of these environments emerges when one of the oldest artificial modifications to the environment is erected, namely, a wall, and a whole population is fenced in like cattle. The security wall, the border fence, the checkpoint, the frontier, the physical or virtual barrier that separates extreme social environments from the ordinary landscapes of human habitation, has become the site of some of the most compelling artistic expressions in our time. Comedian Bill Maher has suggested that the notorious Bush administration proposal for a 750-mile-long barrier between the United States and Mexico be constructed, not as a wall, but as a Wal-Mart. As Maher notes, this would involve building a Wal-Mart of no more than average size; it could have a northern entrance for American shoppers and a southern entrance for the Mexican workers, each of whom would return to their proper locations at the end of the day.[11]

In a more practical address to the flourishing of walls directed at populations, murals have made a comeback, and not simply murals that commemorate or adorn or embellish, but murals that deconstruct their own support, resisting separation and attacking the walls on which they are painted, imagining a world of open borders and the free, unobstructed movements of human bodies. A binational group called "Artists without

8. On bad utopias, see Mike Davis and Daniel Bertrand Monk, eds., *Evil Paradises: Dreamworlds of Neoliberalism* (New York: New Press, 2007).

9. The population of Khayelitsha was estimated at over a million when I visited in the 1990s. See Steven Otter, *Khayelitshad: uMlungu in a Township* (London: Penguin Global, 2008).

10. Harvey, *Justice, Nature, and the Geography of Difference* (Oxford: Blackwell, 1996). See especially chapter 11, "From Space to Place and Back Again," 291–326.

11. See chapter 13, "Border Wars."

Walls" in Israel-Palestine[12] has conducted numerous actions, performances, and site-specific interventions to resist the notorious Israeli barrier known euphemistically as the "security fence" (actually a ten-meter-high wall of concrete slabs that slices through Palestinian villages, cutting farmers off from their fields, merchants from their markets, teachers from their students, and families from their relatives). These artists employ mural painting, video, and performance art to dramatize the inhumanity of the wall and to make it disappear. Sometimes this is an act of self-delusion, as in the now-famous mural at Gilo, which literally (or is it figuratively) "disappears" the real Palestinian village of Beit Jala, while causing a fantasy landscape of a depopulated Arabian pastoral to take its place. But it can also take the form of a resistance that testifies to the failure of even the most brutal military occupations to completely eradicate artistic creativity.

The wall, then, has become the central architectural manifestation of the extreme social environments of our time, along with the watchtower. It has become so central, in fact, that a kind of intertextuality has arisen between different walls, so that the Berlin Wall and the Warsaw Ghetto find themselves reinscribed and memorialized in the graffiti on Israel's wall, and some walls even echo the political symbolism of another, quite distant structure. The paintings on the wall between Protestants and Catholics on Falls Road in Belfast aligned the parties with Israelis and Palestinians. I will leave it to you to guess how this alignment went.

Of all the extreme social environments we might single out on this planet, the tiny region known as the "Gaza strip" must be paradigmatic for our time. It combines all of the extreme elements in one compressed space: a strip of land about twice the size of Washington, DC, with one and a half million inhabitants, one of the most densely populated environments on the planet. The degradation and poverty in which Gaza's Palestinians live, and the ways in which sudden and unpredictable violence can shatter what meager lives they have managed to create for themselves, is well documented. Gaza is, in effect, a giant prison camp, arguably among the largest in human history, in which a sizeable civilian population is quarantined, embargoed, surveilled, fenced in, starved, humiliated, and (now and then) massacred. Despite all the talk of Israel's withdrawal from Gaza, the strip remains, in every technical sense of the word, under military occupation.[13]

12. See Charlotte Misselwitz, "The Wall Jumpers" in Qantara.de 2005. http://www.qantara.de/webcom/show_article.php/_c-310/_nr-245/i.html
13. See Rashid Khalidi, "What You Don't Know about Gaza," *New York Times*, which points out that the CIA officially regards Gaza as under military occupation, de-

My only access to Gaza, like that of most people, is via the media. It is an environment that few Americans or Europeans have entered or experienced directly, and so one has to rely on representations, narratives, and descriptions in words, photographs, drawings, and moving images. In short, it is an environment that is, for almost everyone, a product of art in the extended sense I have been giving it, an art that ranges from journalism to propaganda to mural paintings and performances. Gaza is perhaps the perfect demonstration of my claim that art is not an ornamental "addition" to social life but a necessity for the maintenance of human sociability and the willingness to resist, especially in the most extreme circumstances.

The most salient fact about the extremity of Gaza that emerges in its representations is that it is not a kind of accidental condition, a deplorable result of Palestinian intransigence, stubbornness, or refusal to recognize the state of Israel. Of course Hamas should recognize Israel, just as a matter of practical survival. When a bully has his foot planted on your throat, and he demands that you acknowledge that he is in the right, what else are you to do? But I also find it understandable that some people would rather die than yield their claim to acknowledgment and respect.

So Gaza is not a tragic side effect of misunderstanding. It is actually the clearest manifestation we have of contemporary long-range strategies of ethnic cleansing. The real objective of Israel since its founding, as Ilan Pappe has shown, has been the removal of the Palestinians from Eretz (Greater) Israel.[14] The kind of ethnic cleansing that we have recently seen in Kosovo and Darfur was carried out in Palestine in 1948. Approximately half of the people of historic Palestine were driven from their homes, encouraged by assassinations, demolitions, beatings, and the occasional massacre, all authorized by the Israeli government. Israeli general Rafael Eitan put it most clearly when he expressed a wish that the Palestinians would die off like "drugged roaches in a bottle."[15]

Although ethnic cleansing is a clearly defined crime against humanity, involving a "policy of a particular group of persons to systematically eliminate another group from a given territory on the basis of religious, ethnic,

spite the removal of the settlements in September 2005. See http://geography
.about.com/library/cia/blcgaza.htm.

14. See Pappe, *The Ethnic Cleansing of Palestine* (Oxford: One World Publications, 2006).

15. See Steven Erlanger's obituary of Eitan, *New York Times*, November 24, 2004, http://www.nytimes.com/2004/11/24/obituaries/24eitan.html (accessed July 15, 2014).

or national origin,"[16] it is not a static, single event but a dynamic process that is continually evolving new strategies, ranging from outright massacres to embargoes, quarantines, and policies designed to destroy the fabric of civil society in the target population. The Israeli policy of destroying or closing Palestinian schools, bombing government buildings where tax and census records are kept, and continually disrupting the infrastructure of daily life (markets, roads, communication networks, hospitals, electricity, clean water) is a strategy designed to make normal communal life impossible. Ethnic cleansing need not, in other words, involve direct and visible violence. It can operate, as it does in Gaza, as a systematic violence against everyday life and the deliberate production of an extreme social environment that will (if all goes according to plan) ultimately self-destruct. The role of Israel and the United States in encouraging an ongoing civil war between Hamas and the Palestinian Authority is perhaps the most dramatic evidence of this strategy.

When one looks at Gaza in this framework, as a peculiar and almost unprecedented combination of features, it becomes intelligible as an extreme social environment. It is, at one and the same time, a small coastal region with a temperate climate and a mainly agricultural economy, a prison or refugee camp, an ethnic ghetto, a quasi-sovereign nation with a democratically elected government, a failed rogue terrorist state, a gigantic slum ruled by criminal gangs and paramilitary thugs, a military adversary that is portrayed as launching unprovoked attacks against the most powerful military machine in the Middle East, and a symbol of humiliation and outrage to the entire Arab world. Photography cannot capture the complexity and density of this world, though it can produce iconic moments, to which I will return. The most eloquent testimony comes in the art of the moving or sequential image, in documentary films, and in the graphic documentaries of Joe Sacco, which range from the tiny detail to Brueghelesque panorama, all punctuated by the most vivid transcriptions of conversations with Gazans. Curiously (or maybe it is not so curious) Palestinian films tend to be mythic, filled with magical realism, while Israeli filmmakers tend toward the documentary.[17] If you want to see the moral horror of the occupation from the Israeli side, you need only look at the plethora

16. Drazen Petrovic, "Ethnic Cleansing—An Attempt at Methodology," *European Journal of International Law* 5, no. 3 (1994): 342–60. Cited in Pappe, *Ethnic Cleansing*, 1.

17. Compare Catholic and Protestant mural art in Belfast: the Catholics tend toward romantic and mythical subjects, while the Protestants prefer a rough, direct realism.

of documentary films (including the animated documentary *Waltz with Bashir*, dir. Ari Folman, 2008) to see the combination of guilt, anxiety, bad faith, good faith, and helplessness that afflicts Israelis of conscience, who find themselves tethered by blood, ethnicity, nationality, and history to a monstrous repetition of the horrible crimes committed against them by the Nazis. The thought has crossed the mind of many Israelis, I'm sure: we have become what we beheld. We have met the enemy and he is us.

I want to conclude with two iconic photos and one painting that I hope will put in perspective the aspects of Gaza that reveal its nature as an extreme social environment. The first is a straightforward landscape panorama (not reproduced here) of Gaza City under bombardment at twilight, with the congested center of the city exploding in a massive firestorm.[18] With an image like this in circulation, it becomes rather difficult to sustain the fiction of humane "surgical strikes" that avoid casualties to civilians. No doubt any civilians caught near government buildings in Gaza were being used as "human shields." Fortunately for the Israeli military strategists, these shields offer no deterrence whatsoever against its exercise of superior firepower.

The second image is not from the 2009 bombing of Gaza but was taken by photographer Mahmud Hams two years earlier, in 2007. It is a close-up of a dead mother with her two dead babies draped across her body (figure 14.2). The man in the background is trying to keep one of the babies from rolling off her mother's body. I know that someone will bring up the fact that the photographer has been accused of doctoring photographs and producing tendentious, prejudicial images. In short, this picture will be dismissed as "Arab propaganda."

I remain agnostic on this question and accept the possibility that the photo might be fabricated or staged. But let's admit, then, that this makes it *art* of a certain kind—not a routine form of representation but an effort to create a memorable image, to compose a scene. Indeed, the hand steadying the dead baby is a clear signal that the picture has been *manipulated* in the most literal sense of the word: the photographer or his assistant in a sense "shows his hand."

But why does this image work? And why did it come back out of the archives in 2009, two years later? First, and most obviously, because it is a *recurrent* scene that is inevitable in any large-scale attack on a congested

18. As I wrote these lines in July 2014, images of the current bombing of Gaza City were appearing on all the American news networks. No doubt new morgue photos are being taken right now.

14.2 Mahmud Hams, "Gaza City Morgue" (2009). Photograph: AFP/Getty Images.

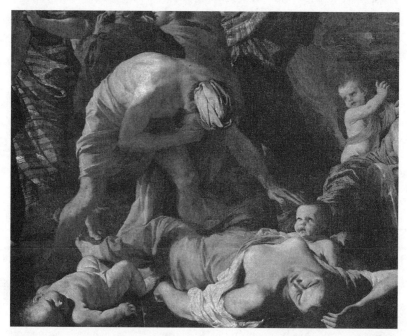

14.3 Nicholas Poussin, *The Plague at Ashdod* (1630) (detail). Oil on canvas. 148 × 198 cm. Musée du Louvre, Paris. Photograph: Alfredo Dgli Orti/The Art Archive at Art Resource, New York.

urban environment and, second, because of an incident in January 2009 that was only reported in verbal descriptions. The headline of a January 8, 2009, story in the *New York Times* reporting on the Israeli incursion into Gaza a few weeks before the inauguration of Barack Obama could almost be the caption of the 2007 photograph: "Gaza Children Found with Mothers' Corpses."[19] In fact, when I tried to follow up this story by searching for photographs associated with it, the Google search engine immediately lead me to Hams's morgue photo. But this anachronistic verbal relay could just as easily lead me to an even more remote and unlikely tableau found in one of the great classics of Renaissance painting, Nicholas Poussin's *The Plague at Ashdod* (see figures 14.1 and 14.3).

Poussin's painting depicts the plague brought on the Philistines in the city of Ashdod, a town about halfway up the coast between Gaza and modern-day Tel Aviv. The Philistines have just defeated the Israelites, killing thirty thousand men. And now the plague has descended upon them, killing the guilty and the innocent without discrimination. We see a statuesque tableau vivant of terror and panic, with figures appropriated from Poussin's hated rival, Caravaggio. The most prominent of these is in the center foreground: a dead mother with her still living infants starving at her breast.

I don't bring Poussin out of the past to argue for influence. The photographer may or may not have known he was composing a group that echoes a whole tradition of pietas, martyrdoms, and scenes of massacre and catastrophe in Western painting.[20] My aim is rather to let Poussin's painting open a window into the unconscious of Judaeo-Christian Europe, and to link Gaza's present with a deep history that is made visible in this picture. As we pull back from the detail, we see that there is a secondary scene inside the temple on the left rear of the picture. We see the impassive Ark of the Covenant, which the Philistines have captured in the battle, and the fallen statue of their idol, Dagon, with his head and hands cut off. We

19. See Alan Cowell, "Gaza Children Found with Mothers' Corpses," *New York Times*, January 8, 2009.

20. Probably the ur-source of this motif of the dead mother with infants is to be found in Pliny the Elder's *Natural History*, in his description of the legendary painter Aristide of Thebes, who is supposed to be the first painter to show *ethe*, or "soul and the emotions," in a painting. Pliny describes Aristide's painting of "the capture of a town, showing an infant creeping to the breast of its mother who is dying of a wound." For further discussion, see my essay "Idolatry: Nietzsche, Blake, Poussin," in *Seeing Through Race* (Cambridge, MA: Harvard University Press, 2012), chapter 6.

are to understand, so Poussin tells us, and most art historians, that this is the primary subject, the real subject, and the scene of the plague is an allegorical shadow of the real story, which is the *miracle* at Ashdod— the magical destruction of Dagon, the shattering of the enemy's idol by the more powerful god of the Israelites. The Ark's dangerous resemblance to an idol generally goes unremarked or is explained away by references to the hidden, secret, invisible interior.

From this point of view what we are beholding in the foreground is, indeed, a representation of a human catastrophe; but it is also a direct result of divine justice, which has an incorrigible tendency to exert collective punishment, encouraging massacres, expulsions, and even (in the episode of the Golden Calf) the murder of thousands of one's own people.[21] All these are manifestations of divine law and justice, frequently within a discourse of idolatry and iconoclasm that turns the enemy—that is, the native inhabitants of the land—into brutish materialists who engage in depraved sexual practices and worship mute stone idols. But the real motive of the destruction is not really this moral judgment. As Moshe Halbertal and Avishai Margalit note in their masterful study *Idolatry*, "the ban on idolatry is an attempt to dictate exclusivity, to map the unique territory of the one God."[22] The mandate of iconoclasm is made explicit by Joshua in Numbers 33:52–53: "When you cross the Jordan into Canaan, drive out all the inhabitants of the land before you. Destroy all their carved images and their cast idols, and demolish all their high places. Take possession of the land and settle in it, for I have given you the land to possess."[23] The "idols" of the Philistines and Canaanites play the role of what the Romans called the *genius loci*, or "genius of the place." They are local deities like the famous *baalim*, which are simply gods of the oasis that establish the claim of a nomadic tribe to return to that place seasonally. The accusation of idolatry and the practice of iconoclasm has a double purpose, then. Its practical aim is to erase all historical traces of the native inhabitants, to conduct an ethnic cleansing of all images, monuments, and symbols of prior possession, and thus to erase all evidence of rival claims on the land. But its idealistic or ideological aim is equally important: it is to lay claim to

21. See my discussion of the Golden Calf and the massacre of the Israelites in *What Do Pictures Want?*, 132–35.
22. *Idolatry* (Cambridge, MA: Harvard University Press, 1992), 5. See also the discussion of idolatry in chapter 6, "Migrating Images."
23. See my essay, "Holy Landscape," in *Landscape and Power*, 2nd ed. (Chicago: University of Chicago Press, 2002), 281.

being an instrument of divine justice, to portray ethnic cleansing as God's will to purify the land.

Modern Zionism did not invent this convenient fusing of religion, conquest, and colonization. It inherited it from the entire tradition of Christian anti-semitism that Poussin is channeling in his painting of the plague (or is it the miracle?) at Ashdod, an event that occurred just a few miles from Gaza. This is a peculiar form of anti-semitism that is capable of transferring its animus from Arabs to Jews, from internal pogroms to Middle Eastern crusades, without missing a beat,[24] and Poussin is squarely in the middle of it in early modern Europe, as art historian Richard Neer has demonstrated. The clearest evidence of this is the way that Poussin recycles the figure of the mutilated, fallen Philistine idol to represent the body of a fallen Israelite in his later painting *The Destruction of the Temple in Jerusalem* (1638). As Neer notes:

> The idol of Dagon has reappeared here, in the heart of Jerusalem. It lies at the dead center of the picture, with its head once again on the ground nearby. This time, however, blood trickles from the severed neck: although the pose is the same, the figure is no longer a broken idol but a murdered Jew. The marginal statue has moved to the center; the pagan has become Jewish. The figure even retains its greenish hue, which no longer signifies *statuary* but *death* Interpreted thematically, this allusion might be taken to suggest that the Jews are, in the age of grace, de facto idolaters. This position was not uncommon in the seventeenth century.[25]

What does this picture say to us in the twenty-first century? Why does it seem to resonate so strongly, peeling away its many layers of allusion and citation to connect with a contemporary environment of extremity. Certainly it shows without flinching the central, iconic feature of ethnic cleansing, namely the slaughter of the innocents. The program of ethnocide is never confined to the killing of a military enemy. It involves the cutting off of human reproduction, the punishment not just of one's adult enemies but of their children and their children's children. The second thing the painting reveals is the point of view from which these crimes are seen as the acts of divine justice, the punishment of evildoers defined

24. See Gil Anidjar, *The Jew, the Arab* (Stanford, CA: Stanford University Press, 2003), for a masterful account of the parallelism of these two objects of Christian anti-semitism.

25. Neer, "Poussin and the Ethics of Imitation," in *Memoirs of the American Academy in Rome*, ed. Vernon Hyde Minor, vols. 51–52 (2006–2007): 297–344; 323.

as idolaters. The second commandment makes this clear when Jehovah declares that he will not be content with smiting idolaters but will bring vengeance down on them even "unto the third and fourth generation." And the third thing the painting reveals is the fantasy of technical superiority and omnipotent power that accompanies the fantasy of absolute justice. The Ark of the Covenant is not merely the repository of the law, but of the irresistible power to enforce that law. It is, as the leading Hollywood fantasies about it testify, a weapon of mass destruction.[26]

But Poussin is a great painter, and I did not bring him to Gaza simply to make explicit the messages that are perhaps less clear in the contemporary media coverage of that extreme environment. Although Poussin was no doubt a pious Christian anti-semite in his personal views, and in the artistic subjects prescribed for him, he was also an avid student and lover of classical art. His hatred of idolatry is deeply compromised by his love of Greek art, an art riddled with idolatry. He could not have known that the Philistines were probably not Arabs but Myceneans who had migrated down the coast from Greece to dwell in Ashdod and Gaza.[27] But his artistic eye and hand could not represent them any other way. Poussin's Ashdod is a Greek city, and its citizens are Greeks as well, a city where the arts of architecture and sculpture are flourishing—up till the moment of destruction that he depicts for us. Poussin's anachronism ultimately overcomes his historicism. He is a true artist, and of the idolaters' party, without knowing it.

26. This is the basic premise of *Raiders of the Lost Ark* (dir. Stephen Spielberg, 1981).
27. I owe this factoid to my colleague, Richard Neer.

15: THE HISTORICAL UNCANNY

Phantoms, Doubles, and Repetition in the War on Terror

Most people are familiar with the psychoanalytic concept of the uncanny. It is focused on individual experiences of the strange, the fantastic, the weirdly disturbing. It also concerns more specific phenomena: (1) The uncertainty about whether something is merely accidental and contingent, or obeys a structure of causality that is not immediately evident; this is often exemplified by the observation that something is "merely coincidental" or (conversely) that it is "not a mere coincidence." (2) The appearance of something strange that, on reflection, turns out to be quite familiar—thus the relation of what Freud called the *unheimlich* and the *Heimlich* (homely), and a feeling that something long forgotten or repressed has returned. (3) The appearance of the double, the mirror image or twin, the figure known as the "doppelganger" as well as, more generally, the phenomenon of doubling and redoubling that goes by the name of repetition. And (4) the appearance of a ghost or specter that produces an uncertainty about whether one is witnessing a supernatural event or something that has a rational explanation, and particularly the moment when something that we suppose should be dead or inanimate (a doll, a corpse, a wax figure) has come to life.

The uncanny is not originally a psychoanalytic concept but comes, as Freud notes, from aesthetics and literature. (There is no entry on the uncanny in Laplanche and Pontalis's *The Language of Psychoanalysis*.) It is a kind of transitional phenomenon in literary history between what Tzvetan Todorov called "the fantastic" (stories filled with magic and supernatural events) and the detective story, in which mysterious and strange events turn out to have a rational explanation.[1] Edgar Allan Poe is generally recognized as the great master of the uncanny, precisely in his location between fantasy and detective fiction. The uncanny is, then, a literary genre that emerged historically in a transition between fantastic and realistic, supernatural and naturalistic fictional modes. It is the genre of ambiguity

1. Todorov, *The Fantastic: A Structural Approach to a Literary Genre*, trans. Richard Howard (Ithaca, NY: Cornell University Press, 1975).

15.1 Forkscrew Graphics, "iRaq/iPod" (2004). Silkscreen poster inserted into iPod billboard, new Bleeker Street station, New York.

par excellence, exploring the boundary between imagination and reality, metaphoric and literal expression. It therefore concerns some of the most durable uncertainties in human life; it is difficult to imagine that there is anyone who has not experienced one of its manifestations. (Recall Freud's famous disavowal that he doesn't personally have much truck with the uncanny—except for one time, his "mirror moment"—or maybe getting lost in a red light district that he is trying strenuously to escape.)

But the question I would like to raise is the following: would it make sense to speak of a *historical* uncanny, an experience that is not merely individual but shared collectively, and shared in relation to a collectively experienced event? An event that is not merely literary, but concerned with factual historical narratives? And further, an event that is collectively understood to mark a turning point or significant moment in a historical period? Certainly historians have not shrunk from thinking of their subject in literary terms: historical ironies and tragedies are legion; narratives of national founding seem invariably to take on mythic and epic dimensions; and (as Marx insisted) every historical event seems to require repetition, the first time as tragedy, the second as farce. A certain old-fashioned ver-

sion of historiography known as *Geistesgeschichte* with its search for the "spirit of the age," or *Zeitgeist*, might be thought of as the moment when the historical uncanny veers back toward its origins in the ghost story.[2]

So perhaps we should consider the usefulness of the notion of an uncanny historical epoch, one characterized by strange coincidences, repetition, doubles and ghosts, and uncertainty about whether events are in the control of fantastic or realistic images, metaphors or literal statements about the facts. The most common example of this would be a historical event (and of course we will have to interrogate what is meant by this phrase as well)[3] that produces widespread uncertainty as to whether it is accidental or causally determined. In addition, the event that marks the onset of a distinct historical epoch would have to take on the status of a public icon, a widely recognized image that circulates across the media with "no caption needed" to explain its importance.[4] Perhaps it is "no coincidence" that the present moment, the aftermath of the period of world history dominated by a "global war on terror," bracketed by the events of 9-11-2001 and the global financial crisis of 9-8-2008, qualifies, not only as an example of the historical uncanny, but is the very moment when the inevitability of this concept became obvious. Certainly 9-11 has many of the generic qualifications: the sense of repetition and déjà vu in the perception of the event itself; the return of the repressed or forgotten friend and ally as an implacable enemy; and an overabundance of conspiracy theories contending with realist narratives that stress the role of accident, luck, and timing. At the other end of the period we find the financial crisis of September 2008, which could be seen, on the one hand, as the result of nu-

2. When I asked Carlo Ginzburg if historians have a theory of coincidence, his immediate response was to mention the largely discredited notion of a "spirit of the age."

3. Consider Alain Badiou's concept of the event—the moment when one must "decide upon the undecidable"—as the occasion of revolutionary action, and the onset of the event to come—the "eventual rupture" in love, science, politics, and art. For a provocative alternative, suggesting that revolution is not so much an "event" as a *language*, see Ariella Azoulay's essay "The Language of Revolution—Tidings from the East," on the Arab Spring, in *Critical Inquiry*, http://critical inquiry.uchicago.edu/features/special.shtml.

4. See Robert Hariman and John Lucaites's important book, *No Caption Needed: Iconic Photographs, Public Culture, and Liberal Democracy* (Chicago: University of Chicago Press, 2011), on the emergence of news photographs as iconic events in modern history.

merous acts of individual irresponsibility (on the part of mortgage lenders, financiers, and ratings agencies) or, on the other, as a dark conspiracy of insiders exploiting a predictable and systematic product of deregulation.

It may be the case that any historical event will have something uncanny about it, to the extent that there is some uncertainty—that is, a debate—about its necessary or contingent status. On the one hand, conspiracy theory; on the other, mere bad luck, incompetence. Evildoers hidden behind the scenes that need to be unmasked, or mere human frailty and stupidity combined with *Fortuna*. On the one hand, a systematic practice that produces predictable results; on the other, a glitch, a mistake, an exception to "standard operating procedure."

The historian committed to rational explanation of historical events will tend to see patterns of repetition, and will note historical analogies—for instance, between the conditions that led up to the Great Depression of the 1930s and those preceding the Great Recession of 2008. The systematist will argue that the purpose of historical research is, as the proverb has it, to *prevent* repetition by learning from history and thereby helping to head off the unpleasant experience of the uncanny return of the same. The historian of contingency will start from the premise that historical analogies are always of doubtful usefulness, that history is a series of particular occurrences that obey no discernible design or pattern. History, as Richard Rorty insisted (echoing Henry Ford),[5] is "one damn thing after another," and therefore its narrative shape is determined by the literary form of irony rather than the uncanny, though this difference may itself become uncertain under the right conditions. Often the judgment that we are witnessing a "historical irony" amounts to a perception of the uncanny. Isn't it ironic, for instance, that in the same week of September 2008 that the world's financial system crashed, the artist Damien Hirst put up for auction a solid gold calf—ancient symbol of greed, materialism, and idolatry—that fetched millions of pounds, a dramatic display of the uncanny linkages between the bursting bubble of financial speculation and a wildly inflated and deeply cynical art market?

An even more striking example of the historical uncanny in our time would have to be the miraculous election of Barack Obama in 2008, an event that probably depended upon the coincidence of the financial collapse, and marked, with a distinctiveness rare in historical periodization,

5. Thanks to Jim Chandler for reminding me of this source for Rorty's remark. Other sources include Winston Churchill, Arnold Toynbee, and Edna Saint Vincent Millay.

what looked like a bright line ending the era of the Bush administration. Of course, subsequent events have suggested that the event was perhaps less of a game-changer than was initially imagined (Obama continues many of the same policies, and his administration is riddled with the same actors), but at the level of the imaginary, Obama's election had something undeniably uncanny about it. Not merely the visual spectacle of a certifiably African American politician rising to the highest office in what remains a racially divided country, but the even more striking features of the *acoustic* image conjured by Obama's name, which is a synthesis of the names of the principal enemies of the United States during the preceding era. Saddam Hussein and Osama bin Laden are synthesized, as it were, in the name Barack Hussein Obama, fusing not only the terrorist and the tyrant but the Muslim as well, a synthesis that was repeatedly emphasized in caricature and political polemic to turn Obama into an illegal immigrant and a figure comparable to Stalin, Hitler, and the Joker. It was as if all the enemies of America in the twentieth century had been fused into a single caricature, and (even more improbably) elected by the first clear popular majority in over a decade.

But all these examples of the historical uncanny are relatively shallow and schematic. They are merely instances of ironic reversal coupled with a kind of affect—ambivalence, an alternation between curiosity, wonder, and anxiety. Rather than accumulate examples, an exercise that is a bit like playing tennis with the net down, I want to focus on a specific historical period, the recent past of the Bush presidency, and the "war on terror," which dominated American foreign policy and still does today, despite attempts to replace the phrase with the euphemism "overseas contingency operations." Many (including the chief officials of the Bush administration) have argued, of course, that the war on terror, despite its patently metaphoric character, is not a metaphor and a "public relations locution" but (as historian Philip Bobbit describes it) a literal truth, and the only rational framework for strategic thinking in the twenty-first century.[6]

My argument has been that this period, the very recent past, has all the characteristics of the narrative and aesthetic features of fantasy, irony, and the peculiar mixture of them known as the uncanny. Poised between

6. Bobbitt dismisses the notion (common within the Bush White House) that the phrase "war on terror" was a metaphor coined for purposes of public relations. He provides the most systematic argument to date for the *literal* truth of the phrase, entitling the lectures he gave in 2009 at Stanford University "The War on Terror Is No Metaphor." See also his book *Terror and Consent: The Wars for the Twenty-First Century* (New York: Anchor Books, 2009).

the genres of the fantastic and the detective story, this period has brought onto the historical stage not only the tropes of repetition and return, but a quite vivid phantasmagoria in the form of what documentary filmmaker Rory Kennedy has called "the ghosts of Abu Ghraib." It has also produced a new, updated, and technoscientific version of the uncanny *doppelganger* in the form of the clone, the figure of the indefinitely duplicated life-form exemplified at the low end by stem-cell research and the virus or cancer, at the upper end by the image of the terrorist as a faceless, anonymous, indefinitely reproducible organism that inhabits the body politic in sleeper cells, exactly like a cancer or virus. The global war on terror has, as I have argued, had the effect of "cloning terror." It is a cure that has accelerated the progress of the disease, a medicine that increases rather than arrests the proliferation of pathogens.

My larger argument, much more provisional and speculative, concerns the question of theory and method raised by the notion of the historical uncanny. A full engagement with this issue would require going back to the classic reflections by Hayden White, Louis Mink, Paul Ricoeur, and Paul Veyne on the role of literary tropes and narratives in the construction of historical accounts. In *Metahistory*, White documents in encyclopedic detail the battle between empirical historiography and the "philosophy of history" that marked nineteenth century reflections on history, relying primarily on Northrop Frye's four narrative categories of irony, romance, tragedy, and comedy to describe the possible literary framing of history.[7] So far as I know, he does not ever consider Todorov's transitional genre of the uncanny, poised between fantasy and empiricism. Could it be that the uncanny would provide, not just a model for the narrative shaping of specific historical events (most notably, the present), but that it could offer some insight into the aporia that historians invariably confront, the moment of undecidable decision between history as doubtful romance and as unresolved detective story?

I will leave these questions to the historians, at least for the moment, in order to focus on another, rather more literal, exemplification of the historical uncanny that goes beyond literary narrative into the realm of public spectacle and visual culture. In the history of media technology, the phenomenon that corresponds most directly to the historical uncanny is the phantasmagoria, the use of optical projection devices to produce

7. *Metahistory: The Historical Imagination in Nineteenth-Century Europe* (Baltimore: Johns Hopkins University Press, 1973). I am grateful to Hayden White for his generous comments on an earlier draft of this essay.

public spectacles involving phantoms, ghosts, and apparitions of all sorts. As Tom Gunning has shown, the nineteenth-century phantasmagoria is the medium of the specular uncanny par excellence, precisely because it does not simply continue the tradition of magic shows and popular fantasy but stages its spectacles "on the threshold between science and superstition."[8] In the earliest and most elaborate phantasmagorias, such as those of Etienne-Gaspard Robertson, the subject matter ranged across literary and historical narratives, from the Gothic novels of Monk Lewis, to historical dramas of the very recent past, notably, the principal figures of the French Revolution. The figures of Danton, Marat, and Robespierre were mingled with those of contemporary scientific inventors such as Benjamin Franklin, whose glass harmonica often provided eerie musical accompaniment, and whose experiments in electricity and "galvanism" were linked to Mesmerism and the reanimation of dead bodies.

If the nineteenth-century phantasmagoria was situated on the historic borderline between "enlightenment and terror," as Gunning puts it (24), what are we to make of the contemporary media spectacle of the global war on terror? Is it possible in an age of new media that the old technology of the phantasmagoria has a new role to play? How has the spectatorial reception and use of the technologies of spectacle changed in our time to produce a new version of the historical uncanny?

First we might notice a few salient points of similarity between the era of the early phantasmagoria and our contemporary media situation. Perhaps most obvious is the shared sense of technophilia, the feeling that we are in the midst of a media revolution as profound as the invention of the printing press,[9] an outpouring of media innovations that seem to promise, on the one hand, the utopian prospects of McLuhan's wired world and global village and, on the other, the self-mesmerizing dystopia of distracted multitasking, twittering, and texting, and complete loss of privacy, accompanied by a massive case of attention deficit disorder, especially when it comes to history and politics. The return of the 3-D cinematic spectacle after a period of quiescence seems to mark a new appetite for illusionism, and the revival of political modes of magical thinking, best exemplified by the reliance of films like James Cameron's *Avatar* on

8. Gunning, "The Long and the Short of It: Centuries of Projecting Shadows from Natural Magic to the Avant-Garde," in *The Art of Projection*, ed. Christopher Eamon, Mieke Bal, Beatriz Colomina, and Stan Douglas (Ostfildern: Hatje Cantz Verlag, 2009), 24.

9. See Samuel Taylor Coleridge's remark on the printing press and the phantoms it produces. See note 12 below.

narratives of white, first-world heroes rescuing colonized native peoples from the genocidal resource wars in which they serve as soldiers, a plot type that might be called "The Return of the Broken Arrow," alluding to Jimmy Stewart's classic Hollywood sojourn among the Apaches.[10] Or we might point to increasingly illusionistic and immersive video games that position the player as the top gun in the war on terror, GI Joe roaming the streets of Kandahar, Baghdad, and Gaza to mow down the anonymous clones of Osama bin Laden. The best antidote to these games that I know of is *September 12*, a point-and-shoot game that positions the player as a controller of drone attacks, hovering over the crowded streets of an anonymous Arab city, picking out armed masked fighters for assassination.[11] When the player kills a fighter, however, he inevitably takes out a number of innocent bystanders, women and children, and the scene of destruction quickly gathers a crowd of wailing mourners who morph before our eyes into more armed, masked fighters. I cannot imagine a more vivid demonstration of the way that the war on terror has the effect of cloning terror. The whole point of this game is to resist immersion in the phantasmagoria of "point and shoot," and to quit playing the game.

Perhaps the most obvious difference between nineteenth- and twenty-first-century historical phantasmagoria is the fact of real-time broadcast media. The closest thing the nineteenth century had to offer was the illustrated newspaper and magazine, and perhaps the "circulating library," which disseminated radical opinions to the populace and, according to Coleridge, amounted to "a sort of mental *camera obscura* manufactured at the printing office, which . . . fixes, reflects, and transmits the moving phantasms of one man's delirium, so as to people the barrenness of a hundred other brains."[12] The onset of the contemporary historical uncanny, by contrast, did not need to wait for the printing office or the deliberate pace of the circulating library. The destruction of the World Trade Center on 9-11 was transmitted instantaneously, in real time, throughout the world, and it was the uncanny spectacle par excellence, striking spectators as the repetition of a scene that they had already witnessed in numerous disaster films of the preceding decade. The event, moreover, seemed to be staged as an uncanny repetition in the very moment of its unfolding, with the brief

10. With Jeff Chandler as Cochise, and Debra Paget as the beautiful Indian Princess; directed by Delmer Daves, 1950.
11. My thanks to Patrick Jagoda for bringing this game to my attention.
12. *Biographia Literaria* (1817), chapter 3, *Collected Works* (Princeton, NJ: Princeton University Press, 1985), 7:48. See my discussion of the camera obscura of unlicensed printing in *Picture Theory* (Chicago: University of Chicago Press, 1994), 120.

interlude between the impact of the two airplanes guaranteeing maximum media attention to the second strike. Déjà vu seemed doubly inscribed in the event itself, as well as in its numerous premonitions.

As for the images that were fixed, reflected, and transmitted in the wake of 9-11, they constituted, as I have argued in *Cloning Terror*, a paradigm shift in the phenomenon known as "the pictorial (or iconic) turn," from the Benjaminian model of mechanical reproduction (epitomized by chemical-based photography and the assembly line) to a new era of "biocybernetic reproduction," characterized by the twin revolutions of high-speed computing and genetic technology and epitomized by the digital image, on the one hand, and the cloned organism, on the other. This "biopictorial" turn is incarnated repeatedly in what has become the central icon of the war on terror, the notorious "Hooded Man of Abu Ghraib," an image for which not only is "no caption needed" but in some sense no adequate caption is possible because it captures so eloquently all the contradictions of the age.

Cloning Terror documented the full range of mutations of the Hooded Man, from protest image to omen of defeat, from endlessly cloned chorus lines to corporate logos in the flow of images interrupting the icons of narcissistic pleasuring with the self-absorption of the tortured body, from the Bionic Abu Ghraib Man at Mount Rushmore to the Statue of Liberty electrified in Baghdad, from helpless victim to conquering sovereign in the political-religious iconography of Moses, Jesus, and Mohammed. Perhaps now it is enough to say that the Hooded Man is the spirit of the age of the war on terror, capturing perfectly its links with cloning, with iconoclastic defacement, with the *ecce homo sacer* of a holy war and a crusade against terror. A perfect dialectical image of "history at a standstill," the Hooded Man captures the uncanny mirroring, the doubling relation of the terrorist and the sovereign, a relation that is also seen in the doubling of Uncle Sam by Uncle Osama, or the hooded Saddam mirrored in the hoodwinked Star Gazer of America's blind faith in its own idealism.[13]

But what precisely is the point of staging this phantasmagoria of imagery from the war on terror? What use is it to make the Spirit of the Age visible for all to see? To me the most obvious answer is, to prevent historical amnesia and the recurrence of an American innocence that is continually "shocked, shocked" to discover the obscene relics hidden in its

13. For more on Walter Benjamin's concept of the dialectical image, see "Metapictures," in *Picture Theory* (University of Chicago Press, 1994), 45–46. For the "Star Gazer," see my discussion of Hans Haacke's work by this title in *Cloning Terror* (Chicago: University of Chicago Press, 2011), 109–10.

own ideological closet. The revelation of the spirit of the age is only half the task, however, of the historical uncanny. The other half is the completion of the detective story that is at the far end of the uncanny's narrative trajectory. The incompleteness of this process is vividly on display in Errol Morris's documentary film about the Abu Ghraib photographs.[14] As a former detective himself, Morris has established a reputation as the most gifted forensic documentarian of our time, taking his camera and sound recorder all the way into the heart of darkness that lurks in historically significant crimes. But in *Standard Operating Procedure*, Morris found himself stalled in the midst of the uncanny. His techniques of documentary reenactment served not as a tool for the forensic testing of hypotheses, as they had to such memorable effect in *The Thin Blue Line* (which led to the reversal of a false murder conviction), but only to immerse the spectator in a phantasmagoria in which the old technique of double exposure allows "ghost interrogators" to stalk the surreal spaces of a haunted Abu Ghraib prison, reconstructed down to the tiniest detail on a Hollywood sound stage. This is a detective story so obsessively focused on the evidence, the visible traces of a crime, that it refuses to follow the invisible trail of criminality that would lead directly to the top level of the US government.[15] Instead, it plunges us into cyberspace, where the fantastic photo archive of Abu Ghraib is arrayed like a starry firmament waiting to be organized into a constellation.

In what is arguably the most memorable scene in the film, Morris records the testimony of Brent Pack, the forensic analyst employed by the army to establish the exact provenance of all the Abu Ghraib photos. This marvelous scene reveals precisely what is new about the digital photograph, and utterly discredits the commonsense myth that digital photos have a less firm grip on the real than old, "indexical" chemical photos. What Morris shows is that the digital photograph has a doubly or triply indexical claim on the real by virtue of the "metadata" that is automatically encoded along with the file that allows production of an analog image. The digital camera encodes time as well as visual space; it also identifies the camera that took the picture, and today it routinely uses GPS to pinpoint the location where the picture was taken. And yet what this scene also reveals is that, despite this unprecedented technical access to the

14. *Standard Operating Procedure* (2008).
15. To be fair, this would have been the more conventional documentary approach to the Abu Ghraib scandal, it was followed precisely in Rory Kennedy's *The Ghosts of Abu Ghraib* (2007). Perhaps Morris felt that the hidden story of high-level cover-ups had already been done sufficiently.

exact particulars of a historical event, the truth of these images seems to recede ever farther from view, leaving the spectator in the uncanny space of a cyber-phantasmagoria. The detective story that would solve the mystery of Abu Ghraib, and of the war on terror, remains, like so many examples of film noir, suspended in uncertainty. The real criminals have gone free, while a few scapegoats trapped in the Wax Museum of Uncanny History—Charlie Graner, Sabrina Harman, Lynndie England—have paid the price. The American Constitution is also paying the price, in the ongoing cover-ups and subversion of the justice system fostered by the Obama adminstration's naïve insistence on "looking forward," refusing not only the imperatives of memory and history, but of justice as well.

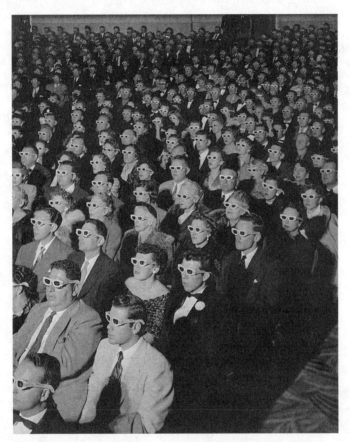

16.1 J. R. Eyerman, audience wearing 3-D glasses (1950s). Photo-
graph: *Life* Picture Collection/Getty Images.

16: THE SPECTACLE TODAY

A Response to Retort

The spectacle today, in the summer of 2014, is not what it was when this essay was first written in 2005. Image science in that period was obsessed, quite naturally, with the spectacle of two American-led invasions, the first in Afghanistan, the second in Iraq. Both of these invasions were responses, of course, to the spectacular destruction of the World Trade Center on 9-11. Both were accompanied by massive propaganda campaigns that crushed antiwar sentiment and cynically misled the American public into a belief that Iraq was somehow implicated in the attacks of 9-11. George W. Bush's political advisers quite deliberately staged the run-up to the invasion of Iraq in 2003 as one would an advertising campaign,[1] selling the war as an expedition that would pay for itself by seizing the richest oil reserves of the Middle East. The exchange of "blood for oil" was presented as a deeply rational calculation that overwhelmed moral reservations and political resistance.

Consider, then, the difference today. It is not spectacle but surveillance that dominates the mediasphere. The collapse of the Arab Spring and the hideous civil war in Syria has not awakened any yearning for American intervention. On the contrary, Americans, and much of the first world, seem thoroughly weary of war, longing only to be left alone. The efforts of Barack Obama and British prime minister David Cameron to muster enthusiasm for an enforcement of international law and humanitarian moral standards are greeted with a shrug or outright dismissal. And there is little evidence that anyone in the Middle East is eager for American intervention. The United States is no longer in control of the spectacle, as it was during the run-up to the invasion of Iraq. It has basically become a spectator, a passive witness to historical events. At the same time, the closest thing to a spectacular scandal is the revelation that, alongside the

1. "From a marketing point of view you don't introduce new products in August," said White House chief of staff Andy Card on September 7, 2002. See *Mother Jones* comprehensive timeline of the run-up to the Iraq war, http://www.motherjones .com/politics/2011/12/leadup-iraq-war-timeline.

withdrawal of American troops from the Middle East, a new regime of massive surveillance has been installed that places the entire population of the world inside a kind of virtual panopticon. Michel Foucault's concept of a "civilization of surveillance" (*The Punitive Society*, 1973), distinct from Guy Debord's "society of the spectacle," seems to have now been fully realized.

But I would not want to suggest that a simple choice between spectacle and surveillance, or an alternation of dominant modes of media power, would be adequate to understanding either phenomenon today. For one thing, surveillance has itself become a spectacle. If there is little appetite for a spectacular renewal of Western military adventures in the Middle East, there is a vast market for the simulation of these spectacles in war games.[2] And the US surveillance regime of phone and e-mail monitoring, BOSS (Biometrical Optical Surveillance System), facial recognition software,[3] and remote control drone attacks has now been subjected to spectacular exposure by the countersurveillance actions of Edward Snowden and Chelsea (formerly Bradley) Manning.

Spectacle and surveillance must be understood, in other words, not as mutually exclusive alternatives, but as dialectical forces in the exertion of power and resistance to power. Spectacle seeks to take power over subjects by distracting them with illusions; surveillance, by contrast, functions in the register of realism, taking power over subjects by treating them as objects subjected to a penetrating gaze that knows where they are and hears what they are saying. The old model of the spectacle-surveillance dialectic was the telescreen of George Orwell's *1984*, which transmitted a constant stream of military propaganda replete with spectacles of mass gathering (the Hate rallies) and mass extermination of enemies, while at the same time functioning as a monitor allowing the private lives of all members of the Party to be observed. This two-way model of spectacle and surveillance is never completely dominant, even in Orwell's dystopian fantasies. Dark

2. My colleague Patrick Jagoda describes the situation vividly: "Games have experienced an accelerated transformation from a minority hacking practice of university labs in the 1960s and the arcades of the 1970s to a global multibillion-dollar industry. . . . Players spend considerable money but also substantial time with contemporary games. In early January 2011, for instance, Activision announced that players of its hit game *Call of Duty: Black Ops* (which earned 360 million dollars in the first 24 hours after its release) logged 600 million hours of gameplay collectively (the equivalent to 68,000 years) during the first 45 days after release (Orland)" (Jagoda, personal correspondence).

3. See Ginger McCall, "The Face Scan Arrives,"op-ed, *New York Times*, August 29, 2013.

little niches remain out of sight of the telescreen, and Winston Smith's private notebook records countermemories that resist the disappearance of history into the Memory Hole at the Ministry of Truth. Gossip, conversation, and other lateral modes of communication cut across the media dominance of the telescreen.

But today, a third media force has emerged that opens a new front in the power struggle with spectacle and surveillance. This is the social media, epitomized by Facebook, Twitter, and all the forms of lateral text-voice-video messaging. Like the postal system, graffiti, and unauthorized mass gatherings, the social media have the potential to produce forms of counterspectacle and countersurveillance, as we see in contemporary phenomena such as the Occupy Movement and WikiLeaks. That is why I have consistently argued against the monolithic application of either the Frankfurt School's "culture industry" thesis or Guy Debord's "society of the spectacle." It is not that I have some naïve trust in "affirmative culture" of the sort that Hollywood provides or the art world promises. It is rather that I want to insist on critical discriminations that examine the actual functioning of artistic and media practices that aim to resist the dominant modes of spectacle and surveillance. World of Warcraft is not the only video game on offer, and corporate baubles are not the only artistic products available. No account of spectacle as a mere expression of the nefarious forces of Capital is going to be adequate to the actual media politics of our time, much less the moment at the height of American war fever a decade ago. That is why the following critique of the spectacle hypothesis, written at the peak of that fever, will, I hope, still be relevant today.

The Retort Collective's book *Afflicted Powers: Capital and Spectacle in the New Age of War* was an important critical intervention in the discussions of the war in Iraq, and the whole strategic vision of the so-called war on terror inaugurated by the events of September 11, 2001.[4] The origin of this book in the 2003 global demonstrations against the US-led invasion of Iraq, remains a moment of spectacular optimism *and* defeat at one and the same time. The authors issued a pamphlet at that time, *Neither Their War Nor Their Peace*, which was crucial in its insistence on identifying deeper structural issues than the isolated question of "peace versus war" in Iraq. It provided an important reminder that the so-called peace of the previous

4. I am deeply grateful to my colleague Lauren Berlant, who dropped everything to perform a heroic editorial cleansing of the mess this essay amounted to in an earlier draft.

decade, the era of the "peace dividend" at the end of the Cold War, had been a low-level war leading inexorably to the outbreak of the war on terror. The sanctions were not a "peace" in any sense of the word.

Afflicted Powers is also a deeply felt meditation on the increasingly marginal position of the Left as a political movement. It is especially useful in its analysis of structures of overdetermination, as in the multilayered account of the "blood for oil" equation and the "future of the illusion" known as US policy toward Israel. As a die-hard Blakean I of course appreciate the identification with what Blake would call "the voice of the devil," speaking from its downcast state on the burning lakes of hell—an all too prescient image of burning oil fields in the Middle East, as well as a reminder of Milton's defeated rebel angels, convening to plot their next move and mobilize their "afflicted powers." And needless to say, I am especially fascinated with the effort to link the contemporary problem of "the Image and Spectacle" to the present war on terror. I believe that it is essential to work through these concepts, from Marx's figures of the commodity fetish and the camera obscura of ideology to Walter Benjamin's "exhibition value," Adorno and Horkheimer's "culture industry" to Guy Debord's "spectacle"—the fundamental Imaginary structures of capitalist modernity.

But I worry that *Afflicted Powers* has constructed another enemy, a straw enemy, not nearly as powerful as the military neoliberalism it correctly identifies as the major force for a new round of "primitive accumulation" and neocolonialism. This enemy bears a large burden of the blame the volume assigns to forces that present obstacles to the Left. It hovers around the fetish concepts of Spectacle, Capital, the State, and Modernity. These concepts frame Retort's analysis of the contemporary political situation in what must be called highly *spectacular* terms, as the mobilizing of vast abstractions contending for power in a mythic struggle, a "Holy War" against "Mammon" and "Moses and his Law," waged on the battlefield of a contemporary "hell on earth." All of the terms (including Spectacle itself) should be capitalized. They are proper names. They are regularly personified, treated as agents with intentions, choices (or not), necessities, and actions. The State has "anxieties" and "obsessions" (20). The Spectacle, as Guy Debord always insisted, even has "plans" for "self development" (*Society of the Spectacle*, 16). "Spectacular power can . . . deny whatever it wishes to . . ." (22). But *Afflicted Powers* claims to argue substance against spectacle. What's really going on?

Apocalyptic rhetoric of this sort is probably unavoidable, if only because it is the operative language of the contestants themselves in the war on

terror. This war is the millennial showdown that Y2K failed to provide, the last battle between Good and Evil. It is the modern Crusade, and so the language of premodern war comes back to haunt even the most self-reflexively critical discourse, along with inflated fantasies of the satanic enemy. It would take more time than I have here to account for the way Retort frames its entire project in the language of Milton and the English Civil Wars. The usual resource for historical analogies has been medievalism, whether it is in the curious upsurge of Augustinian, Franciscan, and Pauline rhetoric in Michael Hardt and Antonio Negri's *Empire*, or in the writings of Giorgio Agamben and Slavoj Zizek.[5] This language, needless to say, finds its popular counterpart in the current sense that "Christendom" is threatened once again by an Islamic horde. Could it be that Retort's use of the highly ambiguous language of Milton's *Paradise Lost* (is Milton on the side of the devils or of the angels? Is Satan conducting a liberation struggle or an imperial venture?) reflects some confusion or at least ambivalence about the moral and political grounding of Left politics at this time?

Along with the Miltonic and apocalyptic modes that haunt this volume is the anachronism we call the 1960s, and May '68, signaled in the centrality of Guy Debord and the Situationist International's concept of the "Spectacle" as the volume's satanic foe. To be fair, we must note Retort's insistence on a critical distance from the categories of Debord: if his version of the spectacle was "an exultant, world-historical force," Retort's is characterized as "minimal, pragmatic, and matter of fact." But somehow these disclaimers ring hollow. Retort seems just as convinced of the "alchemy of spectacle" (130) as Debord was, and this is why they have to deny that they are "sectaries of the spectacle" (17) and claim that "no one concept, or cluster of concepts" can "get the measure of the horror of the past four years," even as they declare that the spectacle is just such a totalizing force: "a social process"; "a form of violence" that (like Mao's political power) "comes out of the barrel of a gun" while artfully hiding itself as "a deadly simulacrum of community" (21), a "manufacture of desire" into "the lifeless bright sameness . . . of the market," and a "pattern of small (saleable) addictions."(20). The spectacle is, in other words, both the macro- and micro-structure of contemporary ideology, both the center and the circumference, the cause and the effect. It is what is hidden *and* what shows itself; it is what produces the agony of a colonized everyday life *and* its numbing anesthetic; it generates a "Prozac state" and an "empire

5. See Bruce Holsinger's essay "*Empire*, Apocalypse, and the 9/11 Premodern," *Critical Inquiry* 34, no. 3 (Spring 2008): 468–90.

of shock and awe," while at the same time it "agonizes" (131) at its own internal contradictions and its vulnerability to the sort of "spectacular defeat" it suffered on September 11 (a defeat which, of course, is magically transformed into a spectacular *victory* for neoconservatism).

While I feel deep solidarity with the fundamental political commitments of *Afflicted Powers*, I find myself less interested in the invocation of old arguments from Marxist thought or reverential repetitions and *detournements* of Situationist slogans. So I agree with the claim that "capitalism" and "primitive accumulation" are not outmoded concepts but take on a whole new set of important meanings in our time of "neo-liberal militarism" (9); I agree with the genealogy that links al Qaeda to a Leninist revolutionary vanguard, and thus makes knee-jerk agitprop rhetoric (like knee-jerk reactionary rejections of "modernity") highly suspect. What I don't care about so much is, thus, precisely the need to wave the banner of the Left. I want to be in solidarity and continuity with the heritage of leftist thought but without the need to rewage old sectarian struggles or to wave the tattered old battle flags, especially when the actually existing Left in American politics constitutes (at an optimistic estimate) 3 percent of the electorate, and that 3 percent is divided against itself over its relation to actual party politics. We also have to be candid about our own romanticism of the Left, the grudging admiration for the Leninism of al Qaeda that seems to strike a recurrent undertone in *Afflicted Powers*. As Hal Foster notes, this nostalgia for Leftist vanguardism puts the remnants of the Left in a position of "enemy-twinship with revolutionary Islam" (201), and that strikes me as exactly the wrong posture.

Therefore I'm glad to see paragraphs like the one on page 10, where the authors renounce the notion of capital as a "magic shaping power, pulling the strings of everything in the world around it," in favor of a concept that makes sense in the *Wall Street Journal* and the McCain-Feingold Act, and that does not need to explain the obvious as if it were the solution of a deep mystery, "solving crimes the criminals have never bothered to conceal" (10). I am also happy to see that the "totalizing closure" of Debord's concept of the spectacle is being dissented from, that an important qualification on the power of the spectacle is its tendency to self-limit: "once the running of the state involves a permanent and massive shortage of historical knowledge, that state can no longer be led *strategically*" (22). The "eternal present" of the spectacle is deadly, not only to resistance to the state and the spectacle, but to the state itself (23). But I would want to insist on some realism about such "strategic" claims. It strikes me as highly likely that the Bush administration's ill-advised war in Iraq is laying the

groundwork for the collapse of the American empire later in this century, just as current Israeli policies are laying the groundwork for the eventual demise of the Jewish state. But neither of these long-term *strategic* failures prevents these states from engaging in shorter-term strategic leadership, however incompetent and flawed. In fact, the persistence of neocolonial illusions is precisely what enables these states to be led strategically and to pursue imperial military adventures with disastrous strategic consequences, as well as horrific short-term consequences for multitudes of ordinary people.

So there may be some fundamental problems with Debord's concept of the spectacle as the framing concept for contemporary political analysis (not that it exactly swept the world before it in its own proper time!). Debord's spectacle is *too* powerful, too all-explanatory. Like every idol, it seems to take on a life of its own. It becomes precisely the *figure* of that "magic shaping power" of capital, as well as of modernity and consumerism. Spectacle is the face, the avatar, the image of capital. Its "totalizing closure" seems unavoidable.

So what is to be done? What should we do with these fetish-concepts? I don't imagine that they are open to any straightforward demystifying tactics, any ruthless critique that will restore them to some kind of abstract purity, descriptive passivity, or analytic rigor. We are stuck with the language of Modernity, Capital, and Spectacle as the "idols of the mind" we have inherited. I propose, then, that we treat these as "eternal" idols in the Nietzschean sense, as icons that can be *sounded but not smashed* with the hammer—or better, the *tuning fork* of critical reflection.[6] What this entails in practice is, first, an acceptance that no amount of polemical critique is going to make these words disappear, along with the impossibly vague, ambiguous pictures they conjure up; second, a recognition of the way they lure us into magical thinking, melodramatic scenarios of imminent crisis, and oversimplified histories (I am heartened here by Retort's own remarks on the need to "desacralize" the concept of the spectacle); and third, an attentiveness to their multiple tonalities, as well as their eternal or timeless character. Could it be that Bruno Latour's argument

6. I am alluding here to Nietzsche's preface to *Twilight of the Idols*, in which he urges "philosophizing with a hammer," or (even better) a "tuning fork" to "sound" the "eternal idols" that have bedeviled philosophy. It has been insufficiently remarked, in my view, that Nietzsche is here arguing for a nondestructive form of iconoclasm, one that does not dream of destroying the idols it confronts. For further discussion, see my *What Do Pictures Want? On the Lives and Loves of Images* (Chicago: University of Chicago Press, 2005), 8, 95.

that "we have never been modern" is functionally equivalent to saying that "we have always been modern"? In my view we must sound the images of the spectacle, not dream of smashing them. We must reconceive the spectacle as the site of struggle, the contested terrain, and stop personifying it as a Baudrillardian "Evil Demon of Images" that will be dissolved by our ruthless criticisms or trumped by our long-term predictions that history will ultimately vindicate us.[7]

In this spirit, let me address a few particulars:

1. The fetishizing of the Left. I'm not so attached to the word. Should I be? Perhaps only in a conversation like this, with friends and comrades who trace their genealogy to the political struggles of the 1960s and their intellectual DNA back through critical theory and Marxism, but also to Durkheim, Bergson, Freud, and Nietszche, as well as to the radical tradition in English letters from Milton to Blake to Shelley. "Whom do we think we are talking to . . . [when] we appeal to something called 'the Left.' . . . Will they not immediately put our book back on the pile of new releases the moment they see the worlds 'Capital' and 'Spectacle' in our subtitle?" (9). Spectacle might just be the "totem of an ingroup" (10). So the authors ask that we "wait and see." But of course this request is, by their own calculation, unlikely to be honored. These words will "immediately" doom the book, not earn it a patient wait-and-see attitude. So the search for "real opposing speech" that the authors rightly call for seems hampered from the start. This is too bad, because this is actually a terrific book, especially in its clear-sighted analyses of the materially and ideologically grounded fetishes—oil and land—sacred and commercial property. What if we want to speak to the Right and the Center as well, and in its language, in a common vernacular that can explode and reframe the issues?

2. I also want to question more generally Retort's engagement in familiar rituals of reactionary iconoclasm, expressed in its scarcely concealed contempt for mass culture, consumerism, and modernity. Why the disdain for "new media studies" and the possibilities of freedom in cyberspace? The fact that a few hackers made overly optimistic predictions in the pages of *Wired* magazine in the 1990s is scarcely grounds for resigning all hopes for the emancipatory possibilities of new media or cyberspace. The new social movements that Retort looks to with some guarded optimism al-

7. I am aware that it would horrify Debord to be bracketed with Baudrillard, but that is exactly what I see happening in the demonizing rhetoric of the all-consuming spectacle, which threatens to become the clone of Baudrillardian simulation.

most invariably depend upon a deep engagement with Internet communication. Retort's nostalgia for premodern forms of community, its hatred for the "disenchantment of the world" produced by modernity, strikes me as especially ill-advised. While pretending to renounce "Jeremiads against the commodity," Retort engages in exactly this sort of rhetoric. "Mass-produced objects," it declares, "cannot and do not work the magic they are presently called on to perform" (179). Is that so? Did African fetishes work the magic they were called on to perform? Is the problem the failure of material objects to fulfil our fantasies? Do we need different objects? Or different fantasies?

This game becomes especially transparent when Retort declares that "objects" cannot perform their magic "if they are standardized" (179). One waits for the other shoe to drop, in a rousing call for a return to manual, handicraft production. Presumably, when the members of Retort go the drugstore, the airport, the auto parts store, or the supermarket, whatever else they may want, it will include some guarantee that the products sold there will conform to certain standards of safety, reliability, and uniformity.

Retort goes on to admit that "in the end we have failed to stifle our distaste" for the "modern condition"(180). And dis*taste* is exactly the right word here. Beneath the radical rhetoric, there is a disturbing undertone of old-fashioned elitist snobbery, a nostalgia for some unspecified lost utopia of real human values and authentic cultural productions, whether located in traditional communities or in authentically leftist vanguard movements (all of them united by their hatred of modernity). What doesn't seem to occur to the authors is that the demonization of modernity may be exactly what is crippling their analysis and leaving them stranded on the burning lake of hell, with Milton's fallen angels. Suppose modernity were, like the spectacle, treated not as a demonic idol to be smashed, but as a sounding board or instrument to be played or (better yet) a terrain to be contested? I presume that Retort would not want to dispense with standardization, or flush toilets, or general anesthesia, in the world it hopes for. This means that some aspects of modernity will have to be retained, and a critical, discriminating analysis of modernity will have to take the place of totalizing polemical denunciations.

3. One senses in Retort's condemnations of modernity, consumerism, and the technical potentials of new media and cyberspace a tacit break with the whole Marxian emphasis on *modes of production* as a key to understanding the real battleground on which political struggle is to be waged. Retort seems to be accepting a picture of contemporary culture as

a world of nothing but rampant consumerism accompanied by increased alienation and meaninglessness. It dismisses outright any emancipatory possibilities in cyberspace as "a ticket to data-punching," and has nothing to say about the emergence of new, decentralized forms of journalism (the blogosphere), the new accessibility of global media outlets, Internet telephony, or the rise of virtual communities. If one believes the authors, the only ones who believe "that the virtual life is the road to utopia" are "the webmeisters of revolutionary Islam" (188). Is this a statement of envy for the revolutionary fervor of the jihadists? A jibe at their utopianism and faith in technology? Or a tacit confession that they, too, have become "true believers in the spectacle" they are supposed to despise?

To me, the worst moment in *Afflicted Powers* comes in Retort's answer to Hal Foster's invitation to say something about "art, or indeed . . . culture," that is not coopted in advance by the all-consuming power of the spectacle. Their response is to quote the fervent words of Mohammad Sidique Khan, one of the London suicide bombers, as "the voice of our time." They follow this with the following characterization of contemporary art:

> We look around at the actually existing artworld of the Empire and see no reason to expect much in the same vein. We shall ask readers to put along-side Mohammad Sidique Khan's last testament a listing of the themes and styles of this week's gallery offerings in New York and London . . . and judge for themselves. (207)

This may be the most blatant example of philistine sophistry in the entire book. Adorno must be spinning in his grave. The idea that the "themes and styles" of the "artworld" at any time should be "in the same vein" as, or weighed in the balance of political seriousness with, the statements of a fundamentalist suicide bomber reminds me of the most vulgar calls for "relevance" and "commitment" from artists and intellectuals. It is a gesture worthy of Stalin. It also betrays an ignorance of much of what is happening in contemporary art and culture, coupled with an absolute contempt.

Has the Retort Collective paid any attention to the work of the Critical Art Ensemble, or the work of the "Interventionists" curated at a recent show at Mass MOCA by Nato Thompson? Has it noticed the antiwar "culture jamming" strategies of Code Pink or Forkscrew Graphics or Freeway-Blogger.com? Has it occurred to them that some forms of art in inauspicious times may have to pursue quieter strategies, being content to "stand and wait," as Milton put it. Blake insisted that poets should "bring out

number, weight, and measure," the (standardizing) criteria of poetic form, "in a year of dearth." Has Retort noticed that "new media studies" is not some simpleminded celebration of technophilia but an attempt to critically engage with the new forms of communication, experience, and productivity made possible by contemporary media inventions? Has it noticed that the invention of digital photography and video has made possible new forms of resistance, precisely on the terrain of the spectacle? That the revelations of the Abu Ghraib scandal would have been inconceivable without digital cameras and e-mail? That we are now living in what will be regarded as a golden age of political documentary, in which films such as *Fahrenheit 911*, *The Corporation*, *Outfoxed*, *The Fog of War*, *Control Room*, BBC's *The Power of Nightmares*, and *An Inconvenient Truth* treat moviegoing publics to bracing and brilliantly designed interventions on the strategic terrain of the spectacle?

My point is not that the Retort Collective should have "balanced" all their bad news with some inventory of positive developments. The problem is more radical than that. It consists in their adoption of a position that forecloses any possibility of hope, other than the grim, ironic conviction that the spectacle will finally self-destruct, the state will cease to function strategically, modernity will destroy itself (along with all the rest of us), and the merciless laws of the history and the dialectic will be fulfilled. Along the way, Retort will indulge itself in the pleasures of Situationist *detournement*, observing with satisfaction the "falling rate of illusion" just as earlier Marxists pinned their bleak hopes on the "falling rate of profit." The problem, I fear, is that the Retort Collective seems to enjoy its position of despair, downcast on the burning lake of hell, while dreaming enviously of satanic champions who dispatch themselves on suicide missions. I cast my lot with those devils of Milton who take the path of production, inventing new technologies, building a city with music, and endlessly debating the fundamental questions of philosophy. This is a good time to be rereading Blake's *Marriage of Heaven and Hell*.

CODA

For a Sweet Science of Images

To the discoverer in the field of theoretical physics, the constructions of his imagination appear so necessary and so natural that he is apt to treat them not as the creations of his thoughts but as given realities.

ALBERT EINSTEIN, *On the Method of Theoretical Physics* (1933)[1]

To form the golden armour of science
For Intellectual War the war of swords departed now
The dark Religions are departed & sweet Science reigns

WILLIAM BLAKE, *Vala, or The Four Zoas* (1797)[2]

Against the pressure, then and now, to treat the culture of science as context or antithesis to literary production, I recover a countervailing epistemology that casts poetry as a privileged technique of empirical inquiry: a knowledgeable practice whose figurative work brought it closer to, not farther from, the physical nature of things.

AMANDA JO GOLDSTEIN, "Sweet Science"[3]

What picture of science holds this book together? Perhaps by now it is coming into focus. It builds on Einstein's insight that even a "hard" or "exact" science such as theoretical physics is grounded in images, "constructions of [the] imagination." Scientific images are, of course, supposed to be true, accurate, and verifiable. But they are also, as Einstein insists, not to be taken as "given" but as *taken* (like photographs or tracings) or *constructed* (like models). That means they are provisional, subject to cor-

1. Einstein, *On the Method of Theoretical Physics*, the Herbert Spencer Lecture, delivered at Oxford, June 10, 1933. Cited from *Stanford Encyclopedia of Philosophy*, "Einstein's Philosophy of Science," http://plato.stanford.edu/entries/einstein -philscience/ (accessed August 13, 2014).
2. *The Poetry and Prose of William Blake*, ed. David V. Erdman (Garden City, NY: Anchor Doubleday, 1965), 392.
3. Goldstein, abstract to "Sweet Science: Romantic Materialism and the New Sciences of Life," University of California, Berkeley (ProQuest, UMI Dissertations Publishing, 2011. 3616128).

rection, revision, or abandonment. If they assume the status of "settled" science (e.g., Darwinism) that only signals their openness to *unsettlement* and alternative images. It also hints at the possibility that there could be a science of images themselves, and that this would be a science whose object would be understood as a borderline phenomenon negotiating the relations of thought to reality.

The science of images offered by this book is that of Goethe's "tender empiricism" and Blake's "sweet science." It is a critical practice that treats images as the building blocks of our psychosocial worlds, as well as our scientific models of objective reality. For Blake, contrary to his reputation as a Romantic mystic, sweet science is a form of Enlightenment that sets its face against the "dark religions" that mobilize war and destruction. Sweet science engages in intellectual wars of critical research into the possibility of a peaceful and humane future, as well as the truths of nature. It is specifically focused on the role of images in producing forms of understanding and pictures of reality. It is the science of biologists like Norman Macleod, who have shown that the proper object of biology is the image (understood as a self-replicating model, not an individual specimen, or, in the terms of iconology, the image rather than the picture).[4] It is the science of Freud rather than Heidegger, giving us an array of contesting and contested world views rather than "*the* world as picture." (See chapter 8, "World Pictures.") It is a science that not only uses images as aids to understanding, as in the accounts of form provided by mathematics, the pictures of matter and energy provided by physics, or the ideas about life provided by biology. It also puts images themselves under scrutiny as formal, material, and quasi-living entities, "imitations of life," that are subject to a natural as well as a cultural history. (See chapter 3, "Image Science," and chapter 6, "Migrating Images.") It is a science that conceives its object as a borderline entity located at the crossroads between nature and culture, language and perception, figures and grounds. (See chapter 4, "Image X Text," the sections in chapter 2 on the metapicture and the biopicture, and chapter 7, "The Future of the Image.")

Image science, then, is neither a "hard" nor a "soft" science—neither physics nor sociology—but a "sweet" science that pays as much attention to the observer as to the observed, to the subject as to the object, to framing

4. On the image/picture distinction, see chapter 2, "Four Fundamental Concepts of Image Science." For Macleod's account of the image as biological concept, see his article "Images, Totems, Types, and Memes: Perspectives on an Iconological Mimetics," in *The Pictorial Turn*, ed. Neal Curtis (New York: Routledge, 2010), 88–111.

concepts and metaphors as to the empirical evidence they organize. Its epistemology developed in the Romantic interlude between the Enlightenment and modern positivism,[5] the pre-Darwinist era of what Amanda Jo Goldstein has called "sweet science" and a poetically inflected materialism.

Perhaps that is why it shares its name with that other "sweet science," named, coincidentally, in the era of Blake and Goethe.[6] I am thinking, of course, of *boxing*, in which a pair of contestants dance a ballet of intricate tactics and resolute toughness. We don't merely see images; we are struck by them, and sometimes we want to strike back, which is why iconophilia and iconoclasm are irreducible aspects of the affective life of images. Perhaps the sweet pugilistic science of images might take its cue from the practice of *shadow* boxing, in which the fight is with one's own image, as a preparation for all the other images, both the bodies and the arenas in which they are encountered.

The pugilistic metapicture of image science might seem far-fetched at first glance, but a bit of reflection suggests that it has legs. What is boxing, after all, but a sport that demands an immediate face-to-face encounter with another person, involving tactics of both offense and defense, alternating blows and embraces, light jabs (what Roland Barthes called the *punctum*) and knockout punches (Michael Fried's moment of total conviction and presence)? The encounter with an image or a work of art is, in this light, a scene of modulated or controlled violence. The highest praise—or blame—we can give to an image is to describe it as "striking," producing an effect that leaves the beholder marked indelibly, or merely bruised for a moment. Images can offend, enthrall, captivate, and traumatize beholders, which is why they are surrounded by so many taboos and superstitions. Erwin Panofsky famously described the encounter with a picture as akin to greeting an acquaintance on the street by tipping the hat, a custom he traces to the medieval practice of "raising the visor" on an armored helmet to indicate peaceful intentions.[7] Possibly Jacques Lacan had this

5. For a more nuanced account of positivist epistemology, see chapter 12, "Foundational Sites and Occupied Spaces."

6. British writer Peirce Egan coined the phrase in a series of articles on pugilism, *Boxiana*, published between 1813 and 1828. See *iSport*, http://boxing.isport.com /boxing-guides/why-boxing-is-called-the-sweet-science (accessed August 13, 2014).

7. Panofsky, "Iconography and Iconology: An Introduction to the Study of Renaissance Art," in *Meaning in the Visual Arts* (New York: Anchor Doubleday, 1955), 26–54. For further discussion, see "Iconology, Ideology, and Cultural Encounter: Panofsky, Althusser, and the Scene of Recognition," in *Reframing the Renaissance*, ed. Claire Farago (New Haven, CT: Yale University Press, 1991), 292–300.

sort of pacifist gesture in mind when he suggested that a work of art is an invitation to "lay down the gaze," to set aside the visual armor plate of stereotypes and search templates that prevent us from encountering the immediacy and density of visual experience.

Boxing is a sport involving strictly limited combat (no head butting or blows "below the belt"). Peirce Egan described it as the "sweet science of bruising," an artful limitation of violence that administers nonfatal forms of trauma that heal and fade relatively quickly. Like Nietzsche's advice to strike the idols with a hammer or tuning fork so as to "sound the idols" rather than to smash them, boxing is an art and science that aims, not to kill the other but to make him cry out and to yield. Marie-Jose Mondzain asks the question "Can images kill?" and answers that fatal effects are probably rare (as in boxing) but not impossible.[8] Idolatry is that form of encounter with an image that may demand the murder of the other, whether as a sacrifice to the idol, or as punishment for the greatest crime against the invisible, unimaginable god. Certainly a false image can lead to imaginative imprisonment, as suggested in Wittgenstein's admission that "a picture held us captive, and we could not get outside it."

Image science locates its genealogy in Giambattista Vico's *Scienza Nuova*, his "new science," not of nature, but of "second nature," the things that human beings produce—objects, discourses, procedures, and institutions—especially as they are captured and constituted by verbal and visual images. It is deeply affiliated with the German concepts of *Kulturwissenschaft* and (of course) *Bildwissenschaft*, learned traditions that regard images as objects of both historical and philosophical inquiry. Image science has to ask what images are (the question of ontology), what they do (the question of rhetoric and ethics), how they produce meaning (the question of hermeneutics), and what they want (the question of erotics).[9]

I imagine that anyone expecting a highly technical science of images will have read this book with some puzzlement. Where are the graphs and equations, the databases and experimental findings? Where are the statistics and neurological scans, the X-rays and the MRIs? Obviously they are nowhere to be found. The image science elaborated in this book is a qualitative, historical, and psychopolitical science. It is interested in images both as objects and instruments of investigation into human realities.

8. Mondzain, "Can Images Kill?" *Critical Inquiry* 36, no. 1 (Autumn 2009).
9. See my *What Do Pictures Want? On the Lives and Loves of Images* (Chicago: University of Chicago Press, 2005) for fuller elaboration of these questions, especially the last one.

It addresses images as the focus of a critical realism that remains loyal to a tradition of representation making truth-claims based on evidence and a critical stance toward the theoretical frameworks within which that evidence appears.

It also aims to be, then, a relatively practical and applied science, one that deals with the image as an object of inquiry that pervades everyday life as much as the arts, ordinary practices of seeing and knowing as much refined habits of aesthetic contemplation. The image science of this book is, in other words, a tool for understanding the world and ourselves. It is also an image science that cuts across the media, from photography to architecture, sculpture to urban space, verbal to visual metaphor. That is why it has to engage with media aesthetics. Every image has to appear somewhere, in or on or as something, the medium or support for its concrete appearance in a picture or other artifact. Characteristically, the image appears as a figure against a ground, a system nested in an environment (to echo Niklas Luhmann's terms). Most simply, the whole organization of this image science has been structured around the dialectic between figures and grounds, their mutual interdependence and reversals of location, which constitutes the fundamental ontology of images as such.

The image science provided by this book might best be visualized with the help of Allan Sekula's marvelous photograph of a displaced wrench, a graphic allegory of figure and ground, object and space (see figure 5.1). In chapter 5 I discussed it as an exemplar of "critical realism" in its emphasis on the world of tools, practical labor, and the direct engagement of the body in moments of effort and attention. As a symbolic form, the wrench exemplifies the entire world of tools and technology within which images function. In itself, it is a mere "hand tool," emblem of manual production. But in context, in the metallic, mechanized, and globalized world of the international shipping trade, it only makes sense in relation to the machines and structures on which it operates. (This contrasts it with, for instance, a stone axe or arrowhead, the kinds of tools that exist prior to the invention of machines; it is, in that sense, a "machine tool" hybrid.)

The wrench is also slightly displaced in the immediate environment in which Sekula found it. The caption tells us this is a "welding booth," an enclosed space in which metal joints are fused. A wrench is a tool for turning, for tightening and loosening connections. Here I would like to return to it as a photographic meditation on the way images come into the world. The photograph captures a double apparition, a real thing and its impression, the latter revealed by a slight displacement of the object to expose its trace or afterimage. It is a "contact print" that exemplifies the doubly indexical

and iconic character of the photographic image itself, signifying by its formal resemblance and its status as a material trace like a footprint. It exposes in an instant the very same process that produces a photogram of a leaf laid out on paper and exposed to sunlight, or (by analogy) the extraordinarily long process that allows an organism to leave behind its fossilized image in an appropriate medium such as slowly hardening mud. Despite its location in the completely artificial world of a modern shipyard, then, it reminds us that the image is a phenomenon that crosses the border between nature and culture, nonhuman physical-chemical processes, and human fabrications. How appropriate that it be situated in a shipyard, the "foundational site" for a *planetary* approach to image science that does not dream of reaching a final shore but is compelled to rebuild its vessel on the open sea—in this case, the spaceship earth on which we are all passengers. Sekula's picture of a welder's bench may be located in a shipyard, but it is a synechdoche for the entire system of global capital and the detritus it leaves behind, the fossil trace of disuse and obsolescence. The unused wrench is a figure for the bankrupt, closed shipyard in Los Angeles harbor where it was found. Sekula's gesture of moving the wrench is thus a way of putting it back to work by means of revealing it, materially and photographically, as both an image and a found object.

Sekula's photograph is what Gustave Courbet would have called a "real allegory," a symbolic tableau drawn from concrete experience and daily life, not from an arbitrary world of signs and symbols rendered either opaque or all too legible. It is as much a symptom as a sign of intention, an apparition that opens up a world of unintended meanings. What, after all, is a wrench? It is, first, a classic instance of Marshall McLuhan's definition of a medium as an "extension of man," in this case an extension of the arm and hand, combining the grip of an enclosing fist with the leverage of the extended arm. But it is also a figure of figuration itself, as the "turn" or "trope" that transforms an inert object or word into a metaphor. Poetry is a turning and displacing of words that exposes the forms of life that underly all the dead metaphors that make up discourse. As Emerson puts it, "language is fossil poetry," and thus poetry is what brings language back to its living origin.

Let's think of the sweet technoscience of images, then, as a kind of wrench for adjusting the connections between the hard and soft sciences, nature and culture. Let us also think of it as a monkey wrench designed to jam up the gears in the mechanically repeated clichés about a "two culture split" between science and art.

I realize that I have concluded this book with two unexpected and rather

strange metapictures of image science, boxing and welding, exemplified by two McLuhanesque extensions of the hand and arm, the glove and the wrench. The first is a medium for softening the impact of blows exchanged between persons (boxing gloves are mainly for the protection of the hands, not the face, of the boxer). The second is a medium for enhancing strength through leverage in the process of tightening or loosening the bonds between material objects, or here, between pictures and things. The glove and the wrench, then, exemplify the double role of imagery as a mode of contact between persons and things: (1) its role as an intersubjective or communicative relation, in which the image stands between a creator and a beholder, a sender and a receiver, a relation charged with cognitive and emotional resonance, and (2) its function as an *interobjective* relation between two things, the picture and the thing it represents, a tightening or loosening of the representational bond. Of course, in practice the two functions resolve into a single complex relation of subjects and objects, beholders, artists, pictures, and worlds. Perhaps these two functions of striking and turning are precisely what gets combined in Nietzsche's figure of the tuning fork, which strikes the idols without destroying them, making both the instrument and the object resonate to the sweet music of image science.

INDEX

Page numbers in italics refer to illustrations.